REUTERS

OUR WORLD NOW

2

With 373 illustrations, 364 in colour

Thames & Hudson

PAGE 2 A man wears on his back a portrait of U.S.
President-elect Senator Barack Obama during celebrations
in Nairobi's Kibera slum of Obama's historic White House
victory. Kenyans in Obama's ancestral homeland sang and
danced with joy after the Illinois senator they see as one
of their own was declared the first black U.S. president.
5 November 2008. Nairobi, Kenya. Noor Khamis

Reuters executive picture editor Ayperi Karabuda Ecer
Reuters project director Jassim Ahmad

First published in the United Kingdom in 2009 by
Thames & Hudson Ltd, 181A High Holborn, London WC1V 7QX

www.thamesandhudson.com

British Library Cataloguing-in-Publication Data
A catalogue record for this book is available from the British Library

ISBN 978-0-500-28794-1

Printed and bound in Spain by Grafos S.A.

Contents

2008

Introduction

The demise of Lehman Brothers has become
the poster child for a disaster that has swept
an interconnected world into a new and
challenging era. For our world now is not
what our world was. Financial crisis has
metamorphosed into economic crisis. Boom
has turned to bust in a way not seen since
the Great Depression. Stock markets from New
York to Nairobi have tumbled. Economic growth
has ground to a halt or slipped into recession
from Washington to Wellington.

If there is an iconic photograph capturing
Lehman Brothers' momentous collapse, it was
snapped by Reuters in September 2008, in the
glass and girder temple of free-market finance
that is London's Canary Wharf. Lehman staff,
lined up with backs to the window, were being
briefed as the venerable financial firm's shares
plunged. The distress was palpable; the image
eerily evocative of a firing squad.

This book is a collection of images taken
by Reuters award-winning photographers
throughout 2008. Sometimes celebratory, other
times tragic, it offers a vivid glimpse of our
world in a year of extraordinarily rapid change.

RIGHT Staff attend a briefing at the offices of ailing
investment bank Lehman Brothers in London's
Canary Wharf district. Lehman Brothers Holdings
Inc. filed for bankruptcy on 15 September 2008
in the largest bankruptcy case in U.S. history.
1 September 2008. London, Britain. Kevin Coombs

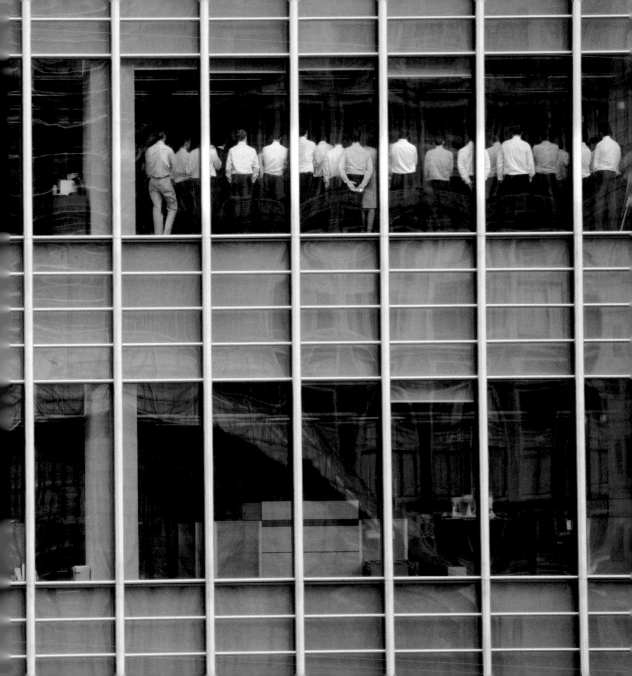

Whether it is laid-off bankers packing their work life into boxes, an inconsolable man in war-torn Georgia clutching his slain brother, or a would-be immigrant from Africa clambering exhausted onto a Spanish beach, people across the world are tied together as never before in an interlinked web of power and money.

The unfortunate Lehman employees were fired en masse a few days after that photograph was taken and a grand old name stretching back to the pre-Civil War United States was gone. This proved to be just one link in an accelerating chain of events that has gripped the world, bringing other financial institutions to near ruin and whole countries to their knees. Consider Iceland. Once a darling of investors, it has suffered a currency and banking system collapse that has sent it scrambling for international aid.

This is not just a problem for the wealthy. The pain of global recession is hitting rich and poor alike. Yes, the bankers and brokers of New York, London, Paris and Hong Kong are hurting. But so too are ordinary people whose retirement savings have been slashed and incomes put under threat. If such people do not spend, goods produced by other people do not get bought. So the problems of wealthy consumer nations are easily spread to poorer producer nations, whether it is to computer-parts makers in China, oil workers in Russia or vegetable farmers in Kenya. Our interlinked world has created great joint opportunities in recent decades. It is now experiencing great collective difficulties.

And so comes change. Governments across the world have thrown off the unfettered free-market philosophy that has dominated for at least 20 years. Nationalization is no longer unthinkable, even in laissez-faire bastions such as the United States. Regulation is no longer a dirty word. Revulsion at lucrative bonuses and perks is now the norm. U.S. carmakers coming cap in hand to Congress for aid were excoriated not for requesting billions of dollars in taxpayers' money to bail out their failing companies, but for flying to Washington in costly private planes. Greed is no longer good: in this changed world of ours, the mantra of Hollywood's Wall Street guru Gordon Gekko has been turned on its head.

Seismic shifts have been reshaping our world in this new millennium. In China, India, Brazil and other emerging economies, millions have been brought out of poverty

RIGHT A cleaner looks at an ATM machine in the lobby of the headquarters of Iceland's Glitnir Bank. Iceland's three biggest banks – Kaupthing, Landsbanki and Glitnir – collapsed in October 2008 under the weight of billions of dollars of debt accumulated through aggressive overseas expansion. 8 October 2008. Reykjavik, Iceland. Bob Strong

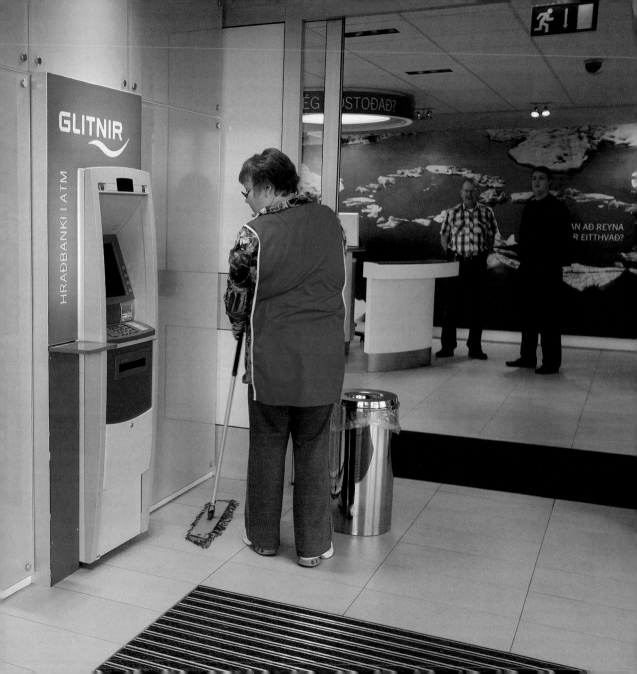

by a never-before-seen global demand for products. This new order is creating a new power structure, with such nations seeking to take their places alongside the traditional economic and political leaders. The display of this new power takes different forms. The 2008 Olympic Games in Beijing were not just a sporting extravaganza. They were China telling the world how far it had come. But Russia's chief exercise of clout in 2008 was military, a reminder that it was once a superpower and intends to return to being one. The rest of the world stood by impotently as Moscow sent troops into neighbouring Georgia, which had tried to retake the breakaway pro-Russian region of South Ossetia. Tanks rolled through debris-strewn streets with impunity.

This rise of developing nation power is unlikely to be reversed. But it may well be slowed by the financial and economic troubles that are sweeping the world, bringing uncertainty with them. Where will the Chinese manufacturer sell its goods if Western buyers stay away from the shops? How will ordinary Russians get rich if oil prices fall as demand wanes? For the billions seeking a better deal in the world, this is not theoretical economics.

RIGHT Chinese women search for usable coal near a coking factory at a cinder dump site. 19 November 2008. Changzhi, China. Bai Gang.

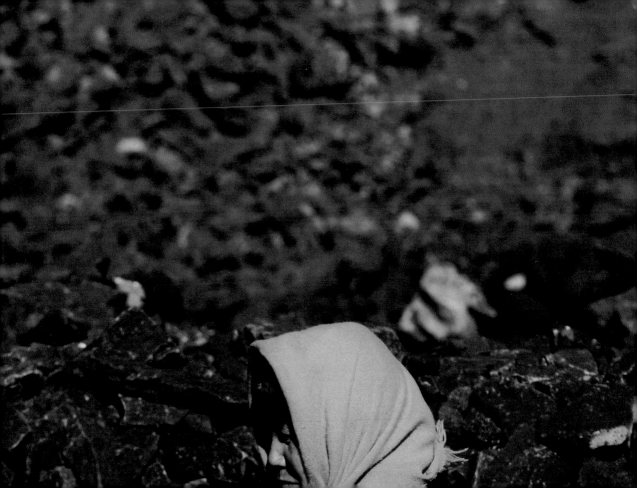

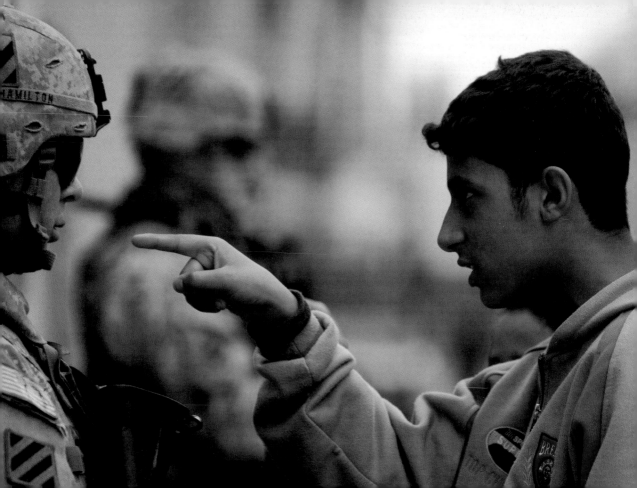

Huge populations have laboured their way out of poverty; they will not quietly return to the hardships of the past.

Not that everything in our world now is new. Environmental degradation, exacerbated as emerging economies prioritize growth over conservation, continues largely unimpeded. For some, it is a matter of waste or foul air. For others it is more stark. Watching the waters lap ever higher on their shores, the people of the low-lying Maldives have begun looking for somewhere else to live. To a perilous degree, environmental destruction and economic development proceed hand in hand, threatening future conflict over resources, land and water. Nor does economic development necessarily lay old conflicts to rest, as the deadly attacks in Mumbai made brutally clear.

Poverty, for all the improvements in some countries, remains entrenched. The poorest of the poor in Africa remain so. Millions went hungry every day even before food prices spiked dramatically in the first half of 2008, leading to riots in several countries. Flows of aid and foreign investment are gravely threatened by the global financial turmoil.

Into this cauldron comes a new world leader. As the first African-American U.S. president, Barack Obama represents an unprecedented break with the past. The son of a Kenyan father, Obama spent part of his childhood in Indonesia. His victory sparked euphoria in Africa and elsewhere. In the United States the joyous chants of his election night expressed a surge of hope at the promise of a sea-change from the two-term administration of George W. Bush.

The Greeks call American presidents 'Planitarchis', literally ruler of the planet. Obama has expressed the wish to restore the United States' frayed international image and repair ties strained under the Bush administration. But he will be hard-pressed to meet the expectations heaped upon him by a worried world. Unfinished wars in Afghanistan and Iraq remain to be dealt with. Economic distress, climate change, renewed conflict in the Middle East, terrorism and domestic demands such as healthcare will all vie for the attention of the new administration.

There will as ever be winners and losers as history unfolds. Reuters photojournalists will continue to bear daily witness to events as they happen across the globe. From headline stories to intimate reportage, their ground-breaking work pushes the boundaries of what news photography is and can be. This second volume of the *Our World Now* collectors' series is an indispensable visual record of a turbulent year that will be remembered as a turning point of our age.

January / February / March

001 Rafah, Gaza

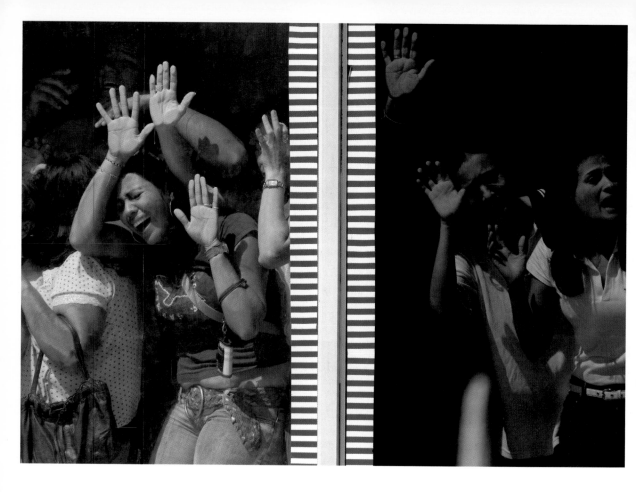

002 Altagracia de Orituco, Venezuela

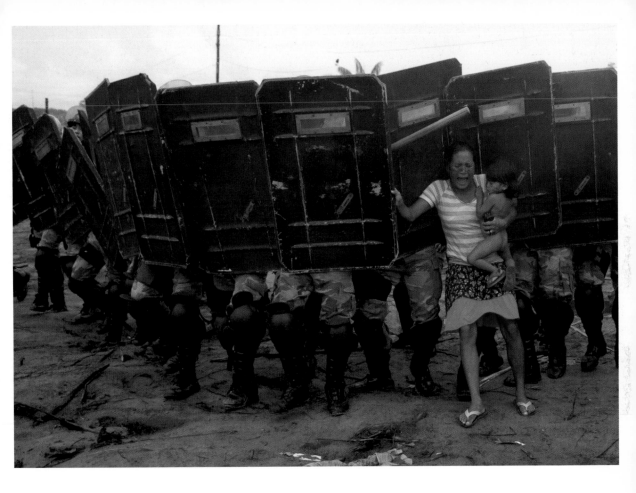

003 Manaus, Brazil

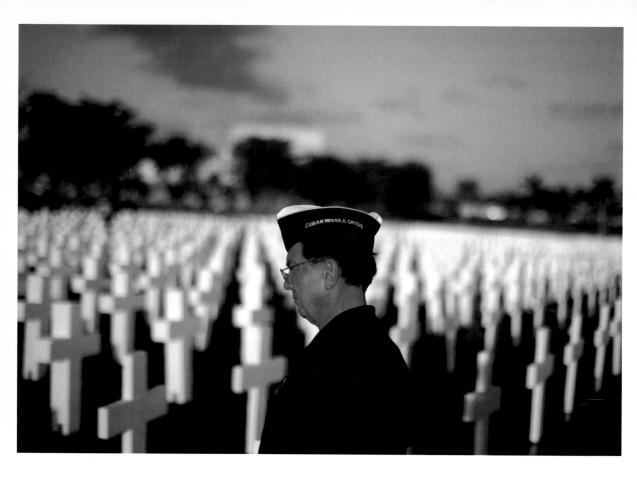

004 Miami, United States

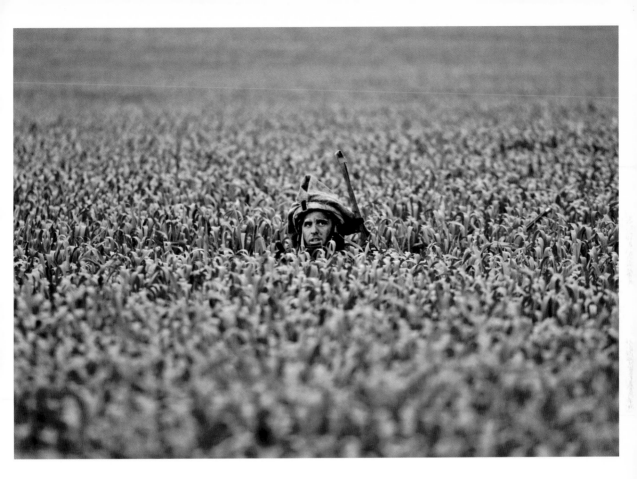

005 Kibbutz Nahal Oz, Israel

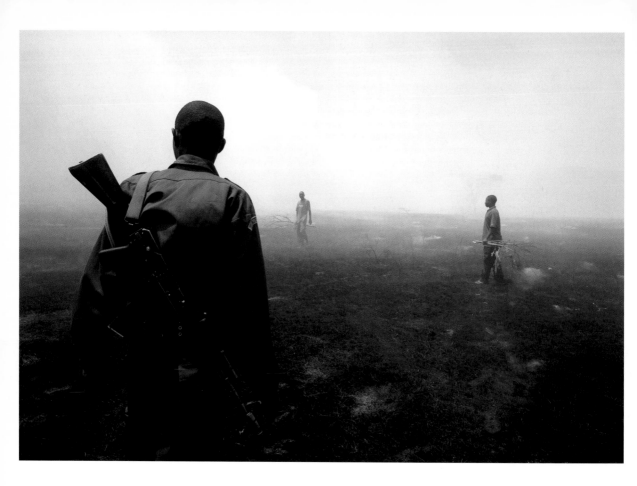

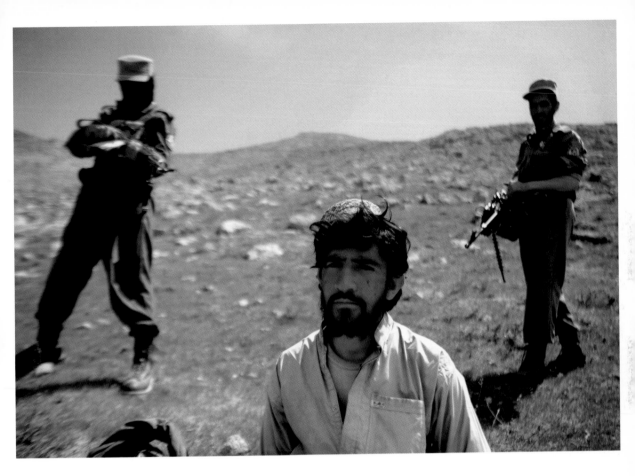

007 Shajoy, Afghanistan

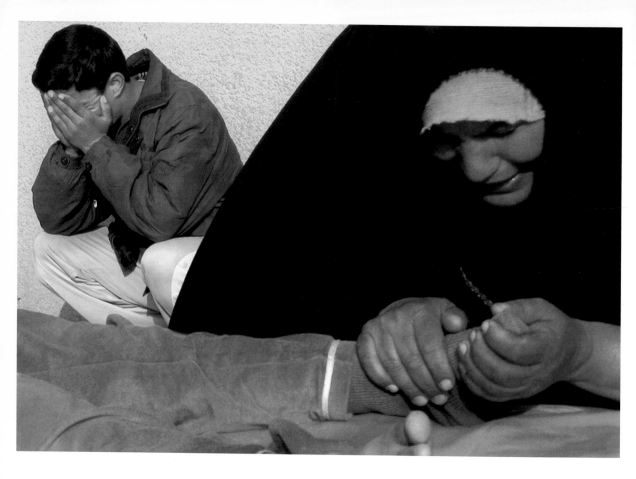

008 Baquba, Iraq

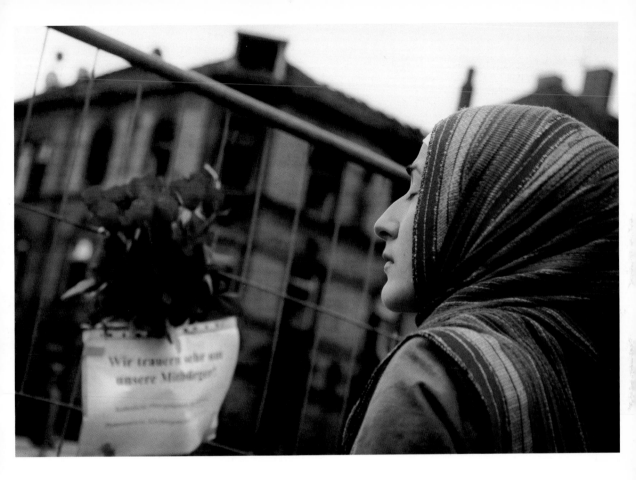

009 Ludwigshafen, Germany

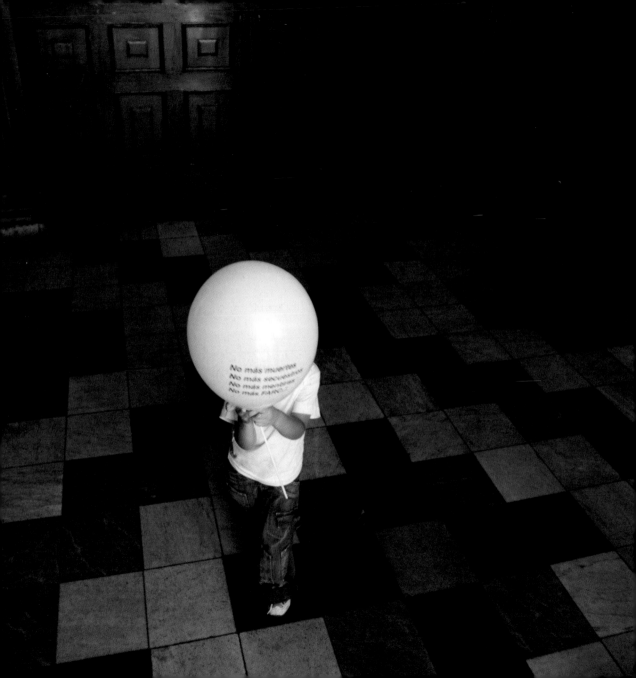

001 002 003 004 005 006

007 008 009 010

001 A Palestinian boy climbs on part of the border wall between Gaza and Egypt after it was blown up by Hamas militants defying an Israeli blockade. 26 January 2008. Rafah, Gaza. Goran Tomasevic.

002 Hostages are pictured inside a bank in Altagracia de Orituco, a sleepy central Venezuelan farming town some 350 km (220 miles) south of Caracas. More than 50 people were held captive in a two-day standoff before the assailants sped away in a white ambulance with six hostages. Police swooped down on the getaway vehicle, arrested the four men and freed the captives. 29 January 2008. Altagracia de Orituco, Venezuela. Edwin Montilva.

003 An indigenous woman tries to hold back the advance of Amazonas state policemen as they evict some 200 members of the Landless Movement from a privately owned tract of land in the heart of the Brazilian Amazon. The landless peasants tried in vain to resist with bows and arrows against police using teargas and trained dogs. 11 March 2008. Manaus, Brazil. Luiz Vasconcelos.

004 A Cuban–American veteran of the Bay of Pigs Invasion walks in a symbolic cemetery at the Tamiami Park in Coral Gables, Miami. Cuban exiles have placed more than 10,000 crosses in the park to honour loved ones who have died fighting Castro's government or trying to cross the sea to the United States. 16 February 2008. Miami, United States. Carlos Barria.

005 An Israeli soldier crosses a field near Kibbutz Nahal Oz, just outside Gaza, as Palestinians protesting against an Israeli-led blockade formed a human chain along roads in the Hamas-controlled Gaza Strip. Israel threatened to use force if they tried to surge into its territory and its troops garrisoned along the frontier were on high alert. 25 February 2008. Kibbutz Nahal Oz, Israel. Yannis Behrakis.

006 A park warden surveys the aftermath of a bush fire in Lake Nakuru National Park in Kenya's Rift Valley. The fire destroyed large patches of the park, one of the country's top tourist destinations. 23 February 2008. Nakuru, Kenya. Zohra Bensemra.

007 Afghan policemen stand guard over a captured Taliban fighter after a gun battle near the village of Shajoy in Zabul province. 22 March 2008. Shajoy, Afghanistan. Goran Tomasevic.

008 Relatives mourn 9-year-old Suroor Salman Hussein in Baquba. Local authorities said the girl was killed by a roadside bomb. 12 February 2008. Baquba, Iraq. Helmiy al-Azawi.

009 A Turkish woman stands outside the site of a burned-out house in the western German city of Ludwigshafen. Nine people of Turkish origin, including five children, were killed in the blaze. Community tensions were heightened amidst speculation that the fire was a racially motivated arson attack. 6 February 2008. Ludwigshafen, Germany. Kai Pfaffenbach.

010 A Colombian boy holds a balloon in San José, Costa Rica, during a protest by hundreds of Colombians across the country and overseas to demand that the FARC rebel group free hostages held for years in secret jungle camps. 4 February 2008. San José, Costa Rica. Juan Carlos Ulate.

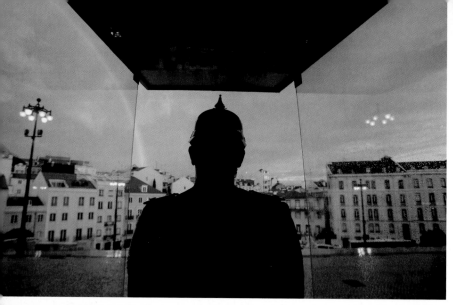

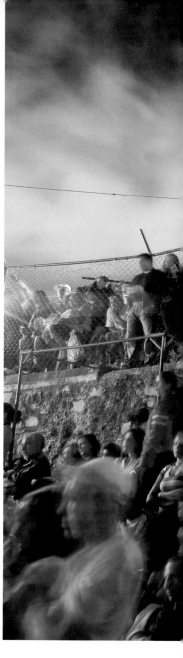

011 [TOP] Lisbon, Portugal **012** [ABOVE] Phoenix, United States

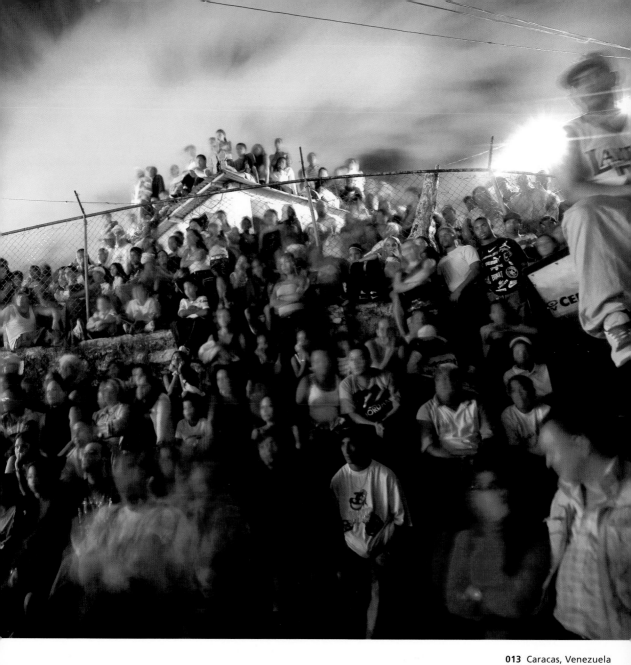

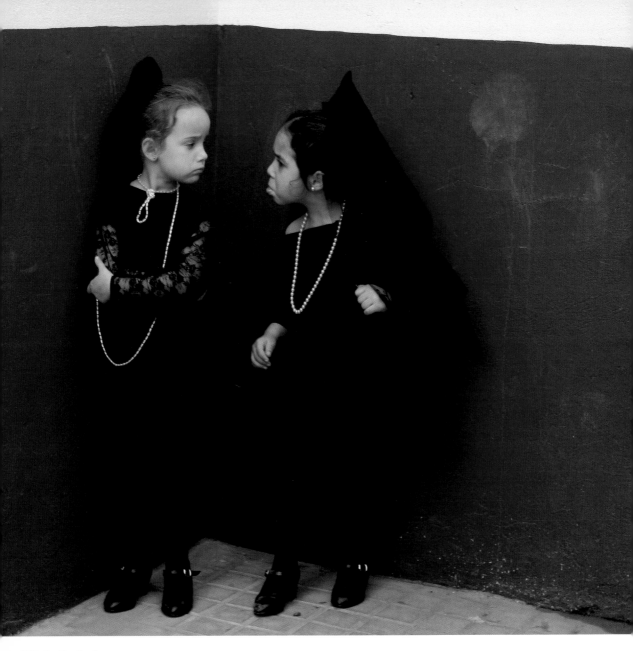

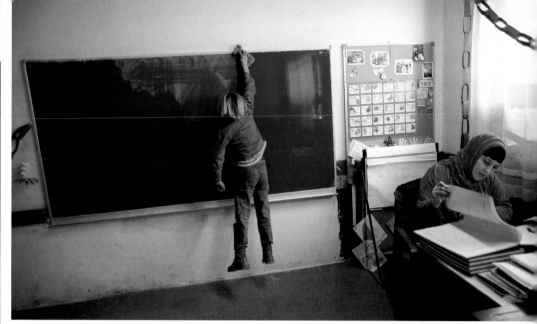

015 [TOP] Banovici, Bosnia 016 [ABOVE] Mamou, United States

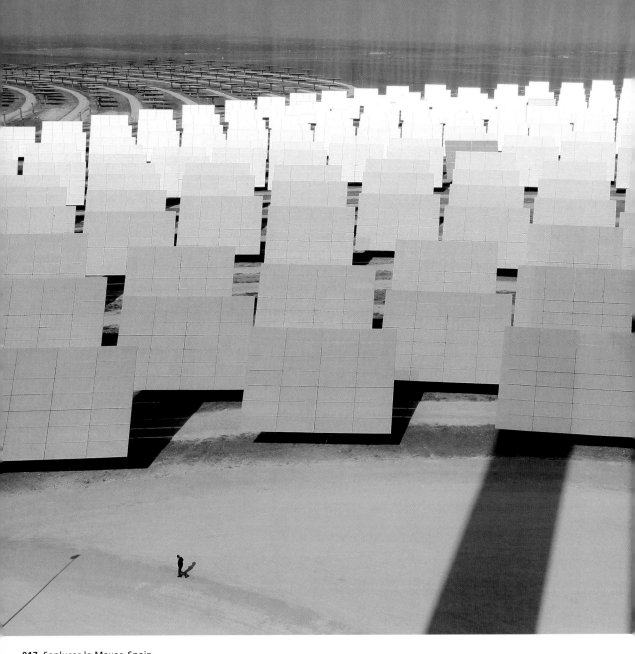

017 Sanlucar la Mayor, Spain

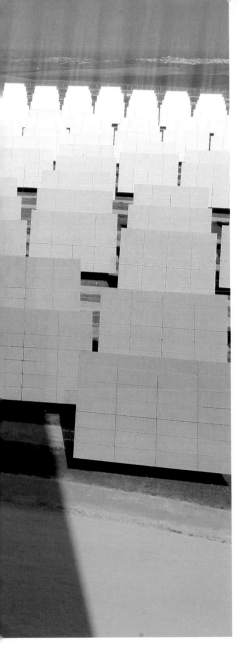
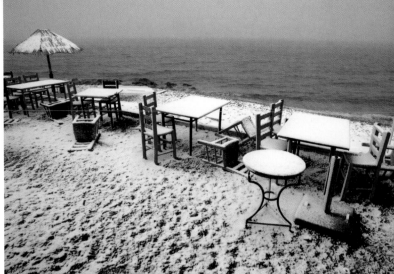
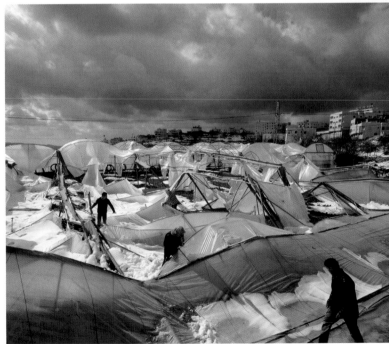

018 [TOP] Oropos, Greece **019** [ABOVE] Hebron, West Bank

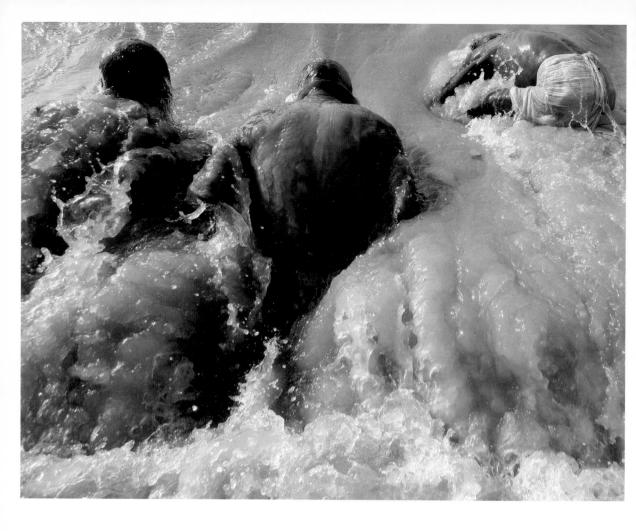

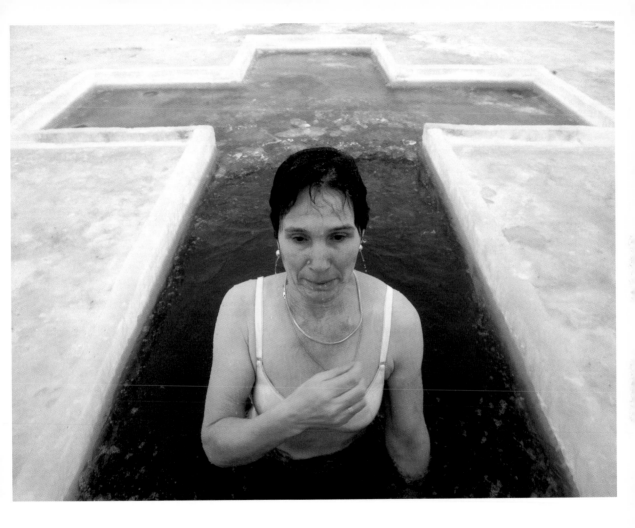

021 Rostov Veliky, Russia

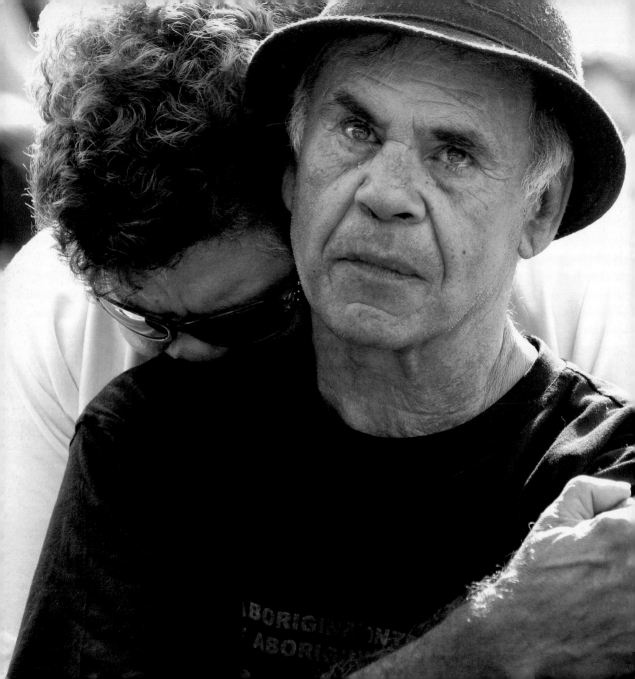

011 012 013 014 015 016

017 018 019 020 021 022

A Portuguese Republican Guard stands at the entrance of the parliament in Lisbon on the day that Prime Minister Jose Socrates announced that Portugal would ratify the Treaty of Lisbon to reform EU institutions by a vote in parliament and not through a referendum. 9 January 2008. Lisbon, Portugal. Nacho Doce.

Celeste Allen, 15, sits on a roof in Phoenix, Arizona, to observe Earth Hour, a global event in which up to 50 million people turned off their lights to show concern over global warming. 29 March 2008. Phoenix, United States. Jeff Topping.

Hundreds of people watch a premiere of the movie *Cyrano de Fernandez* in a ball court in the densely populated hillside district of San Miguel in Caracas. The movie is a hard-bitten version of the classic French play *Cyrano de Bergerac* set in a gun-plagued Venezuelan neighbourhood. 25 February 2008. Caracas, Venezuela. Jorge Silva.

014 Girls wearing traditional mantillas play after a procession in Seville, southern Spain. 13 March 2008. Seville, Spain. Marcelo del Pozo.

015 A Bosnian refugee child wipes the blackboard in a one-room school in a camp built between a coal mine and its waste heap near the town of Banovici. A group of refugees from the Serb part of the country still live in primitive shelters waiting to return to their pre-war homes. 10 January 2008. Banovici, Bosnia. Damir Sagolj.

016 Tait Suire dances on top of a fuel tank during a traditional cajun Mardi Gras run in Mamou, Louisiana. Participants in the run go from house to house collecting ingredients to make a communal pot of gumbo. 5 February 2008. Mamou, United States. Jessica Rinaldi.

017 A man walks next to solar panels at a new Spanish solar energy park near Seville. 13 February 2008. Sanlucar la Mayor, Spain. Marcelo del Pozo.

018 A seaside tavern is seen covered by snow at Oropos village, northeast of Athens. 17 February 2008. Oropos, Greece. Yiorgos Karahalis.

019 Palestinians walk among greenhouses damaged in a snowstorm in the West Bank city of Hebron. 2 February 2008. Hebron, West Bank. Nayef Hashlamoun.

020 Hindu pilgrims take a holy dip in the confluence of the Ganges River and the Bay of Bengal at Sagar Island, about 150 km (95 miles) south of Kolkata, during the festival of 'Makar Sankranti'. 14 January 2008. Sagar Island, India. Jayanta Shaw.

021 A woman takes a dip in an icy lake during Orthodox Epiphany celebrations outside the Varnitsky Monastery in Rostov Veliky, about 200 km (125 miles) from Moscow. 19 January 2008. Rostov Veliky, Russia. Thomas Peter.

022 An Aboriginal woman hugs a man as they watch Prime Minister Kevin Rudd's apology to Aboriginal Australians on a big screen outside Parliament House in Canberra. Rudd told parliament that historic policies of assimilation, under which Aboriginal children were taken from their families to be brought up in white households, were a stain on the nation's soul. 13 February 2008. Canberra, Australia. Mick Tsikas.

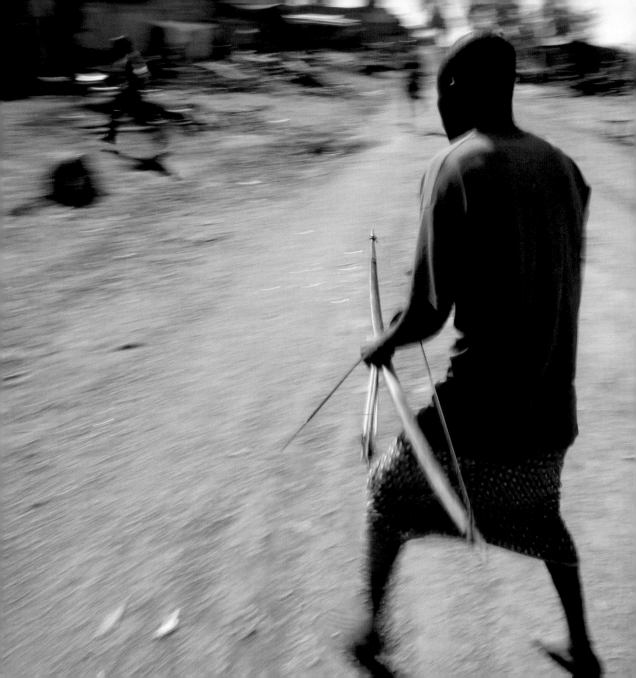

PETER ANDREWS
Photographer
Born: Kano, Nigeria, 1961
Based: Warsaw, Poland
Nationality: Polish

Modern politics, ancient warfare in Kenya

It was the first day of 2008 when I received a phone call from Radu Sigheti, Reuters Africa Chief Photographer, inviting me to cover unfolding events in Kenya as disputed election results descended into violence. Having spent almost 10 years of my life in Africa, including a year in Nairobi, I had been watching the situation closely. I was dismayed at what was happening, but still excited to go back to Africa. Ten days later, I was on my way.

The first few days were quiet and I had the chance to get my bearings, taking pictures at a camp for displaced people near Kibera slum. However, things very soon became tense and dangerous. A mass funeral for 28 people killed during the first days of the violence was followed by new outbreaks, this time in the town of Nakuru in the Rift Valley area.

I counted over 16 burned bodies in one Nakuru morgue. In a hospital full of injured people with mutilated faces I noticed a young man walk in with an arrow sticking out of his head. This was a surprise, almost surreal. I had not expected to witness tribal rivals fighting with bows and arrows – weapons of the past, or so I thought.

A few days later, after covering violence in Nakuru, Naivasha and Kericho, we ended up in the town of Chepilat, tea country northwest of Nairobi. Here we were confronted by tribes preparing for a bow and arrow battle. First they burned the property of their adversaries, torching houses, shops and schools. Then arrows and stones were flying everywhere, an almost Stone Age scene. Young men spun sling shots, ran with arrows in their bows, and made war cries, shouts, screams and whistles. Shooting with slow shutter speeds, I was able to capture something of the drama we found ourselves in the midst of, an ancient confrontation in a world where violent conflict is normally dominated by deadly automatic rifles and explosives. In a small way it was a blessing. The destruction and death toll would have been far worse had these tribesmen been in a position to reach for weapons so freely available in countries not far away.

023 A man armed with a bow chases a looter in the town of Chepilat. Widespread ethnic violence broke out in Kenya following the announcement of disputed election results on 30 December 2007. 4 February 2008.

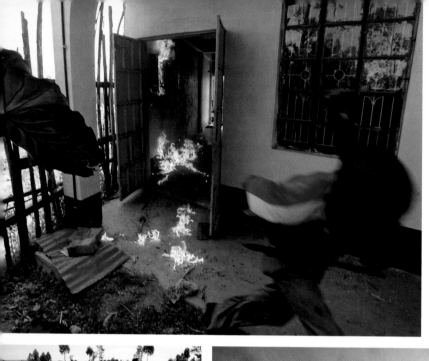
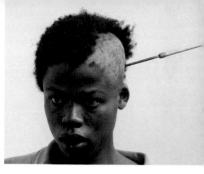
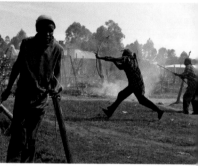
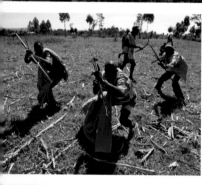
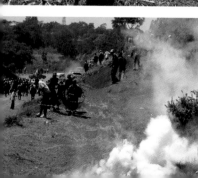
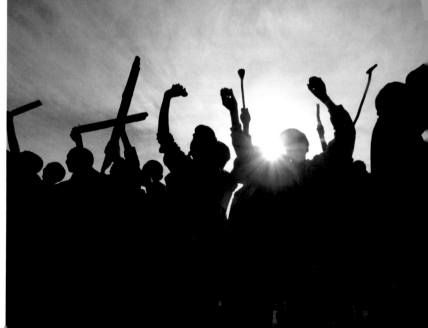

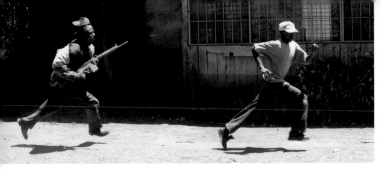

	025	030	
024			
	026		
		031	
027			
	029		
028		032	033

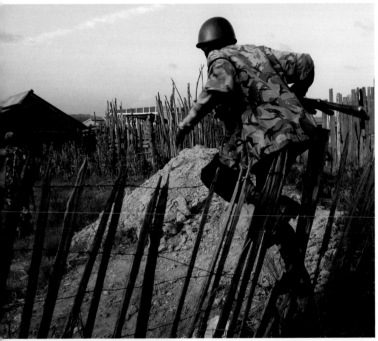

024 A member of the Kalenjin tribe runs away after setting a building on fire in the town of Chepilat, west of Nairobi. 3 February 2008.
025 A young man with an arrow in his head arrives at hospital following ethnic clashes in Nakuru. 26 January 2008. **026** Members of the Kisii tribe fight a battle with Kalenjin tribesmen in the town of Chepilat. 3 February 2008. **027** Members of the Kalenjin tribe prepare to fight the Kisii tribe in Chepilat. 3 February 2008. **028** Protesters are dispersed by riot police using teargas after they blocked the country's main highway in Kikuyu village, near Nairobi. 30 January 2008. **029** Members of the Kikuyu tribe wave clubs and machetes outside Naivasha Country Club. 28 January 2008. **030** A police officer chases a protester in the town of Nderi, north of Nairobi. 30 January 2008. **031** Policemen chase after a group of Kisii men in Chepilat. 5 February 2008. **032** A Luo woman looks through the window of a bus as she leaves Nderi under police escort. 30 January 2008. **033** A truck packed with displaced people leaves the area of Kericho, west of Nairobi. 3 February 2008.

WITNESS

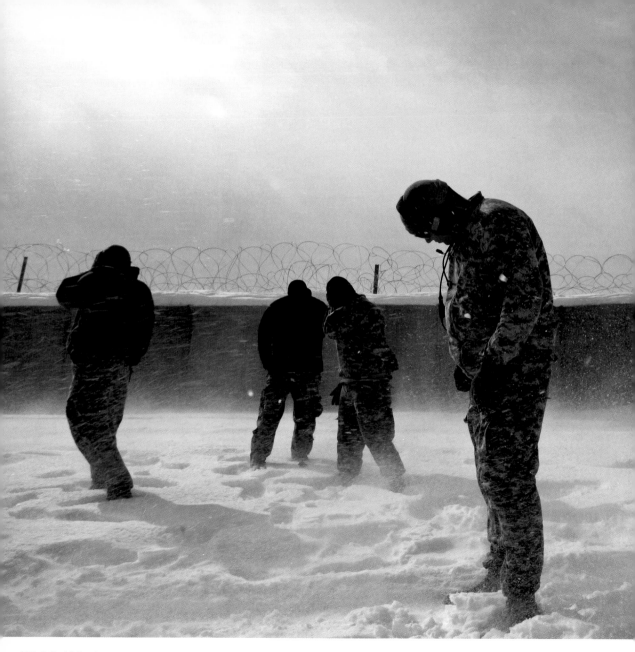

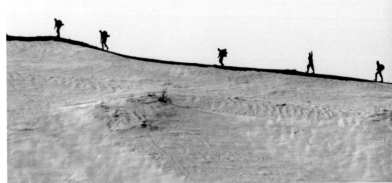
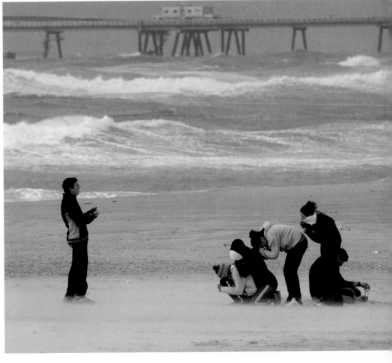

035 [TOP] Sirnak, Turkey 036 [ABOVE] Kibbutz Zikkim, Israel

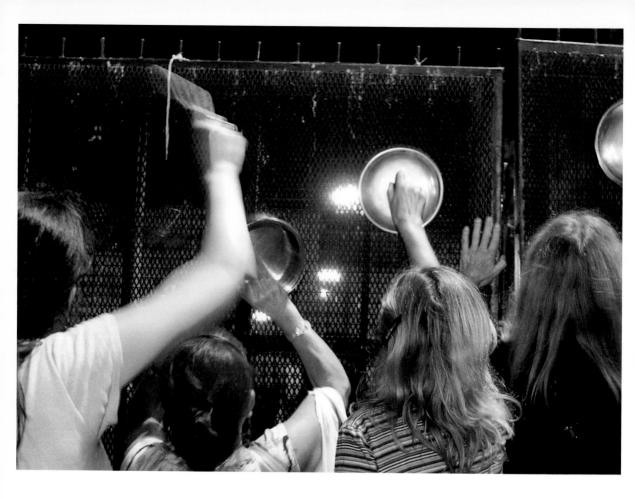

037 Buenos Aires, Argentina

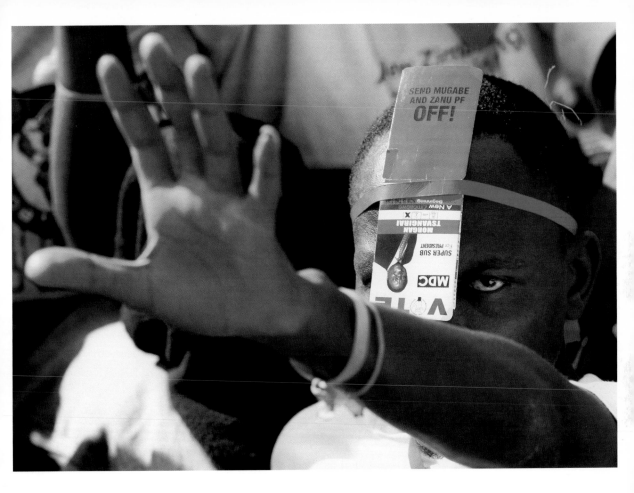

038 Chitungwiza, Zimbabwe

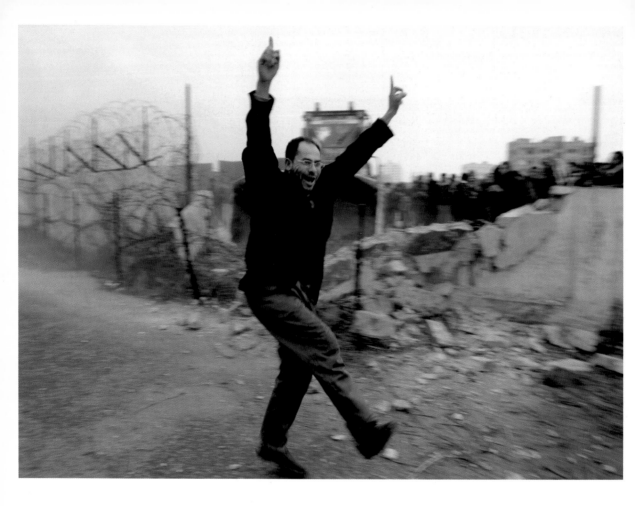

039 [ABOVE] **040** [OPPOSITE] Gaza

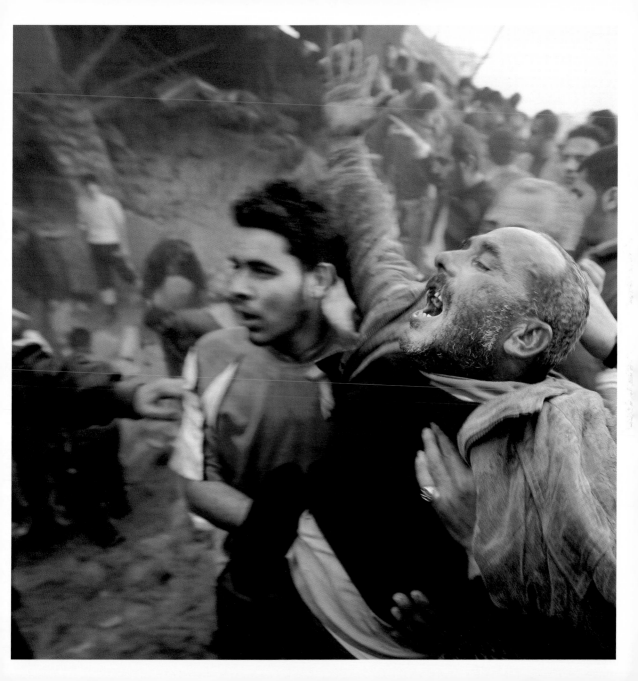

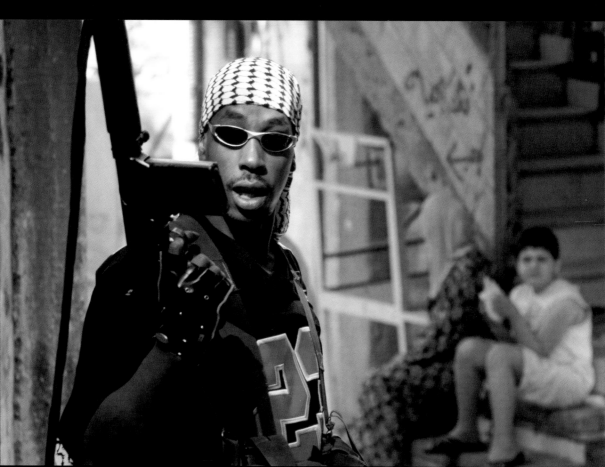

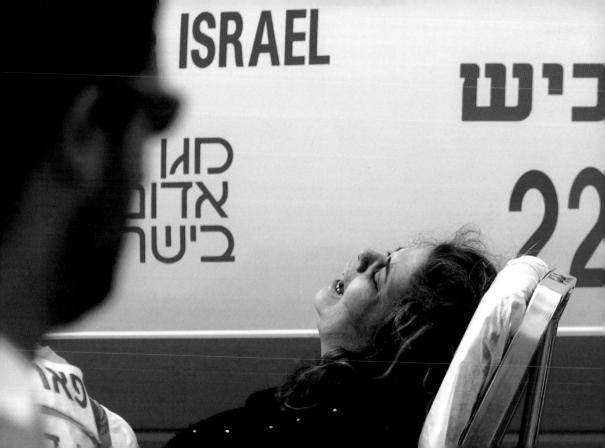

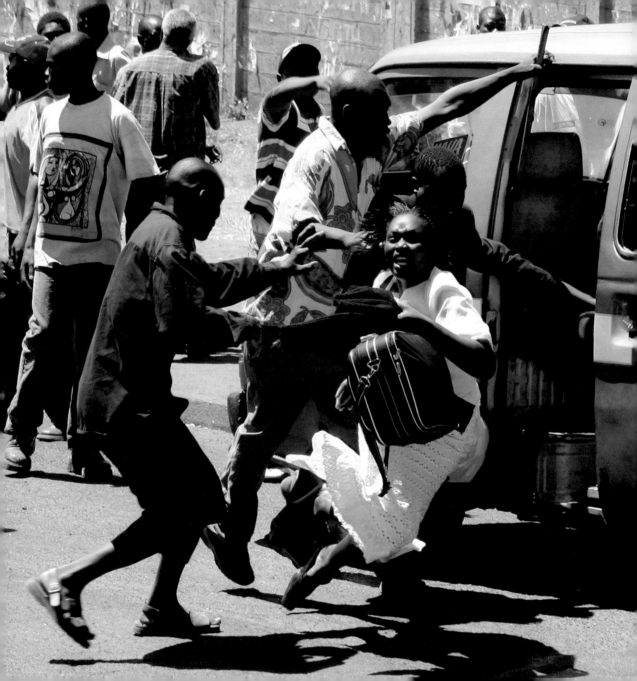

034 035 036 037 038 039

040 041 042 043

034 U.S. soldiers turn away as a Black Hawk helicopter takes off from a U.S. base in the Jaji district of Paktia province, near the Afghanistan–Pakistan border. 27 January 2008. Jaji, Afghanistan. Ahmad Masood.

035 Turkish army commandos walk on a snow-capped summit near the southeastern border town of Sirnak, as Turkey began sending thousands of troops across the mountainous border into Iraq to crush PKK guerrillas using the region as a base from which to attack targets inside Turkey. 24 February 2008. Sirnak, Turkey. Fatih Saribas.

036 Israeli youths take cover as high winds stir up sand on a beach near Kibbutz Zikim, just north of Gaza. 29 January 2008. Kibbutz Zikim, Israel. Amir Cohen.

037 Demonstrators beat a fence around the Casa Rosada presidential house to protest Argentine President Cristina Fernández de Kirchner's tax hike on soy exports. Farmers staged months of protests against the measure, blocking highways and withholding produce from market, before eventually forcing its repeal. 25 March 2008. Buenos Aires, Argentina. Enrique Marcarian.

038 A Zimbabwe opposition Movement for Democratic Change supporter shows the party's open hand salute at an election rally in Chitungwiza, near the capital Harare. 27 March 2008. Chitungwiza, Zimbabwe. Howard Burditt.

039 A Palestinian man celebrates as heavy equipment destroys a section of the border wall between Gaza and Egypt. Tens of thousands of Palestinians poured through the breach into Egypt to stock up on food and fuel in short supply due to an Israeli blockade. 23 January 2008. Gaza. Ibraheem Abu Mustafa.

040 A Palestinian man shouts after an Israeli missile strikes his house in Gaza. Three Palestinians were killed and at least six children wounded in the attack, medical officials said. 1 March 2008. Gaza. Suhaib Salem.

041 A Palestinian Fatah fighter prevents journalists from entering an alley at the Ain al-Hilweh refugee camp at Sidon city in southern Lebanon, after night clashes between rival Palestinian groups in the camp. 22 March 2008. Sidon, Lebanon. Ali Hashisho.

042 An Israeli woman is evacuated after a rocket attack by Palestinian militants in Gaza on the southern town of Sderot. 2 March 2008. Sderot, Israel. Ammar Awad.

043 A woman is robbed as she returns with goods to Nairobi's Kibera slum after post-election riots. 5 January 2008. Nairobi, Kenya. Noor Khamis.

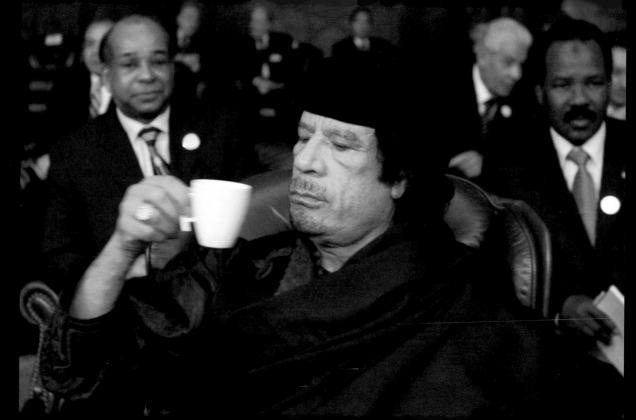

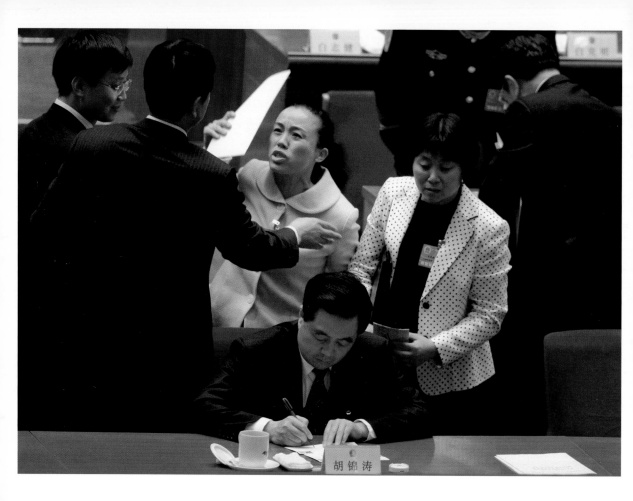

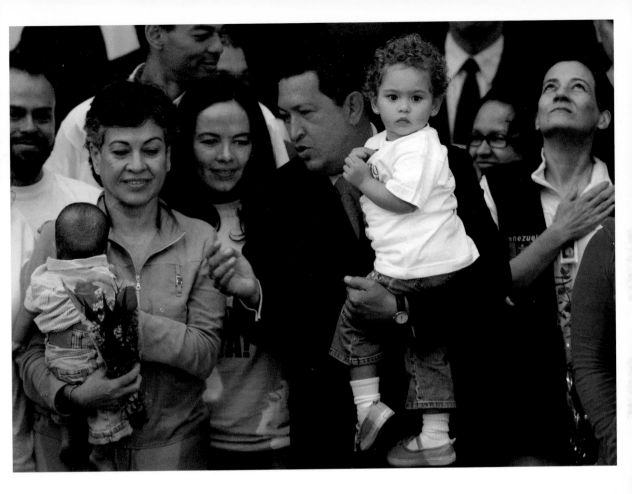

048 [TOP] Cabra, Kosovo **049** [ABOVE] Bica, Kosovo

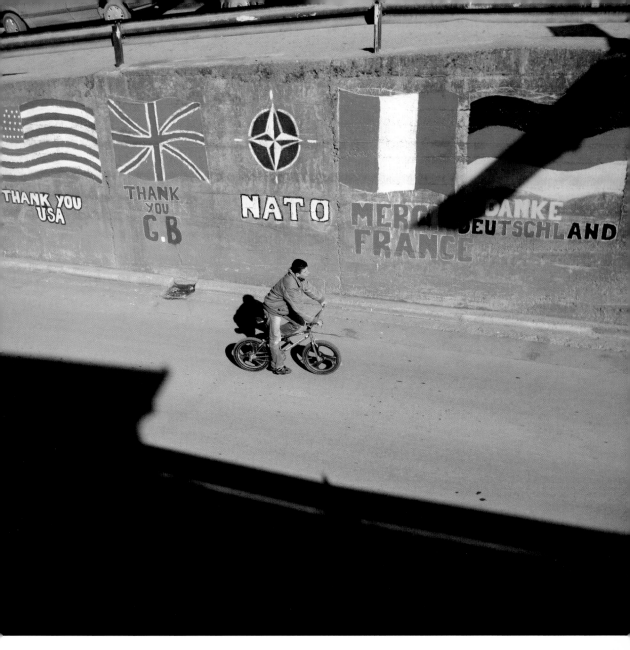

THANK YOU
USA

THANK
YOU
G.B

NATO

MERCI
FRANCE

DANKE
DEUTSCHLAND

050 Gnjilane, Kosovo

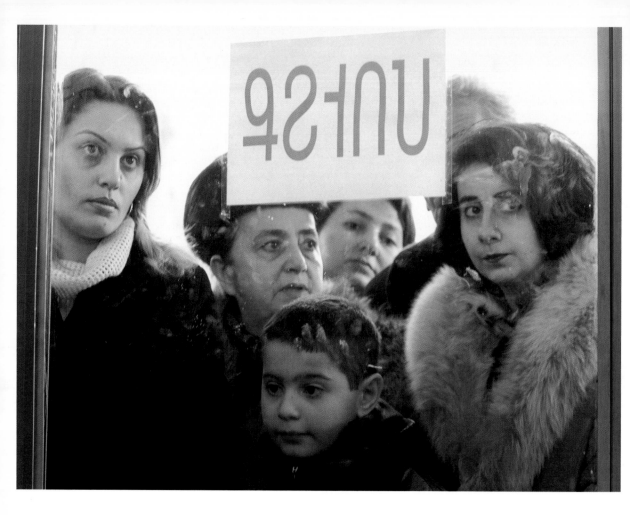

051 Yerevan, Armenia

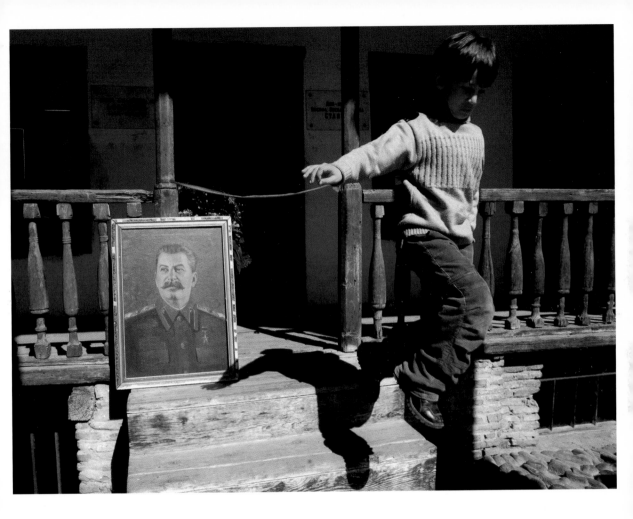

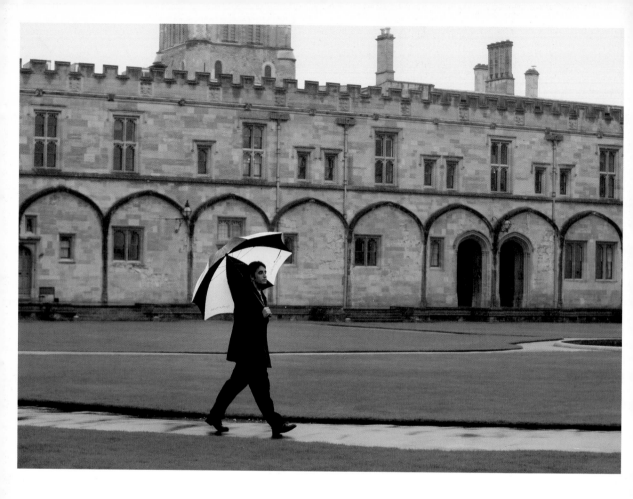

053 Oxford, Britain

054 [OPPOSITE] Rawalpindi, Pakistan

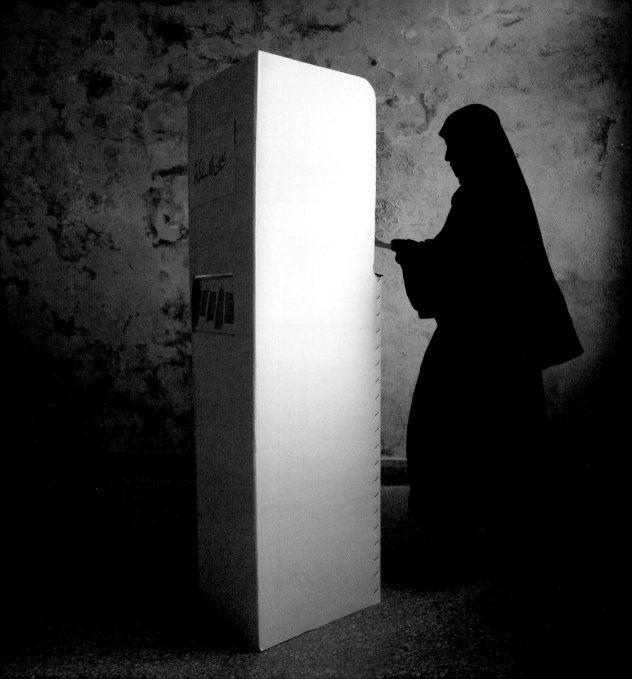

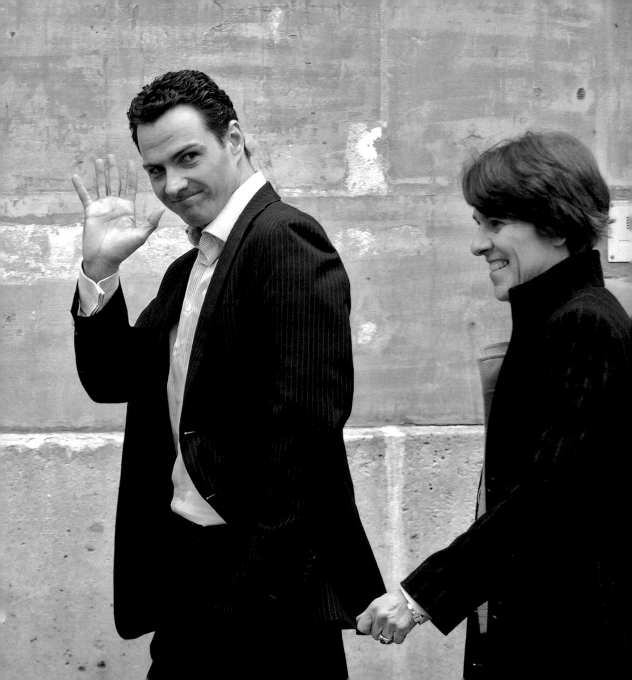

044 045 046 047 048 049

050 051 052 053 054 055

044 Libyan leader Muammar Gaddafi attends the opening of the two-day Arab Summit in Damascus. 29 March 2008. Damascus, Syria. Ahmed Jadallah.

045 Turkey's Chief of General Staff General Yasar Buyukanit (centre), flanked by retired generals, attends the Global Terrorism and International Cooperation Symposium, organized by the Turkish Army in Ankara. 10 March 2008. Ankara, Turkey. Umit Bektas.

046 An official blocks a delegate from seeking the autograph of China's President Hu Jintao (centre) after the plenary session of the National People's Congress in Beijing. 17 March 2008. Beijing, China. Jason Lee.

047 Freed hostages Consuelo Gonzalez (left) and Clara Rojas (right) are welcomed by Venezuela's President Hugo Chavez at Miraflores Palace in Caracas. The two Colombian politicians were held for six years by FARC rebels in secret jungle camps before their release in a Venezuelan-brokered deal. 10 January 2008. Caracas, Venezuela. Jorge Silva.

048 An ethnic Albanian girl leaves the village of Cabra on a bus as NATO peacekeepers secure the area, thwarting a bid by Kosovo Serbs to assert their authority in a northern region after Kosovo's declaration of independence on 17 February. 20 February 2008. Cabra, Kosovo. Damir Sagolj.

049 Security guards of Serbia's minister for Kosovo kill time as he talks to Serbs in the isolated village of Bica. Former guerrilla commander Hashim Thaci was elected Kosovo's prime minister on 9 January and promised independence 'within weeks'. 4 February 2008. Bica, Kosovo. Damir Sagolj.

050 An ethnic Albanian boy cycles past paintings of the flags of countries that supported Kosovo's break away from Serbia. Europe's major powers and the United States swiftly recognized Kosovo's independence, while Serbia reacted with anger. 19 February 2008. Gnjilane, Kosovo. Damir Sagolj.

051 Armenians wait at a polling station in Yerevan to cast their vote in the country's presidential election. 19 February 2008. Yerevan, Armenia. David Mdzinarishvili.

052 A boy jumps off the front porch of the house where Soviet dictator Josef Stalin was born in Gori, Georgia, on the 55th anniversary of his death. 5 March 2008. Gori, Georgia. David Mdzinarishvili.

053 Bilawal Bhutto Zardari, son of assassinated Pakistani opposition leader Benazir Bhutto and chairman of the Pakistani People's Party, walks across a quadrangle at Christ Church College, Oxford, where he is an undergraduate student. 11 January 2008. Oxford, Britain. Toby Melville.

054 A woman approaches a polling booth to vote in Pakistan's parliamentary election. 18 February 2008. Rawalpindi, Pakistan. Adrees Latif.

055 France's rogue trader Jérôme Kerviel walks free from the Santé prison in Paris after five weeks in custody, accompanied by lawyer Elisabeth Meyer. Kerviel left jail after winning a legal battle against detention. He is accused of causing record losses at French bank Société Générale. 18 March 2008. Paris, France. Gonzalo Fuentes.

056 Davos, Switzerland

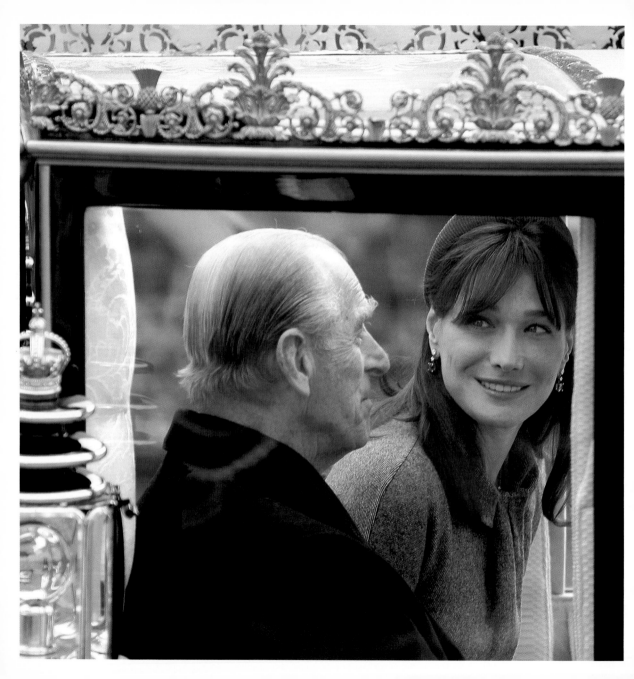

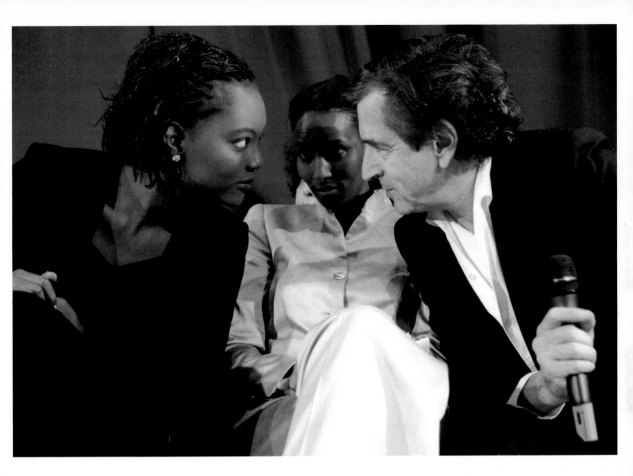

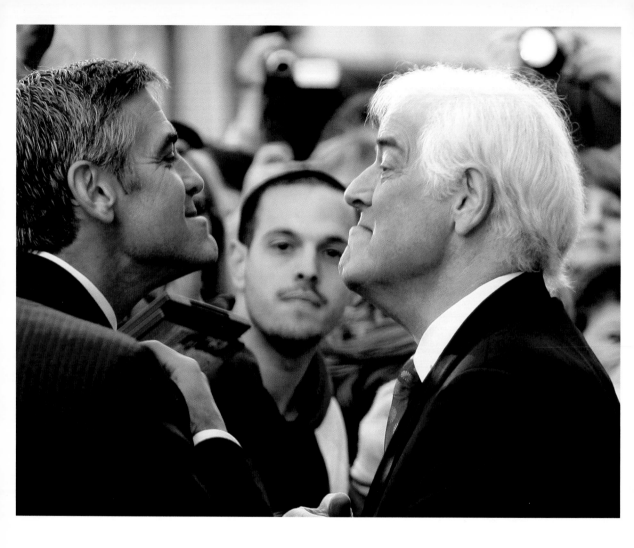

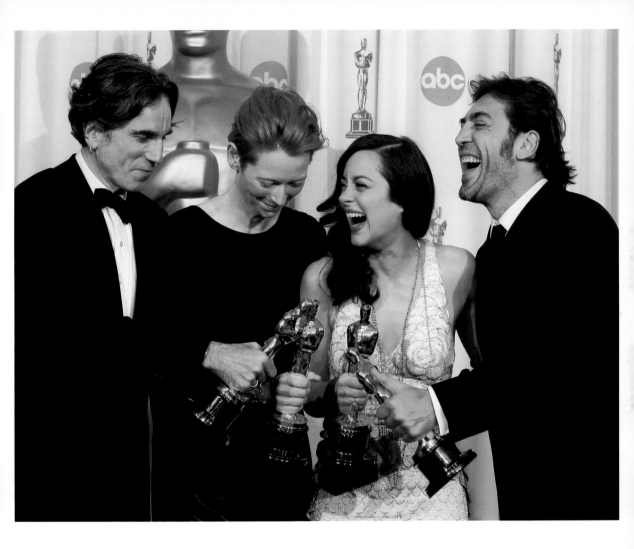

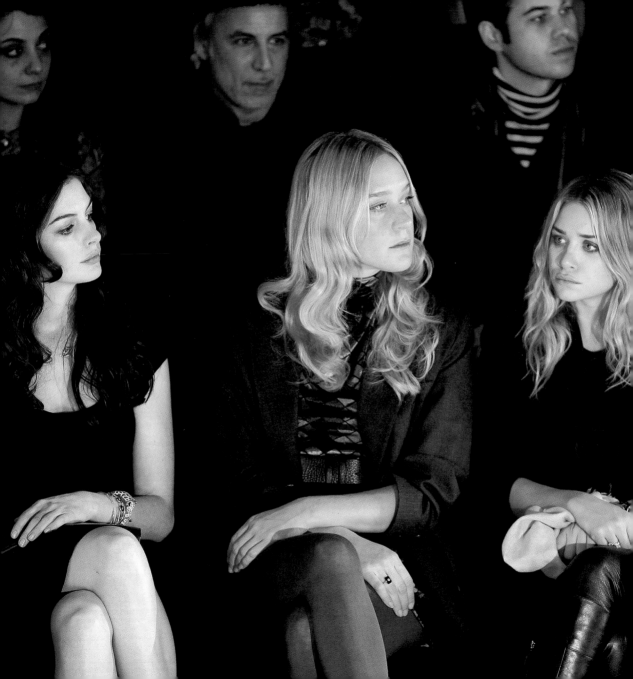

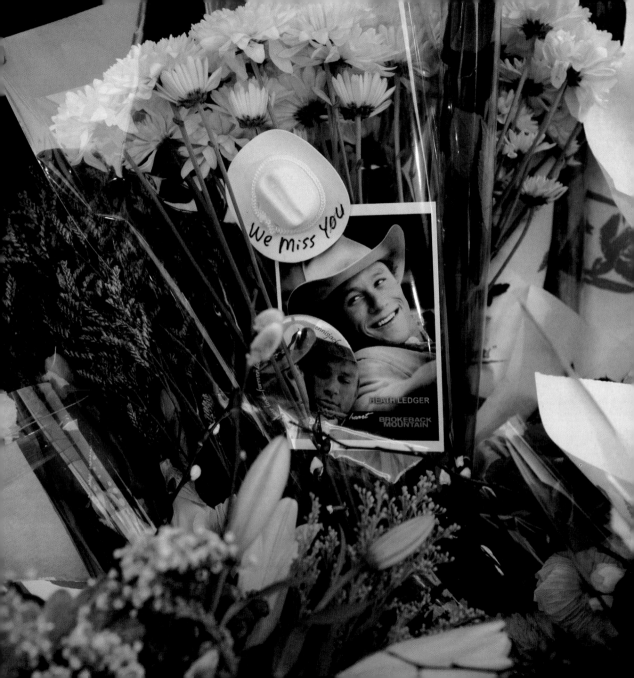

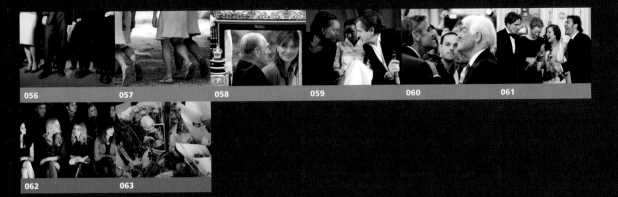

056 057 058 059 060 061

062 063

056 Irish rock singer Bono (right) stands next to Microsoft founder Bill Gates (centre) and Jordan's Queen Rania to pose for photographers at the World Economic Forum in Davos. 25 January 2008. Davos, Switzerland. Stefan Wermuth.

057 Greek actors playing ancient Greek athletes take part in the full dress rehearsal for the Olympic flame lighting ceremony for the Beijing 2008 Games at the site of Ancient Olympia in Greece. 23 March 2008. Olympia, Greece. Kevin Coombs.

058 France's first lady Carla Bruni rides in a carriage with Britain's Prince Philip en route to Windsor Castle. Bruni accompanied President Nicolas Sarkozy on a state visit to Britain that he hoped would improve cooperation between the two countries on illegal immigration, defence and the economy. 26 March 2008. Windsor, Britain. Darren Staples.

059 France's Secretary of State for Human Rights Rama Yade (left), Ayaan Hirsi Ali (centre), a Somali-born former Dutch politician known for her criticism of Islam, and philosopher Bernard-Henri Lévy attend a meeting of French intellectuals and politicians in Paris. 10 February 2008. Paris, France. Gonzalo Fuentes.

060 Actor-director George Clooney has his tie checked by his father Nick Clooney on the red carpet ahead of the premiere of Clooney's new movie *Leatherheads* in his hometown of Maysville, Kentucky. 24 March 2008. Maysville, United States. John Sommers II.

061 Oscar winners pose backstage at the 80th annual Academy Awards in Hollywood. Left to right: Daniel Day-Lewis, best actor winner for *There Will Be Blood*; Tilda Swinton, best supporting actress for *Michael Clayton*; Marion Cotillard, best actress for *La Vie en Rose;* and Javier Bardem, best supporting actor for *No Country for Old Men.* 24 February 2008. Los Angeles, United States. Mike Blake.

062 Actresses Anne Hathaway, Chloe Sevigny, Ashley Olsen and Milla Jovovich (left to right) sit in the front row during the 2008/9 Miss Sixty fall collection show during New York Fashion Week. 3 February 2008. New York, United States. Lucas Jackson.

063 A photograph of actor Heath Ledger from the movie *Brokeback Mountain* lies among flowers at a makeshift memorial in front of the SoHo building where he died on 22 January from an accidental overdose of painkillers and other medicines. 23 January 2008. New York, United States. Nicholas Roberts.

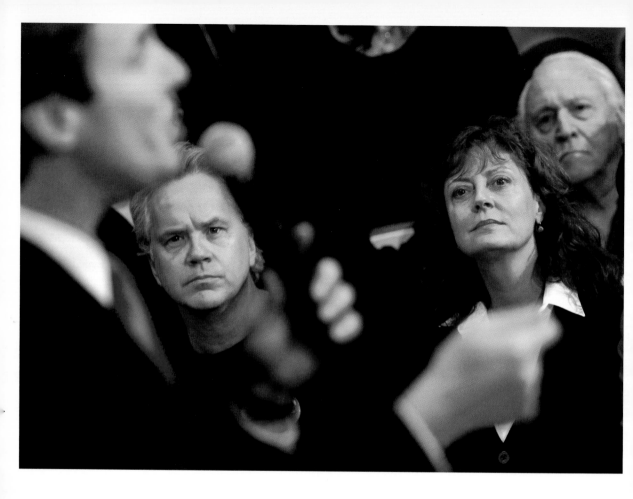

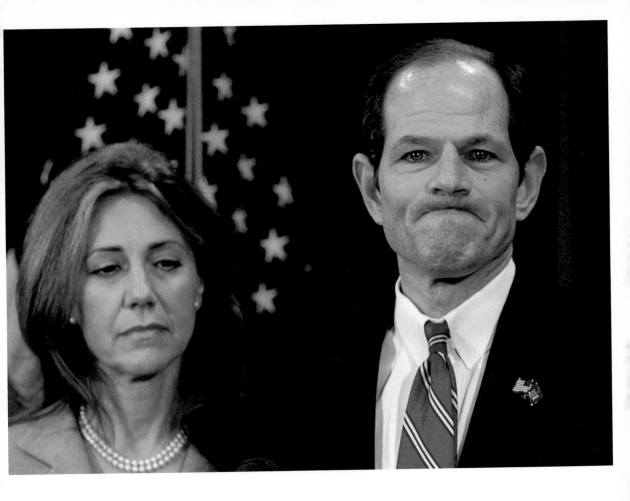

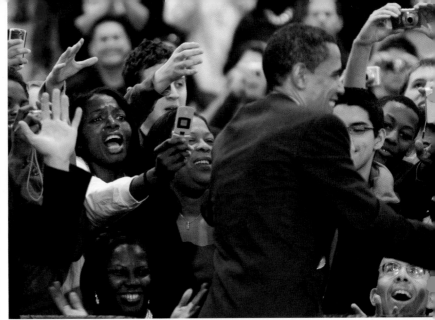
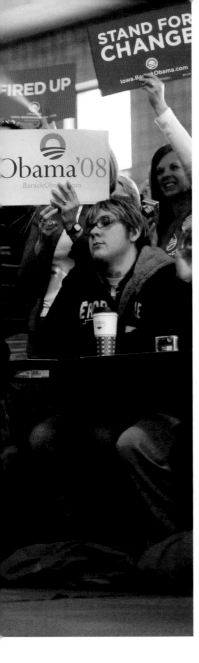
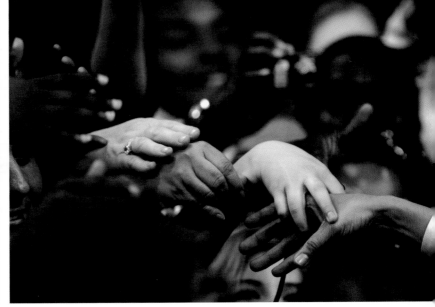

067 [TOP] Alexandria, United States **068** [ABOVE] Dallas, United States

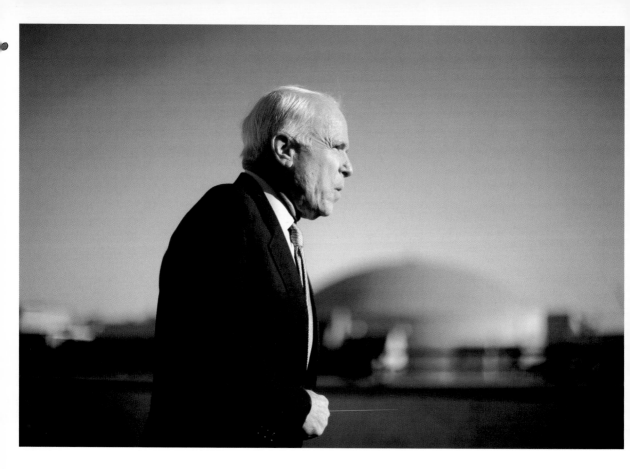

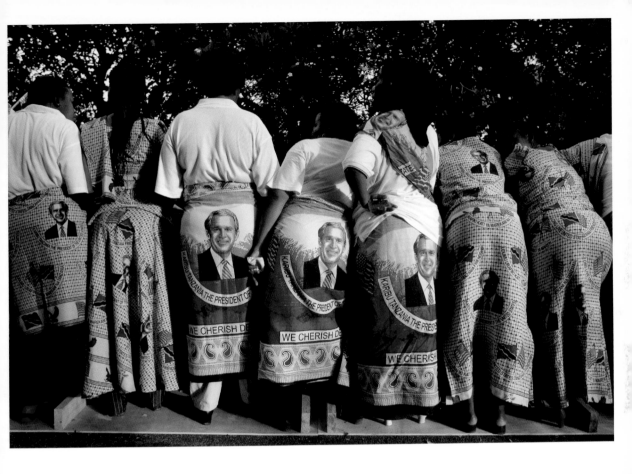

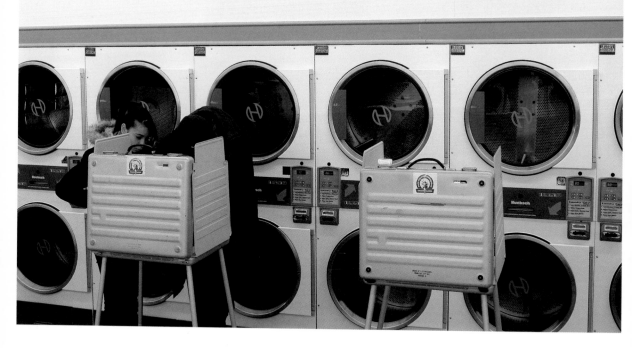

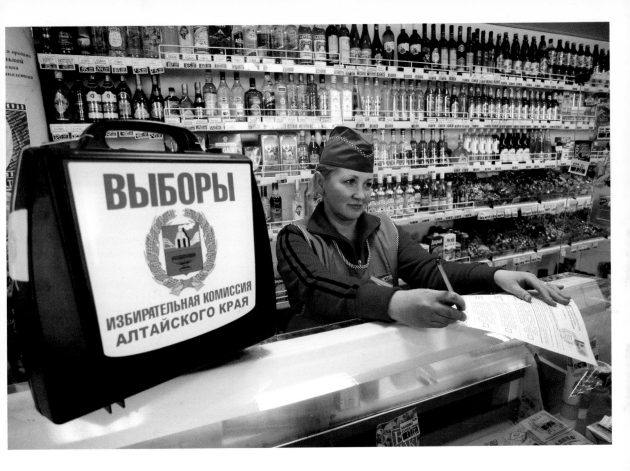

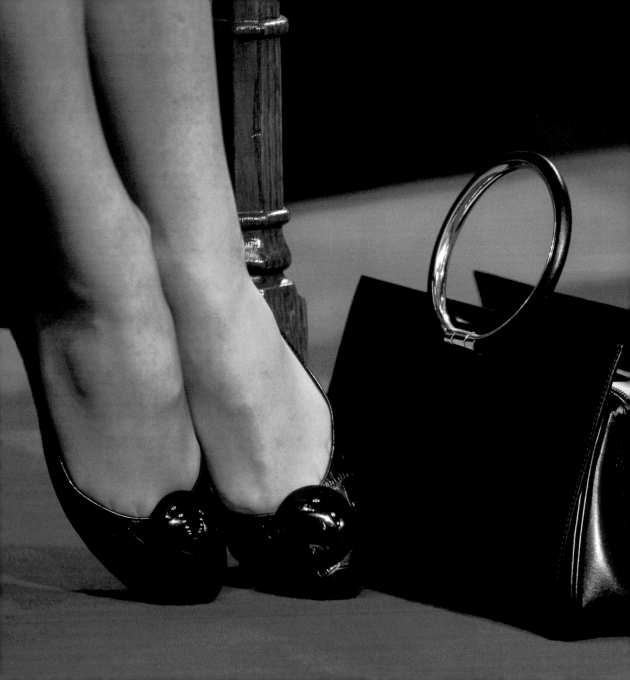

064 065 066 067 068 069

070 071 072 073

064 Actors Tim Robbins and Susan Sarandon listen to U.S. Democratic presidential candidate John Edwards speak during a campaign event at Winnacunnet High School in Hampton, New Hampshire. Edwards admitted in August that he had an extramarital affair in 2006 with a woman who produced videos for his campaign, but said he was not the father of her infant daughter. 7 January 2008. Hampton, United States. Carlos Barria.

065 New York Governor Eliot Spitzer addresses the media with his wife Silda Wall Spitzer at his office in New York. Spitzer apologized to his family for a 'private matter' but made no reference to a *New York Times* report that he may have been linked to a prostitution ring. 'I am disappointed that I failed to live up to the standard that I expect of myself. I must now dedicate some time to regain the trust of my family,' Spitzer told a packed room of reporters. 10 March 2008. New York, United States. Shannon Stapleton.

066 U.S. Democratic presidential candidate Senator Barack Obama speaks to supporters during a campaign rally at Friendly House gymnasium in Davenport, Iowa. 2 January 2008. Davenport, United States. Jim Young.

067 Senator Barack Obama greets supporters during a rally in Alexandria, Virginia. 10 February 2008. Alexandria, United States. Carlos Barria.

068 Supporters reach out to touch the hand of Senator Barack Obama after his speech at a rally in Dallas, Texas. 20 February 2008. Dallas, United States. Jessica Rinaldi.

069 Republican presidential candidate Senator John McCain arrives for a news conference in Annapolis, Maryland. 11 February 2008. Annapolis, United States. Jim Young.

070 Tanzanian women wear outfits bearing the image of U.S. President George W. Bush during a welcoming ceremony at the State House in Dar es Salaam. 17 February 2008. Dar es Salaam, Tanzania. Jason Reed.

071 A Chicago voter casts his ballot at the Su Nueva laundromat, converted to a temporary polling station for the Illinois primary. 5 February 2008. Chicago, United States. Frank Polich.

072 A Russian shopkeeper takes part in presidential elections in a village 20 km (12 miles) from the city of Barnaul. The vote was won by former President Vladimir Putin's chosen successor, Dmitry Medvedev. 2 March 2008. Barnaul, Russia. Andrei Kasprishin.

073 The shoes and handbag of France's first lady, Carla Bruni, are seen as she listens to her husband, President Nicolas Sarkozy, address members of both Houses of Parliament in the Royal Gallery of the Palace of Westminster. 26 March 2008. London, Britain. Stephen Hird.

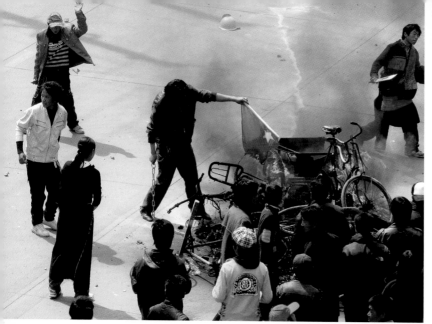

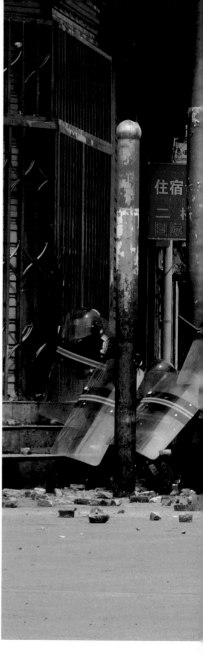

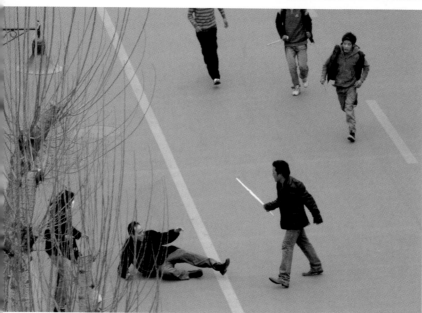

074 [TOP] **075** [ABOVE] Lhasa, China

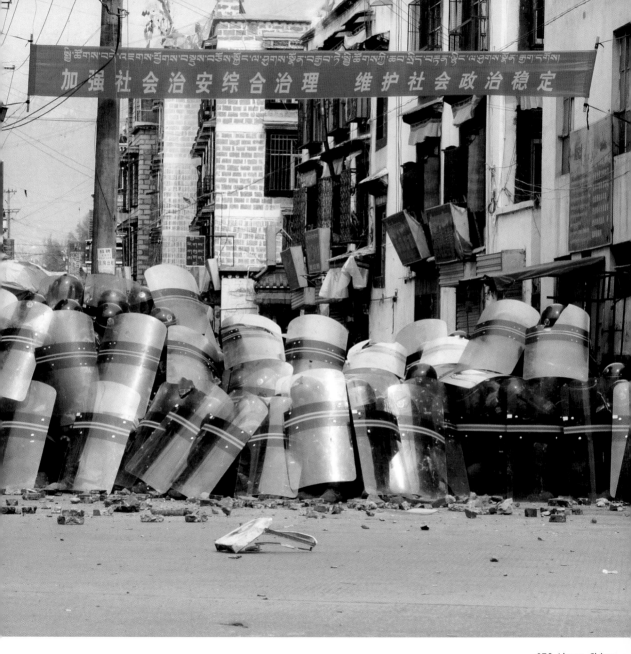

加强社会治安综合治理　维护社会政治稳定

076 Lhasa, China

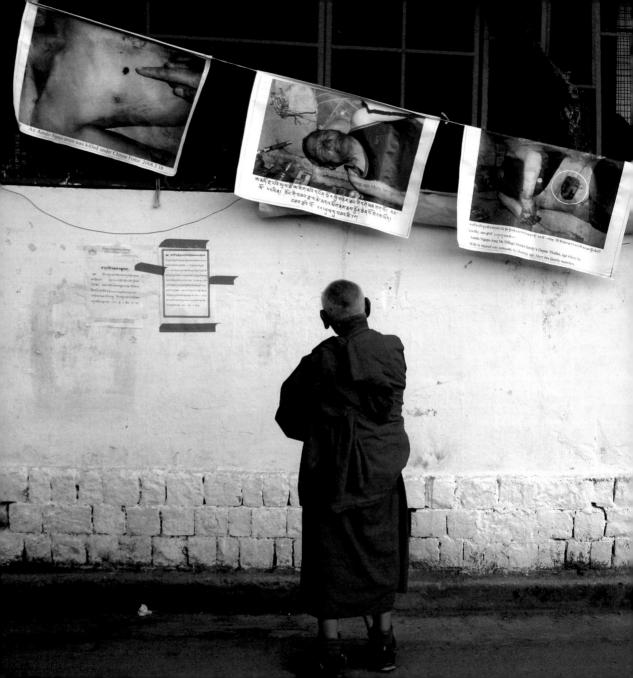

An Amdo Ngapa person was killed under Chinese Force 2008.3.16

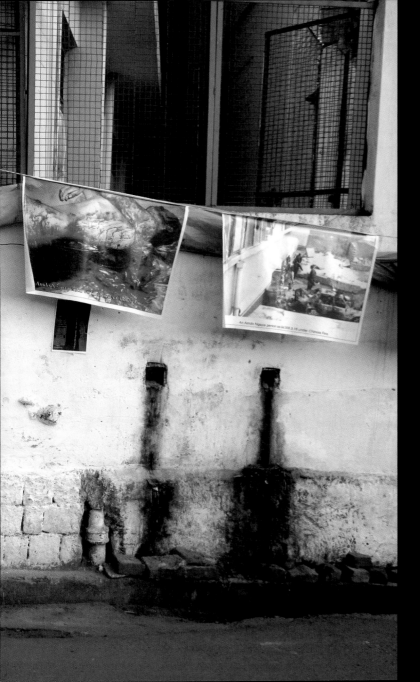

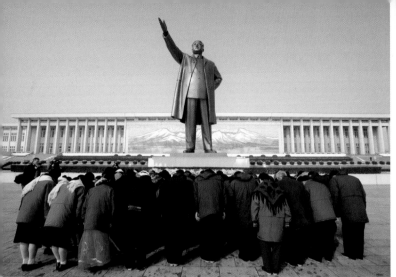

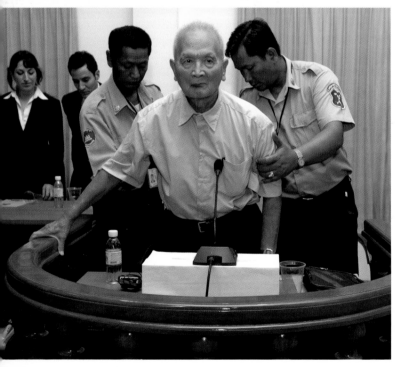

078 [TOP] Pyongyang, North Korea **079** [ABOVE] Phnom Penh, Cambodia

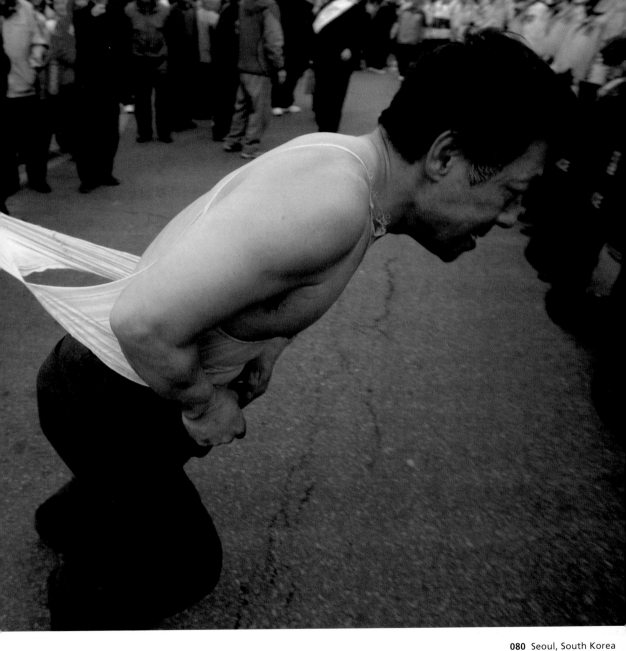

074 A Tibetan demonstrator burns a
Chinese flag during a protest in the
Tibetan capital Lhasa. 14 March 2008.
Lhasa, China.

075 Tibetans carrying sticks and knives
prepare to attack a fallen man during
violent protests in Lhasa. Han Chinese
and their businesses were set upon
by pro-independence Tibetans during
the anti-Chinese uprising. 14 March
2008. Lhasa, China.

076 Chinese security personnel shield
themselves against stones thrown
by protesters in Lhasa. The banner
reads: 'Enhancing public safety
management, safeguarding political
stability'. 14 March 2008. Lhasa, China.

077 A Tibetan monk looks at photographs
of Tibetan victims of the violence
in Lhasa on a wall in Dharamsala.
China said its security forces acted
with restraint during the unrest
and that 19 people died at the
hands of Tibetan mobs. The Tibetan
government-in-exile said 140 died in
Lhasa and elsewhere, most of them
Tibetan victims of Chinese security
forces. 22 March 2008. Dharamsala, India.
Arko Datta.

078 A group of people bow at the base
of the giant bronze statue of the
state founder and 'Great Leader'
Kim Il-sung in the North Korean
capital of Pyongyang. 26 February 2008.
Pyongyang, North Korea. David Gray.

079 The most senior surviving leader of
the Khmer Rouge, 'Brother Number
Two' Nuon Chea, is assisted by
police officers at the Extraordinary
Chambers in the Court of Cambodia.
The former right-hand man to Pol
Pot is charged with crimes against
humanity. 20 March 2008. Phnom Penh,
Cambodia. Chor Sokunthea.

080 A South Korean woman tries to
restrain her husband during a rally
in Seoul denouncing Samsung Group.
About 1,500 residents of the west
coast counties of Jeolla province
gathered to demand compensation
after their lives were ruined by the
country's worst oil spill. The Hebei
Spirit tanker shed 10,500 tonnes of oil
after a crane mounted on a Samsung-
owned barge punched holes in its
hull on 7 December 2007. 6 March 2008.
Seoul, South Korea. Jo Yong-Hak.

081 A demonstrator from the press
freedom group Reporters Without
Borders is arrested during the speech
by Chinese Olympic Committee
President Liu Qi at the Olympic flame
lighting ceremony for the Beijing
2008 Games at the site of Ancient
Olympia in Greece. 24 March 2008.
Olympia, Greece. Mal Langsdon.

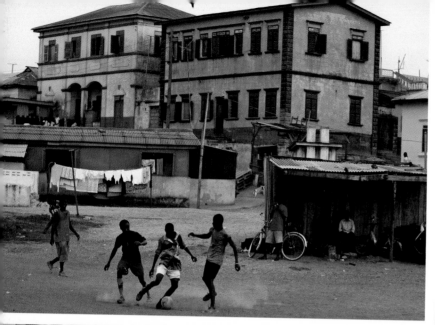

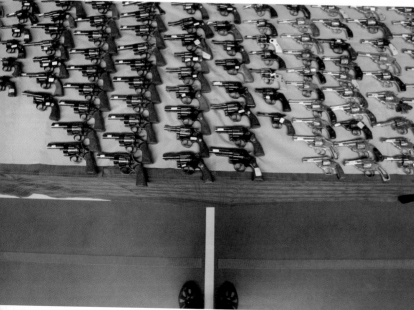

082 [TOP] Sekondi, Ghana 083 [ABOVE] Santiago, Chile

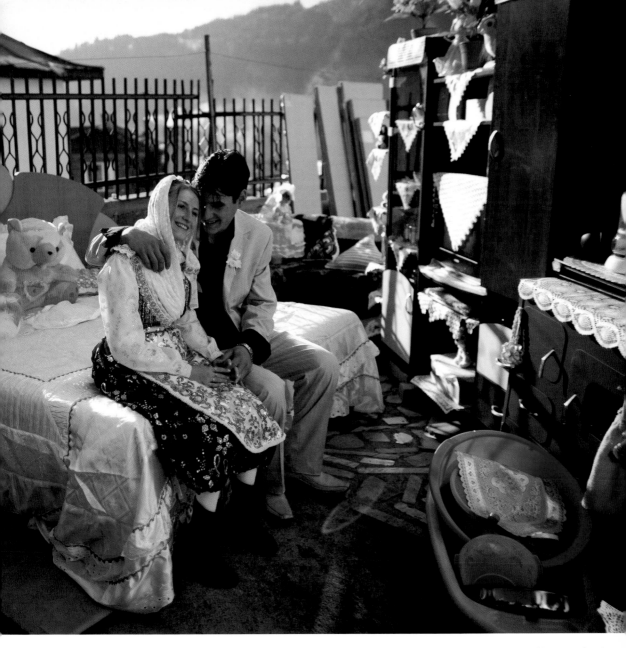

084 Ribnovo, Bulgaria

085 Valle del Jerte, Spain

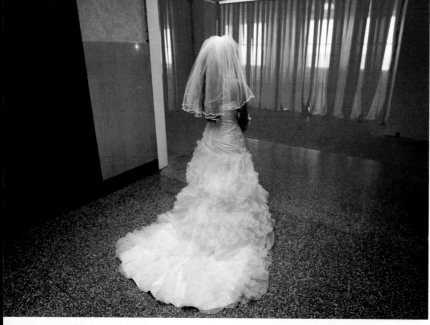

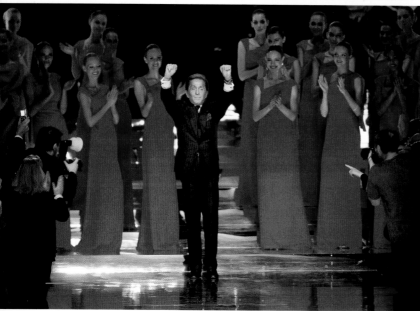

087 [TOP] New York, United States **088** [ABOVE] Paris, France

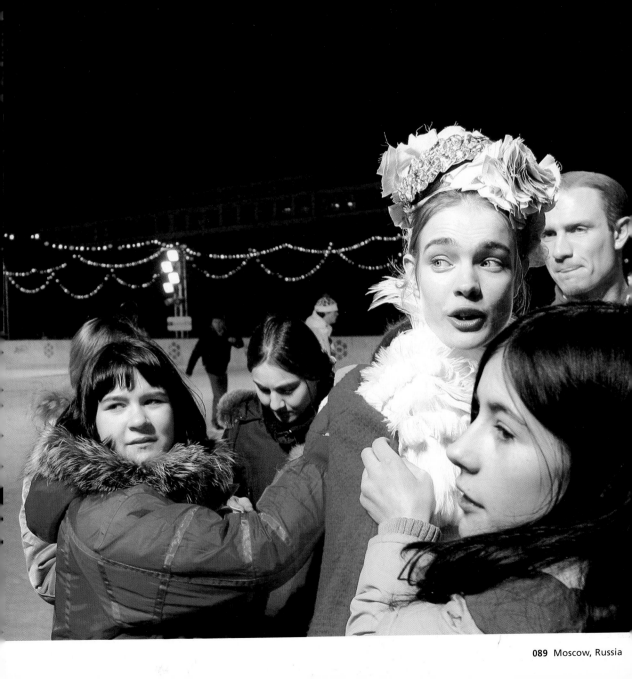

089 Moscow, Russia

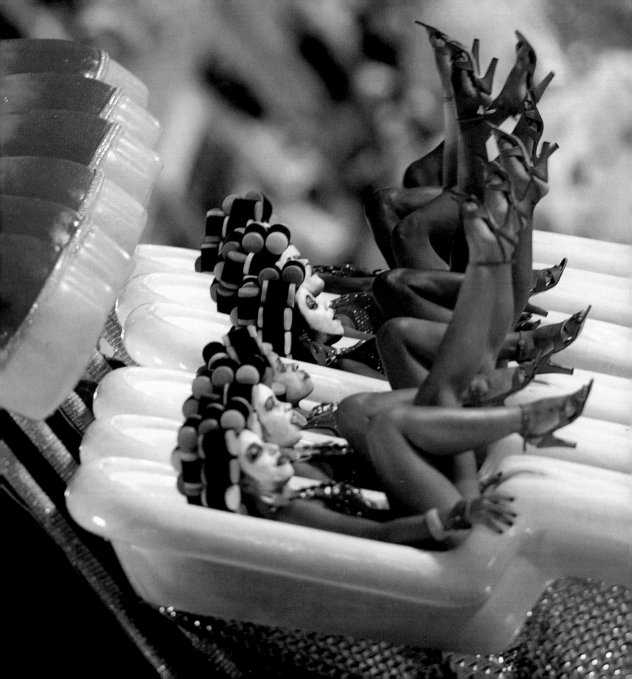

082 083 084 085 086 087

088 089 090

082 Boys play soccer at Gyandu park in Sekondi, Ghana, host country for the 2008 Africa Cup of Nations soccer tournament. 1 February 2008. Sekondi, Ghana. Siphiwe Sibeko.

083 Weapons confiscated under a government arms control programme are displayed inside an army building in Santiago. 5 February 2008. Santiago, Chile. Ivan Alvarado.

084 Bulgarian Muslims Moussa Babechki and his bride Fikrie Sabrieva pose in front of the dowry during their wedding ceremony in the remote village of Ribnovo, in the Rhodope Mountains of southwest Bulgaria. The village, set on a snowy mountainside, has kept alive its traditional winter marriage ceremony despite decades of Communist persecution, followed by years of poverty that forced many men to seek work abroad. 12 January 2008. Ribnovo, Bulgaria. Stoyan Nenov.

085 A girl plays in front of cherry trees in blossom in Spain's Valle del Jerte in Extremadura. The valley is home to more than 1 million cherry trees, which blossom in March and produce fruits between early May and late July. 29 March 2008. Valle del Jerte, Spain. Nacho Doce.

086 A crew member steers a dragon boat during the Chinese New Year Dragon Boat races at Darling Harbour in central Sydney. The race weekend was one of dozens of events celebrating the beginning of the Chinese year of the rat. 17 February 2008. Sydney Australia. Tim Wimborne.

087 Bride Cristina Sosa waits in the hallway of New York's Empire State Building for her Valentine's day wedding to begin. 14 February 2008. New York, United States. Shannon Stapleton.

088 Italian designer Valentino Garavani stands with his models and waves at the end of his Spring/Summer 2008 Haute Couture collection in Paris. This was his final collection before retiring after a 45-year career during which he dressed European royalty and Hollywood stars. 23 January 2008. Paris, France. Benoit Tessier.

089 Russian model Natalia Vodianova attends an event at a skating rink in Moscow's Red Square organized by her children's charity, the Naked Heart Foundation. She has mobilized her celebrity friends to raise money for the charity to build playgrounds for Russian children. 13 February 2008. Moscow, Russia. Denis Sinyakov.

090 Members of the Viradouro Samba School dance on a float designed as a beauty salon during the first night of parades by top samba groups in the Sambadrome, a purpose-built parade area in downtown Rio de Janeiro for samba displays and competitions. 4 February 2008. Rio de Janeiro, Brazil. Fernando Soutello.

2

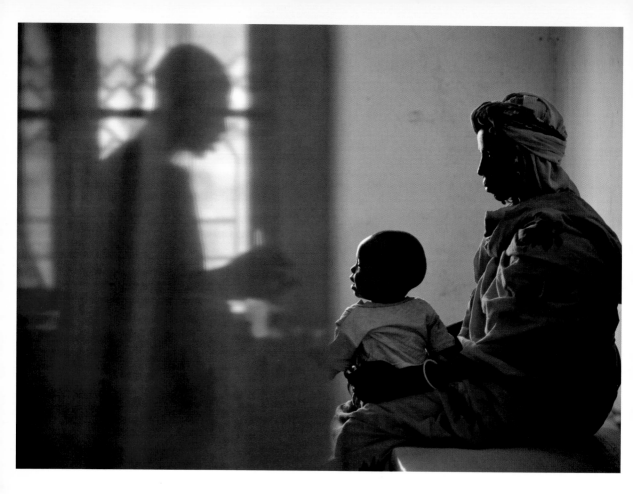

091 Kerfi, Chad

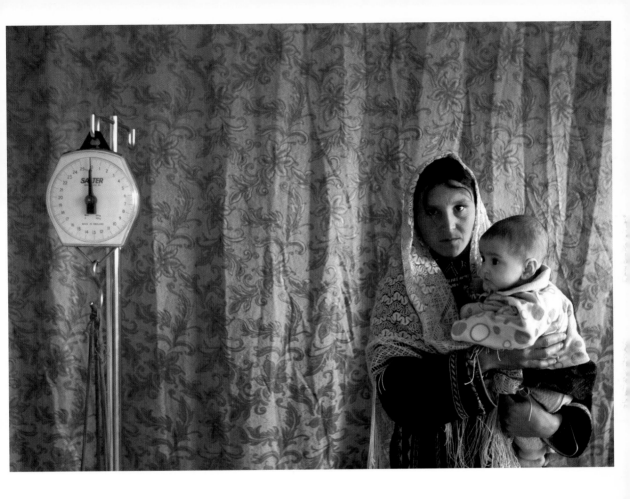

092 Eshkashem, Afghanistan

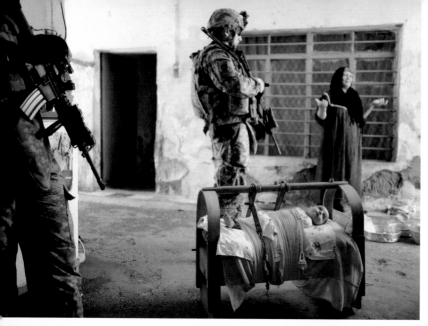

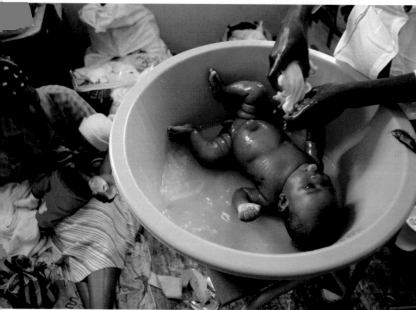

093 [TOP] Mosul, Iraq **094** [ABOVE] Durban, South Africa

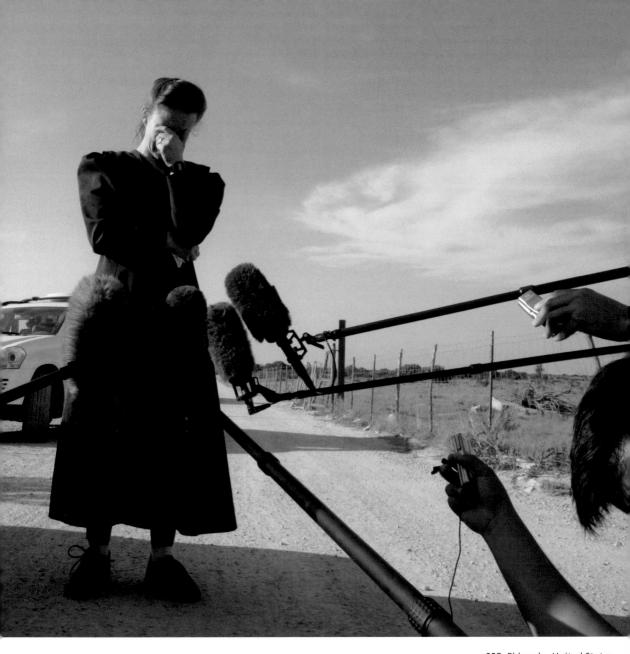

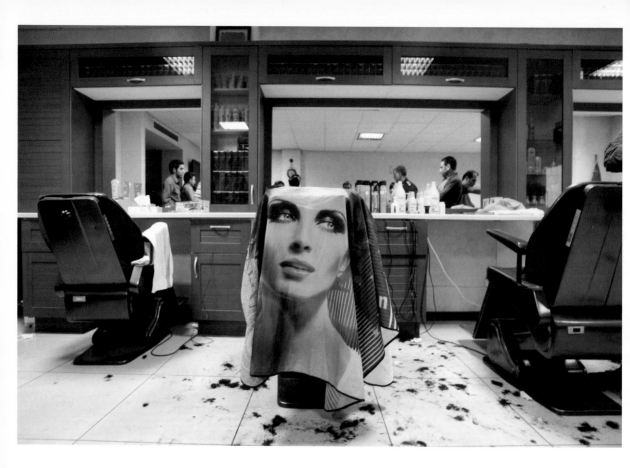

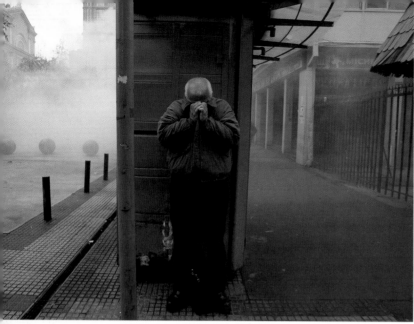

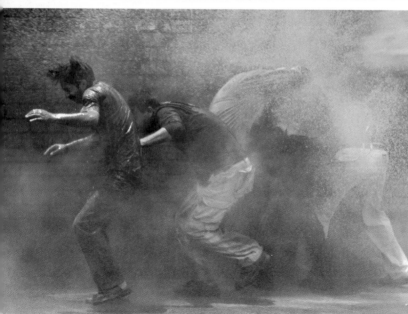

098 [TOP] Santiago, Chile 099 [ABOVE] Srinagar, India

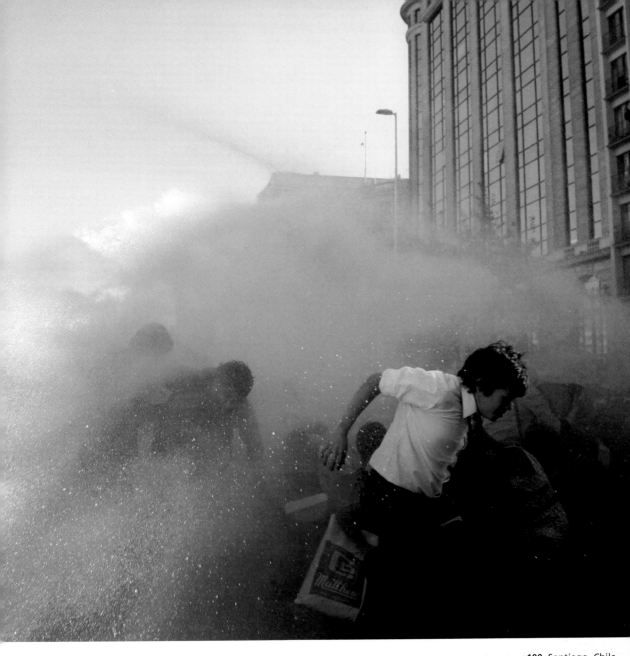

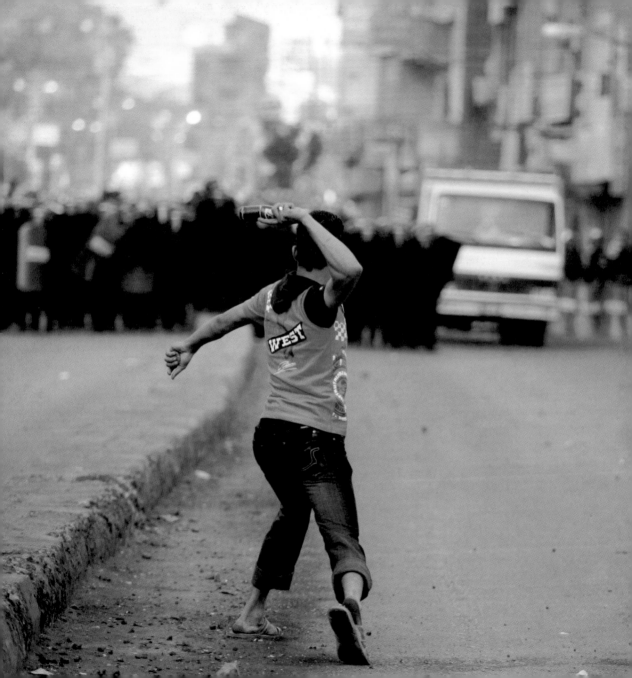

091
092
093
094
095
096
097
098
099
100
101

091 A doctor administers medicine to a sick child at a health clinic run by the medical charity Médecins Sans Frontières Holland in Kerfi, a site for displaced Chadians in the far southeast of the country. Violence in Darfur that has swept across the Chad–Sudan border has created 250,000 Sudanese refugees living in a dozen camps in eastern Chad and 180,000 internally displaced Chadians, U.N. officials say. 10 June 2008. Kerfi, Chad. Finbarr O'Reilly.

092 An Afghan mother visits a health clinic with her child in Eshkashem district of Badakhshan province, northeast of Kabul. Afghanistan has one of the world's highest maternal mortality rates, with one in eight women dying in childbirth. 23 April 2008. Eshkashem, Afghanistan. Ahmad Masood.

093 An Iraqi baby lies in a cradle while a woman argues with U.S. soldiers of 1/8 Bravo Company. The soldiers were searching for weapons, explosives and information about militants during a foot patrol in a neighbourhood of Mosul. 26 June 2008. Mosul, Iraq. Eduardo Munoz.

094 African immigrants in Durban, South Africa, take refuge in the city's Catholic Cathedral during a wave of xenophobic violence in cities across the country that killed more than 60 people and displaced 100,000. 24 May 2008. Durban, South Africa. Rogan Ward.

095 A member of the Fundamentalist Church of Jesus Christ of Latter-Day Saints covers her face as she addresses reporters outside the YFZ Ranch in Eldorado, Texas. Over 400 children were removed by the authorities from the polygamist compound and transferred to foster homes across the state. 24 April 2008. Eldorado, United States. Jessica Rinaldi.

096 A barber shop in Tehran is sealed off by the morals police for giving Western-style haircuts. 16 June 2008. Tehran, Iran. Alireza Sotakbar.

097 A customer approaches the military-themed 'Buns and Guns' fast food restaurant, newly opened in a Hezbollah-controlled suburb of Beirut. The restaurant's chef wears a military outfit and customers sit behind a wall of sandbags. 27 June 2008. Beirut, Lebanon. Cynthia Karam.

098 A pedestrian takes cover from teargas during a rally in Santiago as students clash with Chilean police in protests against a proposed education reform. Opponents of the reform claim Chile's education system is being privatized and that the education of poorer students at ill-funded state schools will suffer. 28 May 2008. Santiago, Chile. Ivan Alvarado.

099 Kashmiri government employees are hit by water cannon during a protest demanding the regularization of their jobs and pay increases. 10 June 2008. Srinagar, India. Fayaz Kabli.

100 Demonstrators against a proposed education reform take cover from police water cannon in Santiago. 16 June 2008. Santiago, Chile. Ivan Alvarado.

101 A protester throws a missile towards riot police during clashes in Mahalla el-Kubra about 110 km (70 miles) north of Cairo. Three people were killed and more than 150 injured over two days of unrest, the culmination of over a year of strikes by workers at a giant state-run textile factory. 7 April 2008. Mahalla el-Kubra, Egypt. Nasser Nuri.

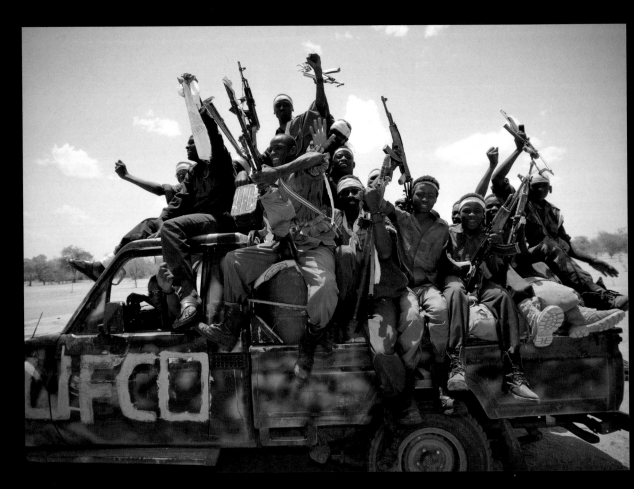

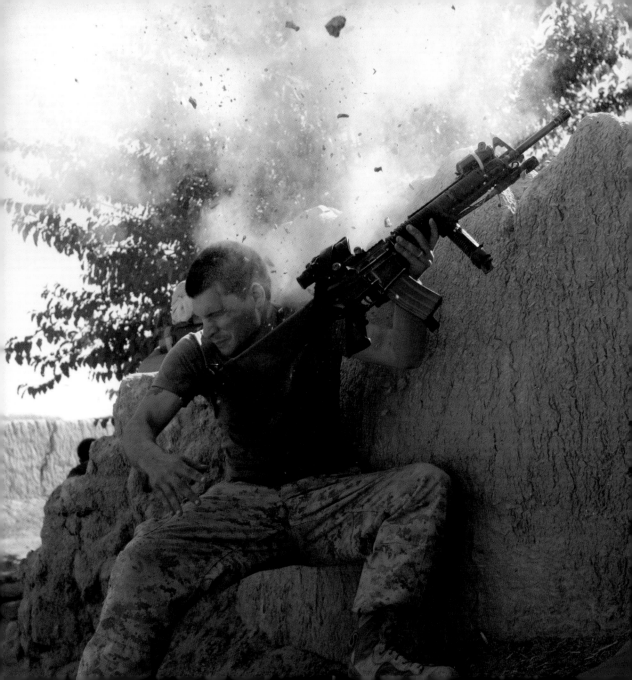

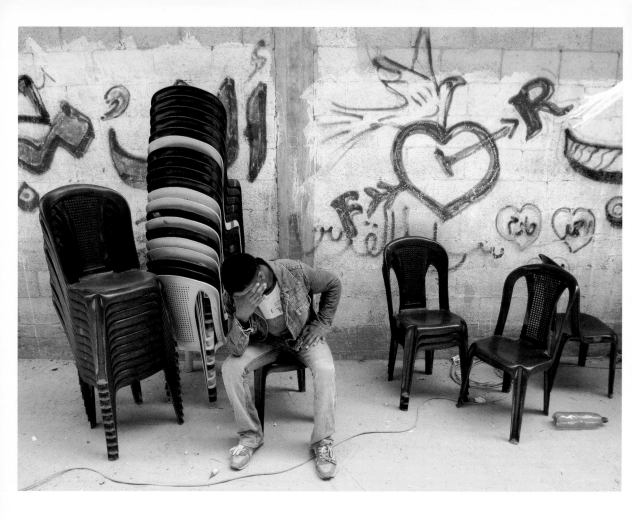

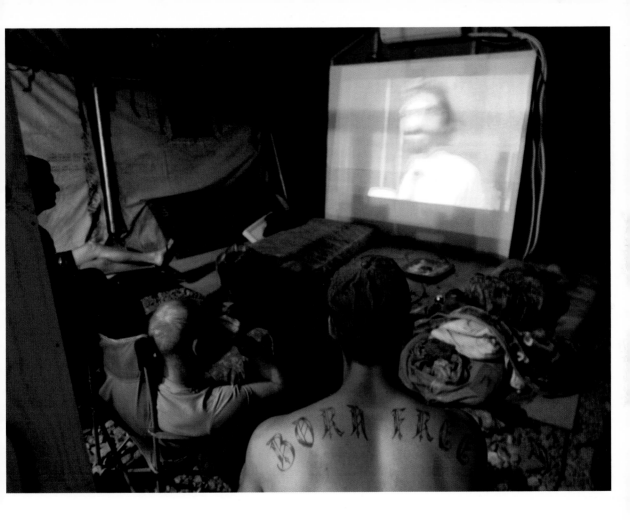

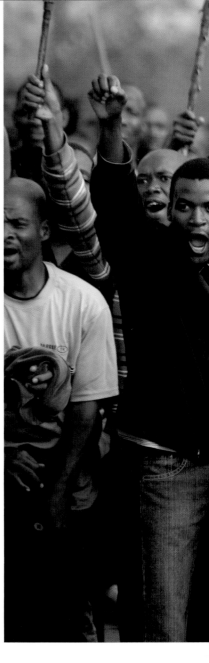

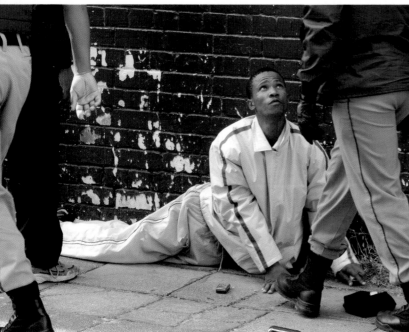

106 [TOP] Cape Town, South Africa **107** [ABOVE] Johannesburg, South Africa

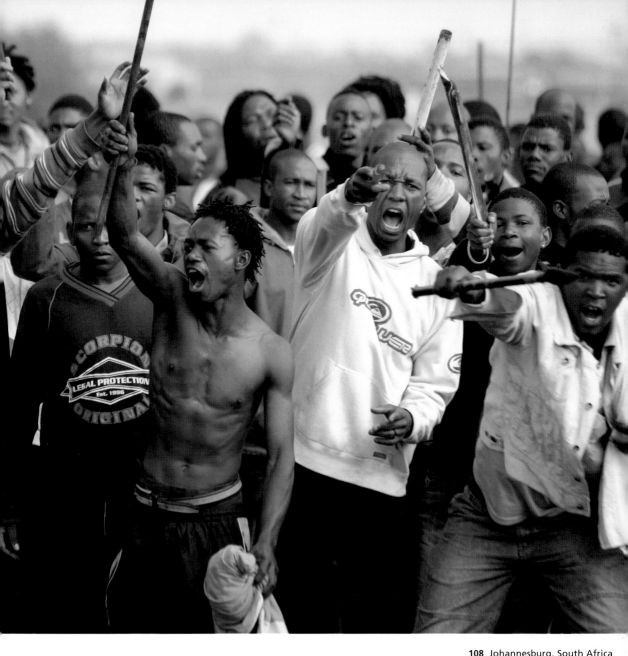

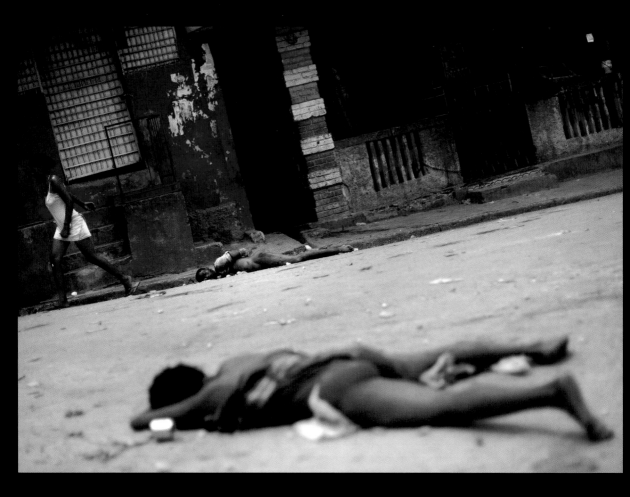

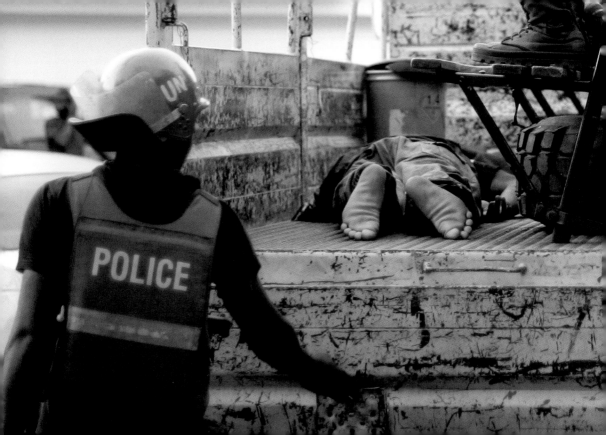

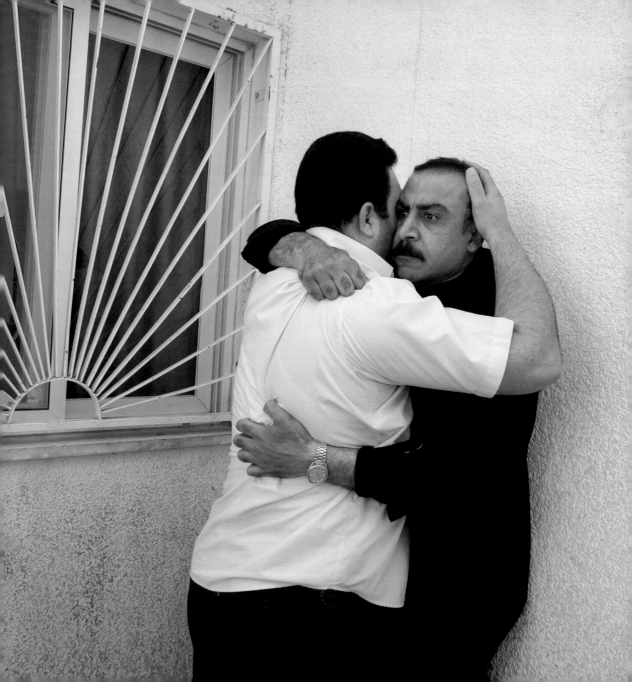

102 103 104 105 106 107

108 109 110 111

02 Chadian rebels cheer as they speed across the desert during an attack on the eastern Chadian town of Goz-Beida, 70 km (40 miles) by road from Chad's eastern border with Sudan's Darfur region. According to the rebels, the attack was part of a westward offensive aimed at trying to overthrow President Idriss Déby. 14 June 2008. Goz-Beida, Chad. Finbarr O'Reilly.

03 U.S. Sergeant William Olas Bee of the 24th Marine Expeditionary Unit has a close call after Taliban fighters open fire near Garmser in Helmand province. He was not injured. 18 May 2008. Garmser, Afghanistan. Goran Tomasevic.

04 A Palestinian man mourns during the funeral of Aateef Al-Garabli in Gaza. Medics said he was killed by an Israeli tank shell. 10 April 2008. Gaza. Mohammed Salem.

105 U.S soldiers watch a movie at a military base in the Zhari district of Afghanistan, some 40 km (25 miles) west of Kandahar. 17 April 2008. Zhari, Afghanistan. Goran Tomasevic.

106 A Zimbabwean immigrant takes refuge at Cape Town's Milnerton police station after fleeing a fresh outbreak of anti-foreigner violence. 22 May 2008. Cape Town, South Africa. Mark Wessels.

107 A suspect is questioned by police during clashes believed to be linked to recent anti-foreigner violence in Johannesburg. Most of the attacks were targeted at Zimbabweans and other immigrants. 18 May 2008. Johannesburg, South Africa. Siphiwe Sibeko.

108 Protesters in Reiger Park informal settlement, east of Johannesburg, chant slogans during clashes believed to be linked to anti-foreigner violence. The violence was the worst to occur in South Africa since the end of apartheid in 1994. 20 May 2008. Johannesburg, South Africa. Siphiwe Sibeko.

109 Two corpses lie in the Bel-Air neighbourhood of the Haitian capital Port-au-Prince. Witnesses said that they and one other person were killed by local gangs. 9 April 2008. Port-au-Prince, Haiti. Eduardo Munoz.

110 A U.N. police officer from Nigeria lies dead in a truck after being shot in Bel-Air, Port-au-Prince. At least six people were killed during a week of violent protests against rising food and fuel costs. Haiti is the poorest country in the Americas, with most of its population scraping by on less than $2 per day. 12 April 2008. Port-au-Prince, Haiti. Eduardo Munoz.

111 Palestinian relatives of Islamic Jihad gunman Fadi Salem embrace each other before his funeral in Gaza. Salem and other gunmen were killed by Israeli troops in the northern part of the Hamas-controlled Gaza Strip near a border crossing with Israel, Palestinian health officials and the Israeli army said. 22 April 2008. Gaza. Ismail Zaydah.

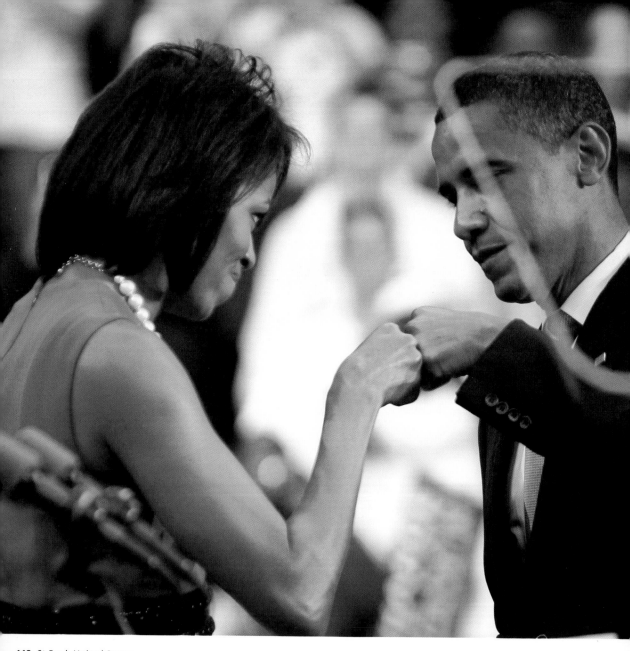

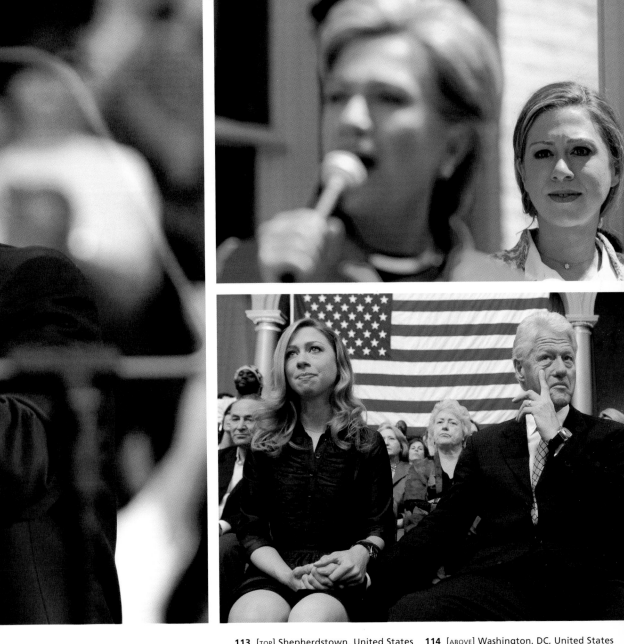

113 [TOP] Shepherdstown, United States **114** [ABOVE] Washington, DC, United States

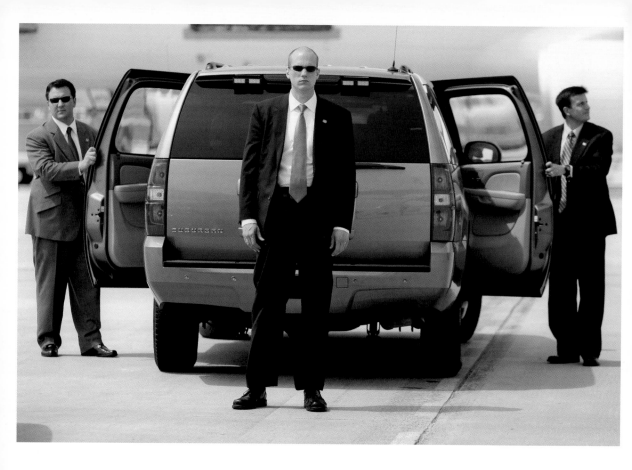

115 Raleigh-Durham, United States

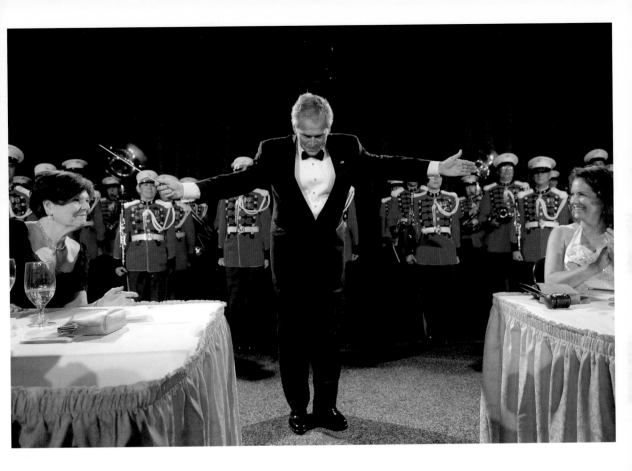

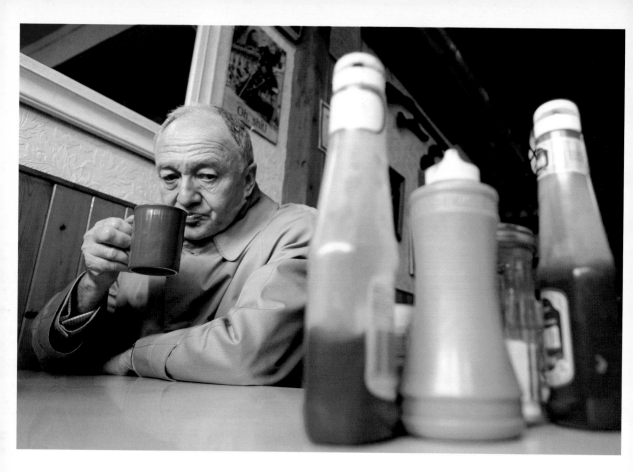

117 London, Britain

118 [OPPOSITE] Madrid, Spain

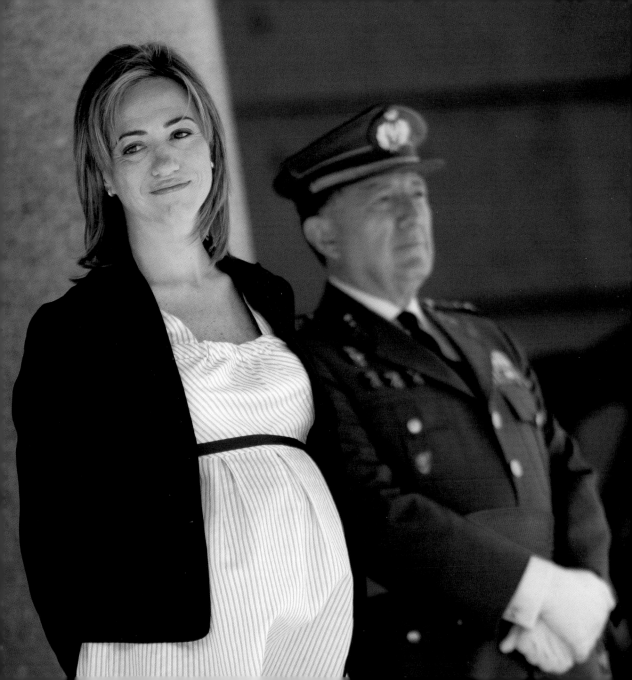

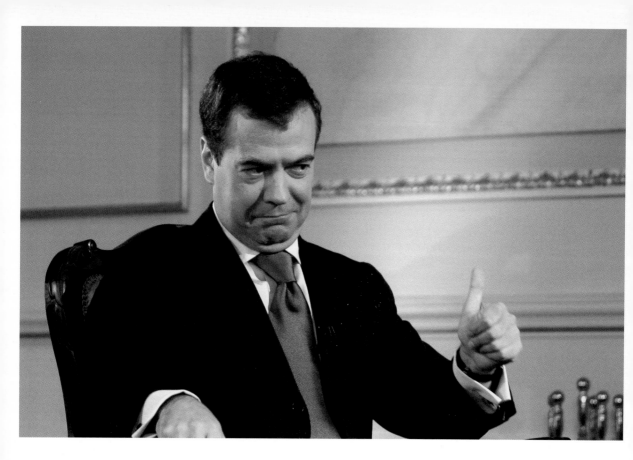

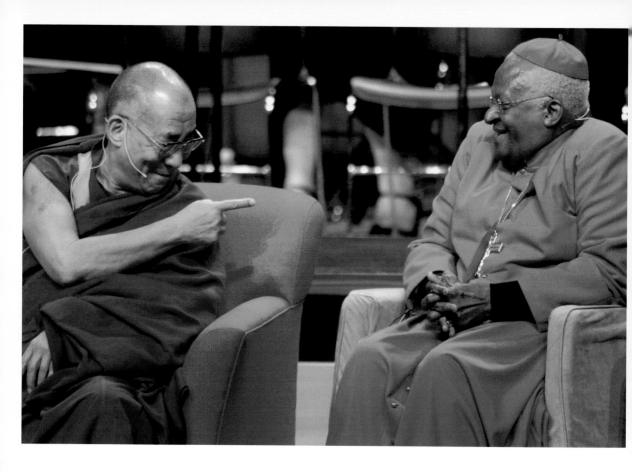

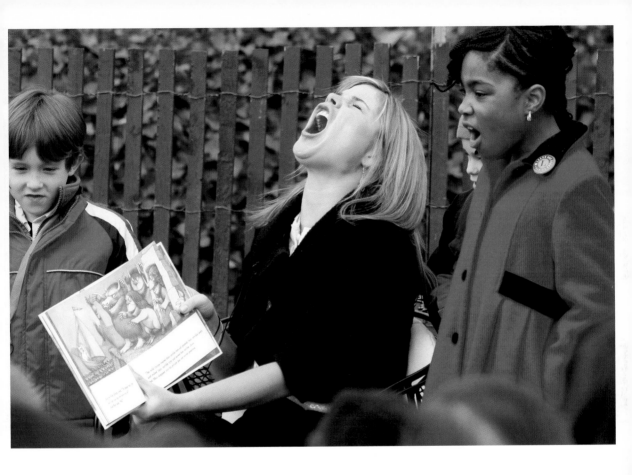

112 U.S. Democratic presidential candidate Senator Barack Obama bumps fists with his wife Michelle before addressing his South Dakota and Montana presidential primary election night rally in St Paul, Minnesota. 3 June 2008. St Paul, United States. Eric Miller.

113 Chelsea Clinton (right) listens to her mother, U.S. Democratic presidential hopeful Senator Hillary Clinton, campaign in Shepherdstown, West Virginia. 7 May 2008. Shepherdstown, United States. Kevin Lamarque.

114 Chelsea Clinton and former President Bill Clinton watch as Hillary Clinton announces that she is to suspend her White House bid. Clinton endorsed Barack Obama to be the Democratic U.S. presidential candidate after a gruelling 16-month nomination fight that badly split the Democratic Party. 7 June 2008. Washington, DC, United States. Jason Reed.

115 Secret Service agents await the arrival of U.S. Democratic presidential candidate Barack Obama alongside his SUV at Raleigh-Durham Airport in North Carolina. 5 May 2008. Raleigh-Durham, United States. Jason Reed.

116 U.S. President George W. Bush takes a bow after conducting the Marine Band rendition of 'Stars and Stripes Forever' at the annual White House Correspondents' Association Dinner. 26 April 2008. Washington, DC, United States. Jonathan Ernst.

117 London Mayor Ken Livingstone drinks a cup of tea in Ken's Cafe in West Ham while out canvassing for votes ahead of the city's mayoral elections. After eight years in office, Livingstone lost to Conservative candidate Boris Johnson in a huge boost to the opposition Conservatives. 30 April 2008. London, Britain. Stephen Hird.

118 Spain's first female defence minister, Carme Chacon, who is pregnant, reviews an honour guard during a ceremony at the Defence Ministry in Madrid. 14 April 2008. Madrid, Spain. Susana Vera.

119 Russia's President Dmitry Medvedev gestures during an interview with Reuters in Moscow. 23 June 2008. Moscow, Russia. Grigory Dukor.

120 Hamas leader Khaled Meshaal combs his hair in his hotel room in Abu Dhabi. Palestinian militants and Israel agreed to cease hostilities in Gaza in an Egyptian-brokered truce announced on 17 June. 18 June 2008. Abu Dhabi, United Arab Emirates. Ahmed Jadallah.

121 Exiled Tibetan spiritual leader the Dalai Lama shares a moment of fun with Archbishop Desmond Tutu as they take part in an interfaith discussion in Seattle. 15 April 2008. Seattle, United States. Robert Sorbo.

122 Jenna Bush, daughter of U.S. President George W. Bush, reads the book *Where the Wild Things Are* to children attending the traditional Easter Egg Roll on the South Lawn of the White House. This annual event dates back to 1878. 24 March 2008. Washington, DC, United States. Jason Reed.

123 A man watches the 'Recommitment March' to the National Civil Rights Museum in Memphis, Tennessee, where Dr Martin Luther King was assassinated 40 years ago in 1968. 4 April 2008. Memphis, United States. Mike Segar.

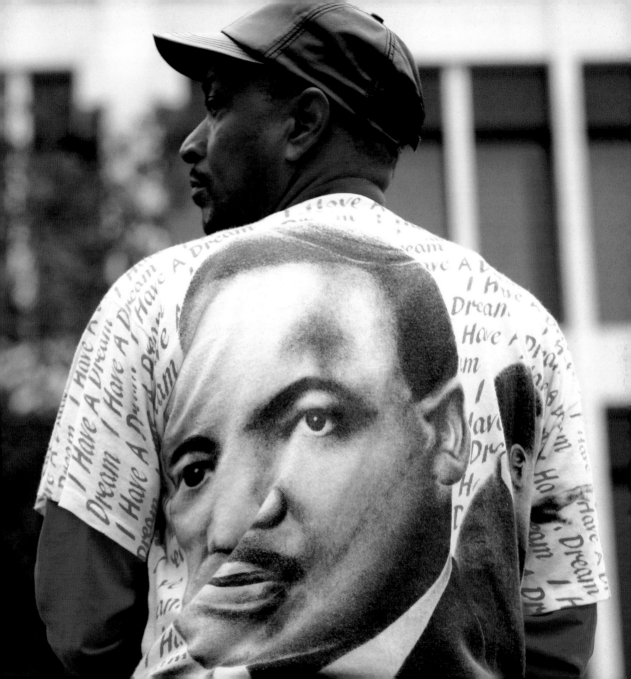

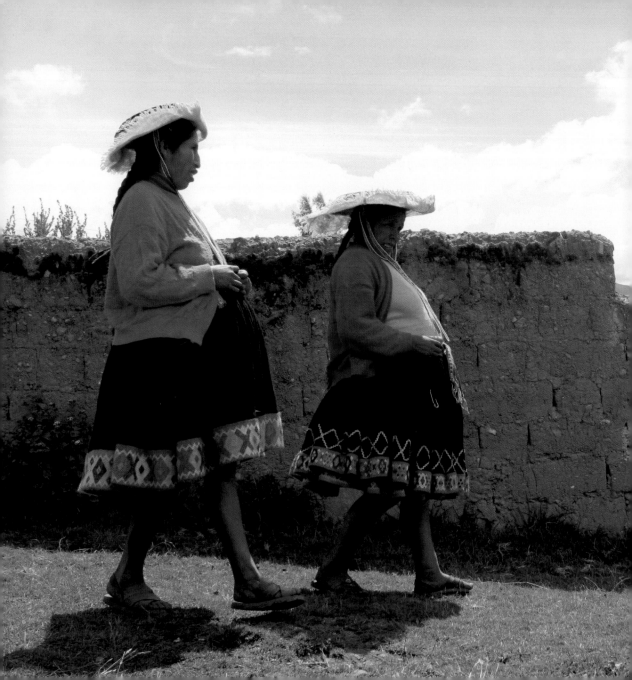

MARIANA BAZO
Photographer
Born: Lima, Peru, 1964
Based: Lima, Peru
Nationality: Peruvian

Peru encourages vertical births to save lives

I travelled to Cuzco to do a feature different from most news stories. Following on from the work of my Reuters colleague, photographer Enrique Castro-Mendivil, this was to be a project over several days that would give me the chance to photograph in depth without the usual rush to file my pictures.

Standing or sitting during childbirth is an age-old practice that is depicted on ancient Andean pottery, and is still the preferred position for many Andean and Amazon women. Some maternity clinics in Peru have now started to encourage women to give birth this way, instead of lying on their backs as in most developed countries. The vertical position helps to reduce pressure on the uterus and increase the oxygen flow to the baby, while reducing labour and delivery time, according to the Peruvian Health Ministry. Most importantly, it is hoped that the new policy will help cut high rates of maternal mortality by encouraging poor, mostly indigenous Peruvian women to place themselves under the care of professionals.

Witnessing childbirth is an overwhelming experience, even for a news photographer like me, used to maintaining a distance from most subjects. It was impossible not to feel empathy for these women, who waited patiently in their agony for their turn to give birth, with nothing to alleviate the pain. Being a woman and a mother was an invitation into their world. They always asked me if I had a child, and that opened the door for me.

On my second day, an obstetrician named Guido told me that this was the night of a full moon, meaning that there would be many births and I should stay overnight. He was right. I was fortunate to witness four births that night – as well as a power cut. The clinic did not have candles or flashlights, let alone a generator. One baby was born by the light of the screen on my Canon 5D camera. Just being there was a privilege. It was an exhausting but deeply moving experience.

124 Peruvian mothers-to-be Juana Huaman (left) and Beingna Condori walk to the maternity shelter in Huancarani on the outskirts of Cuzco. To encourage women living in remote areas to attend clinics, some maternity hospitals in Peru offer them shelter weeks before their babies are due. 23 March 2008. Enrique Castro-Mendivil.

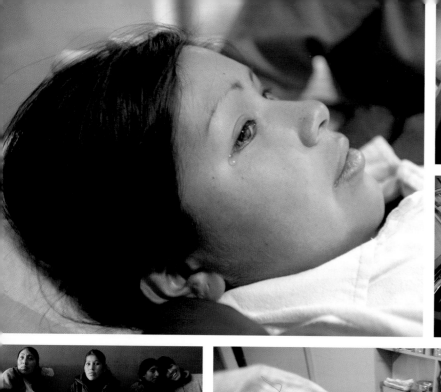
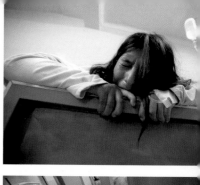
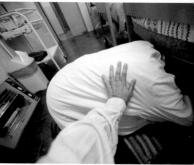
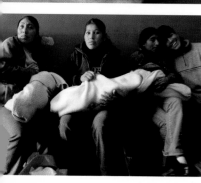
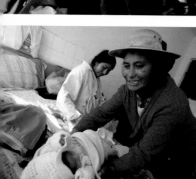
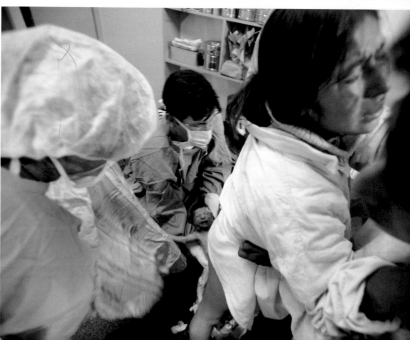

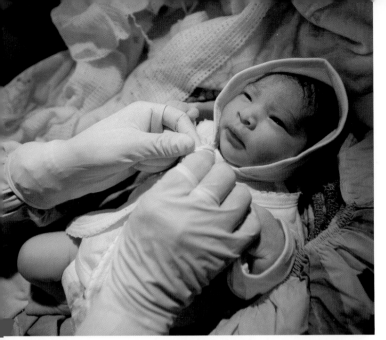

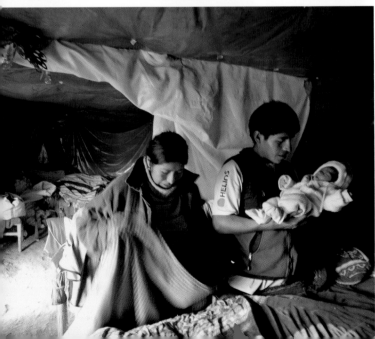

	126	131
125	127	
128	130	132
129		

125 Nineteen-year-old Peruvian Jenny Rodriguez prepares to give birth in the Belempampa Health Clinic in Cuzco, one of many clinics in Peru that have started to permit women to give birth in the traditional standing position, instead of lying on their backs as in most developed countries. 21 May 2008. **126** Mary Luz Rojas endures labour pains before giving birth in the vertical position. 22 May 2008. **127** Mary Luz Rojas endures labour pains. 22 May 2008. **128** Andean women and their newborn babies wait to receive medical attention. 22 March 2008. Enrique Castro-Mendivil. **129** Aturnina Guerra, mother-in-law of Gloria Cusi Quispe (rear), holds her newborn grandson. 24 May 2008. **130** Gloria Cusi Quispe gives birth in the vertical position. 24 May 2008. **131** Estefani Dayana, the newborn baby of 19-year-old Peruvian Jenny Rodriguez, is attended to in the moments after her birth. 21 May 2008. **132** Gloria Cusi Quispe and her husband Richard Guerra put their newborn baby to bed at their home in Cuzco. 24 May 2008.

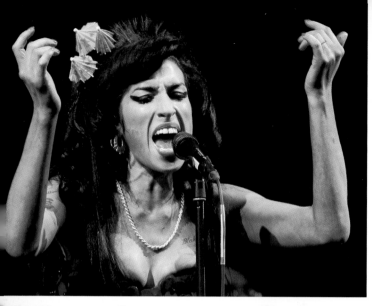

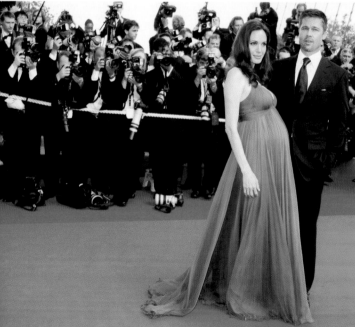

133 [TOP] Glastonbury, Britain **134** [ABOVE] Cannes, France

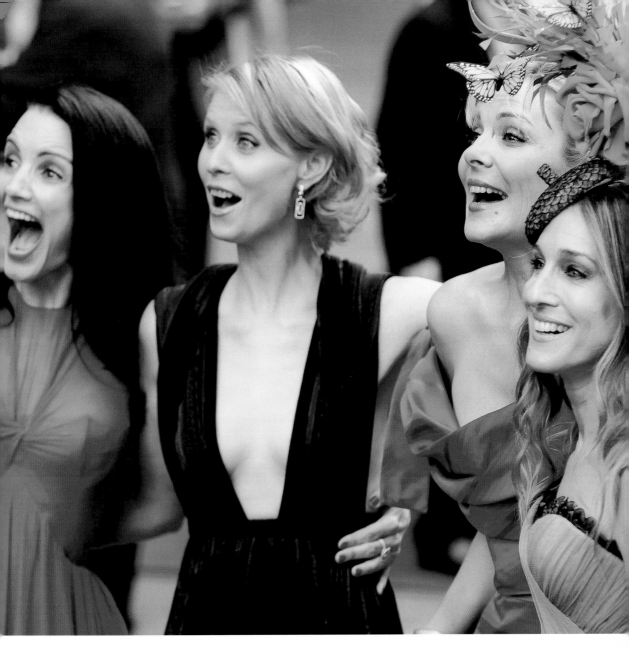

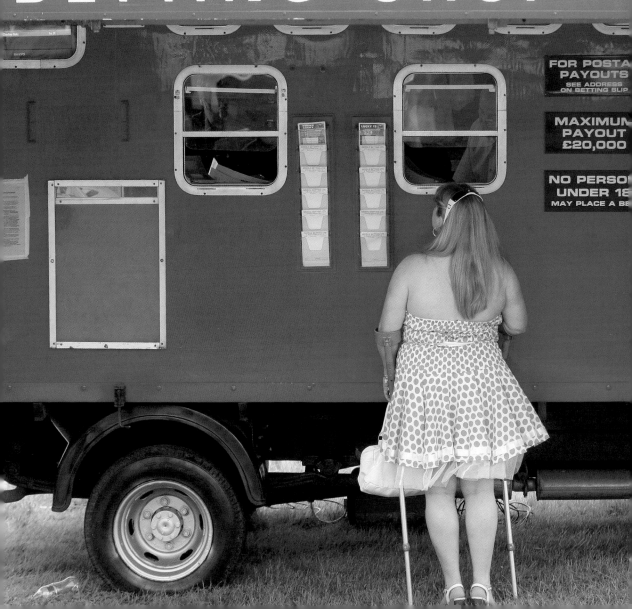

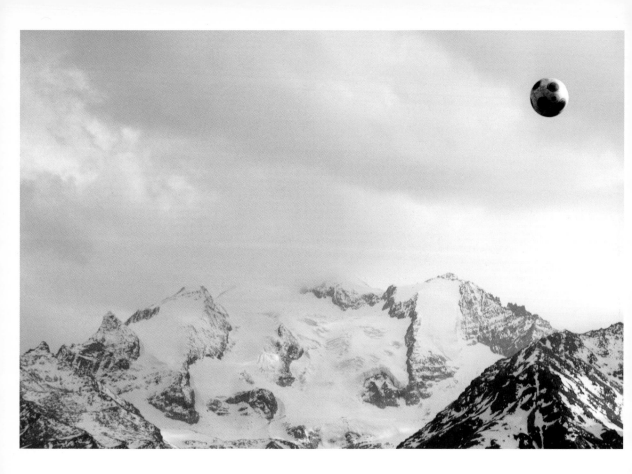

138 Gspon, Switzerland

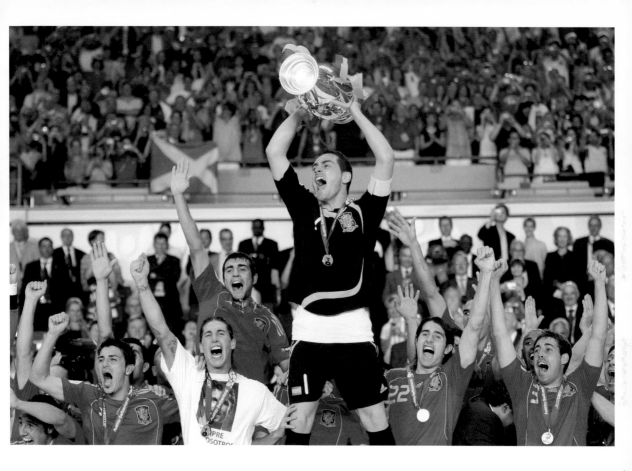

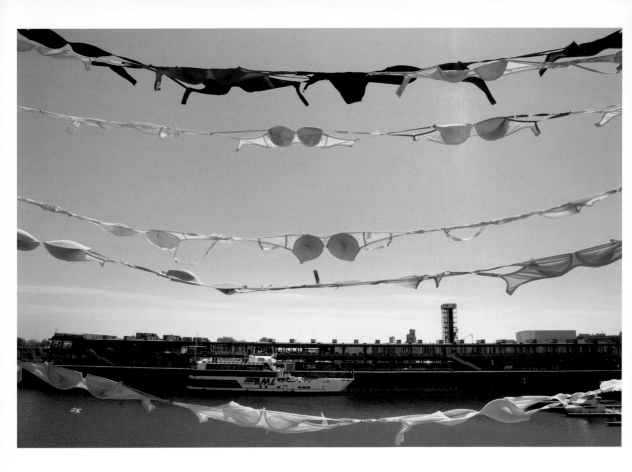

140 Montreal, Canada

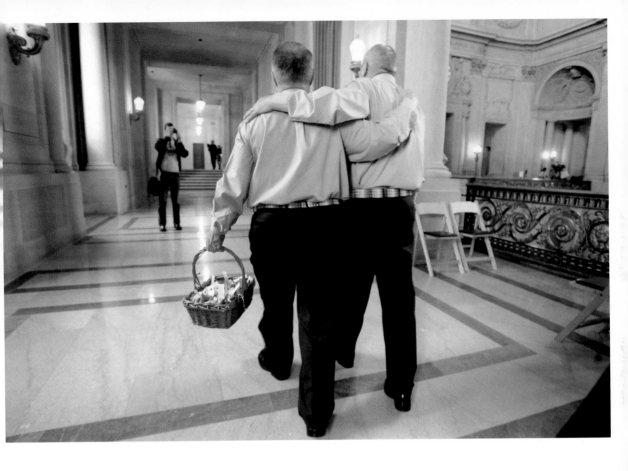

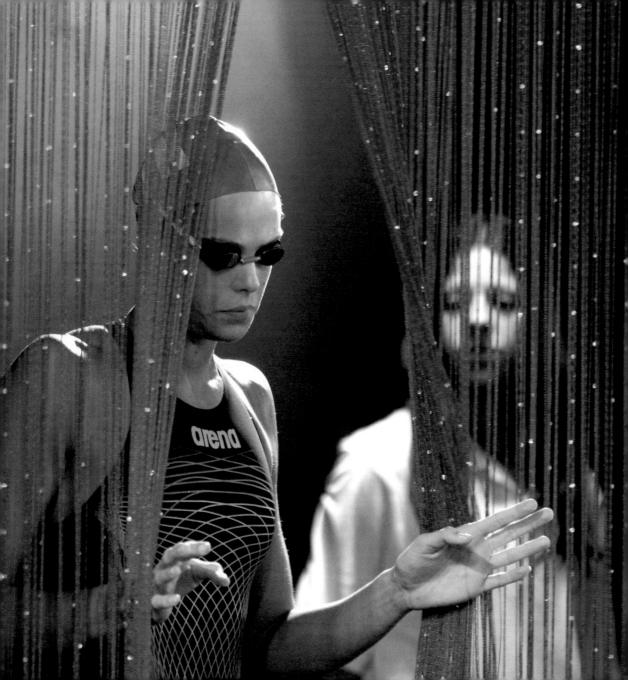

133 134 135 136 137 138 139 140 141 142

133 British singer Amy Winehouse performs at the Glastonbury Festival 2008 in Somerset, southwest England. 28 June 2008. Glastonbury, Britain. Luke MacGregor.

134 Angelina Jolie and Brad Pitt arrive for the screening of the animated film *Kung Fu Panda* by directors Mark Osborne and John Stevenson at the 61st Cannes Film Festival. 15 May 2008. Cannes, France. Eric Gaillard.

135 Actresses (from left to right) Kristin Davis, Cynthia Nixon, Kim Cattrall and Sarah Jessica Parker arrive for the world premiere of *Sex and the City: The Movie* in London. 12 May 2008. London, Britain. Dylan Martinez.

136 Race-goers arrive for the start of the Royal Ascot race meeting in Berkshire, southern England. 17 June 2008. Ascot, Britain. Alessia Pierdomenico.

137 A woman places a bet before the start of the first race of the Epsom Derby Festival at Epsom Downs, Surrey, southern England. 6 June 2008. Epsom, Britain. Darren Staples.

138 A ball is pictured in front of a mountain during the Euro of Mountain Villages soccer tournament in Switzerland. Eight teams from eight European nations compete in the competition, which is played on the highest soccer field in Europe. 23 May 2008. Gspon, Switzerland. Denis Balibouse.

139 Spain's Iker Casillas holds up the trophy as he celebrates with team mates after their Euro 2008 final soccer match victory over Germany. 29 June 2008. Vienna, Austria. Kai Pfaffenbach.

140 Thousands of bras hang in the Old Port of Montreal. A local radio station collected 67,000 bras to raise awareness and funds for the Quebec Breast Cancer Society. 29 May 2008. Montreal, Canada. Christinne Muschi.

141 Partners Bill Wilson (right) and Fernando Orlandi walk through San Francisco City Hall as they prepare to get married on the first full day of legally recognized same-sex marriage in California. 17 June 2008. San Francisco, United States. Erin Siegal.

142 French swimmer Laure Manaudou prepares for the start of the 400 metres Freestyle 'final A' event at the French Swimming Championships. 21 April 2008. Dunkirk, France. Pascal Rossignol.

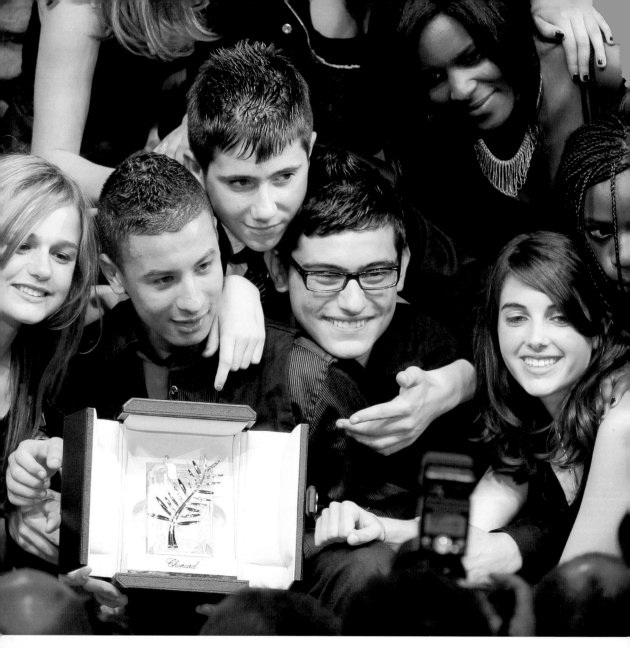

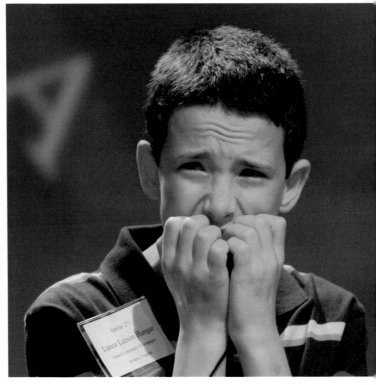

144 [TOP] Tokyo, Japan **145** [ABOVE] Washington, DC, United States

147 Minamiboso, Japan

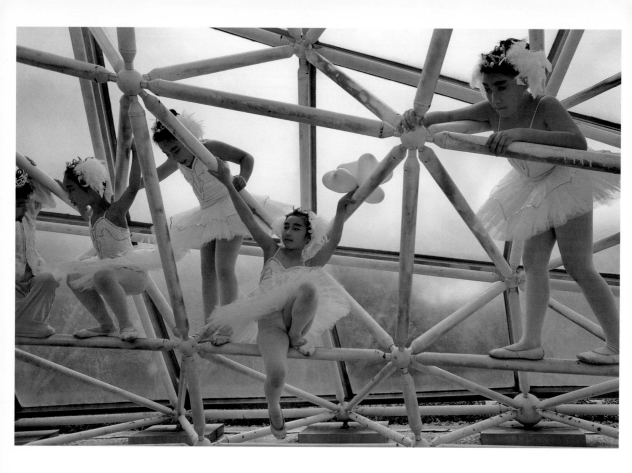

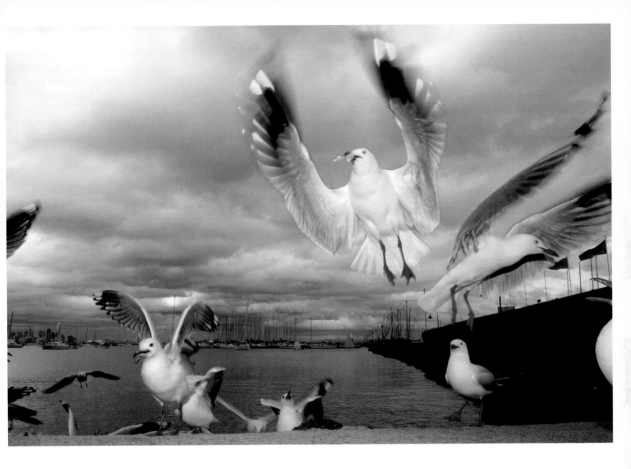

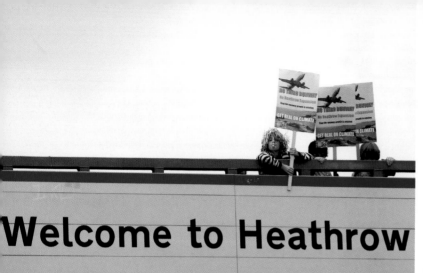

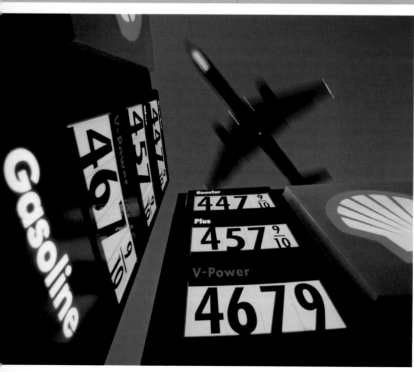

150 [TOP] London, Britain **151** [ABOVE] San Diego, United States

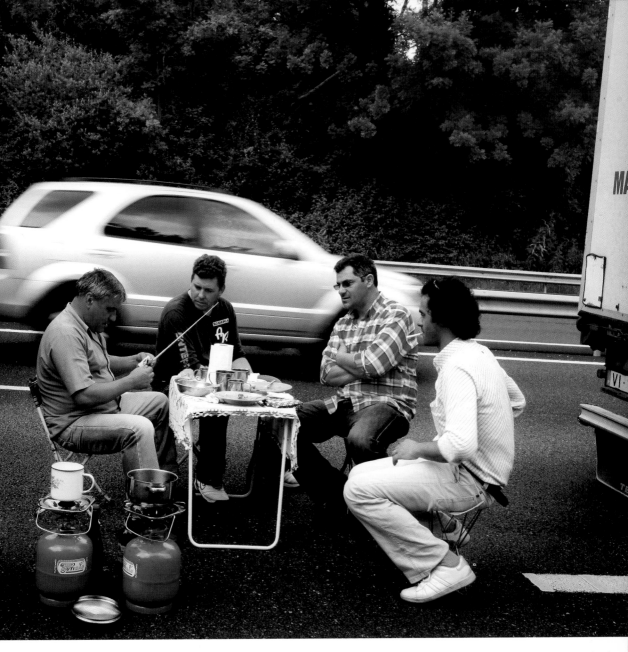

143 144 145 146 147 148

149 150 151 152 153

143 French director Laurent Cantet (right) poses for photographers with students who formed the cast of his Palme d'Or award-winning film *Entre les Murs* (*The Class*) at the 61st Cannes Film Festival. 25 May 2008. Cannes, France. Eric Gaillard.

144 A schoolgirl rests next to a soroban, a traditional Japanese abacus, during the 26th American school soroban contest in Tokyo. More than 100 children from U.S. military bases in Japan took part. 22 May 2008. Tokyo, Japan. Toru Hanai.

145 Contestant Lance Letson Hungar waits anxiously for his turn during the semi-final round of the 2008 Scripps National Spelling Bee in Washington. 30 May 2008. Washington, DC, United States. Molly Riley.

146 A soldier and sniffer dog search for explosives under a stage ahead of a campaign rally by the Communist Party of Nepal. The former Maoist rebels followed their historic election win by forming a special assembly that abolished Nepal's 239-year-old monarchy. 6 April 2008. Kathmandu, Nepal. Adrees Latif.

147 Workers butcher a Baird's Beaked whale at Wada port in Minamiboso, southeast of Tokyo. Japan remains the world's number one whale-hunting nation after conservation groups failed to put a stop to its activities at a weeklong International Whaling Commission meeting in Chile in June. 28 June 2008. Minamiboso, Japan. Toru Hanai.

148 Young ballerinas wait backstage to perform at a mass wedding ceremony in Taipei. 27 April 2008. Taipei, Taiwan. Pichi Chuang.

149 Seagulls are fed by tourists at the Melbourne seaside suburb of Williamstown. 19 May 2008. Melbourne, Australia. Mick Tsikas.

150 Protesters demonstrate against the expansion of Heathrow Airport, west London. Construction plans for a third runway would involve the demolition of the village of Sipson, including around 700 homes. 31 May 2008. London, Britain. Alessia Pierdomenico.

151 Gasoline prices are advertised at a gas station near Lindbergh Field as a plane approaches to land in San Diego, California. Oil prices rose rapidly through the first half of 2008, reaching a record high of $147.27 a barrel on 11 July before dropping sharply back down again. 1 June 2008. San Diego, United States. Mike Blake.

152 Portuguese truck drivers in Irun, near the Spanish–French border, listen to the radio for news of their protest against rising fuel costs. Strikers blockaded distribution centres and stopped heavy goods traffic in their call for the government to establish a minimum haulage fee to counter a 35 percent rise in fuel costs over the previous 12 months. 9 June 2008. Irun, Spain. Vincent West.

153 A woman watches from Titusville, Florida, as the space shuttle Discovery launches from pad 39A at the Kennedy Space Center in Cape Canaveral. 31 May 2008. Titusville, United States. Eric Thayer.

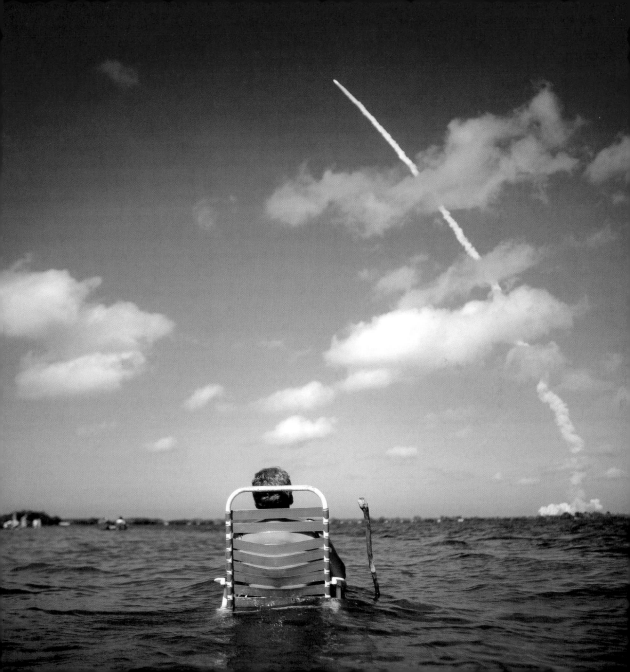

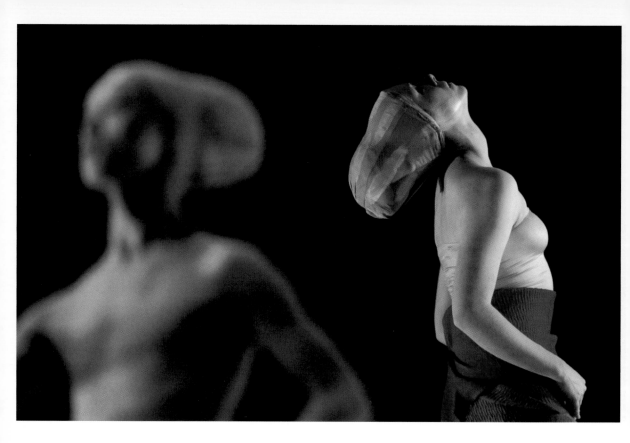

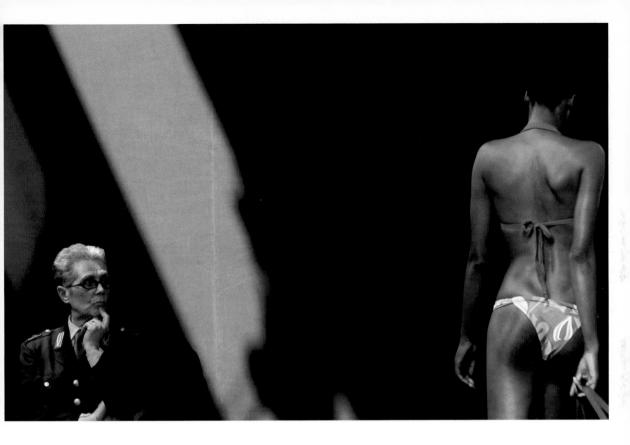

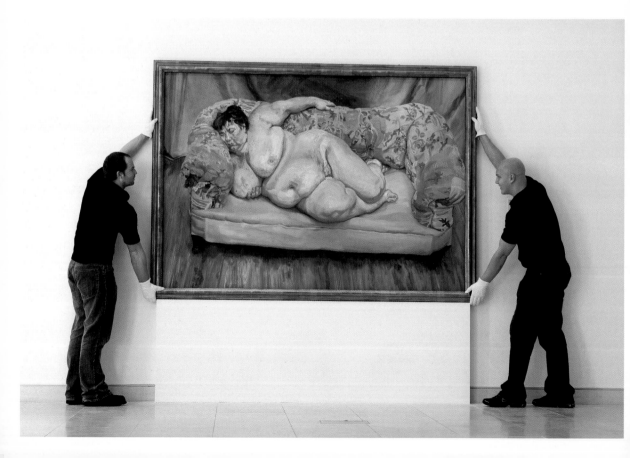

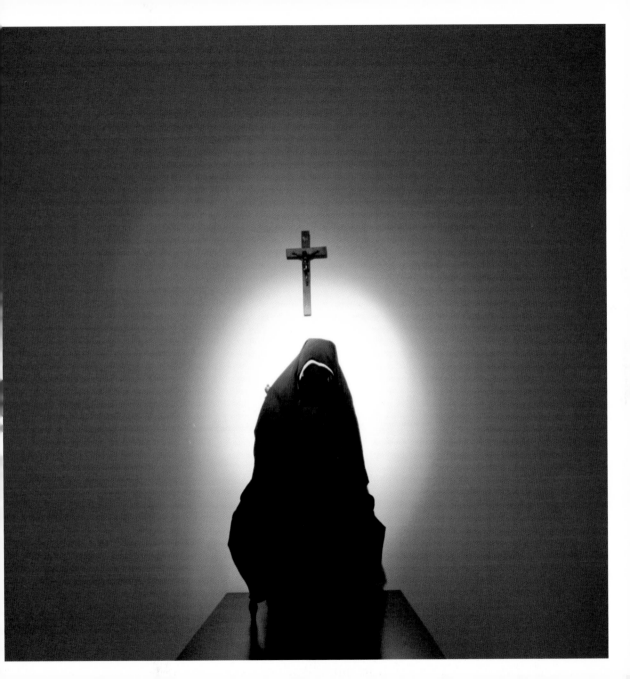

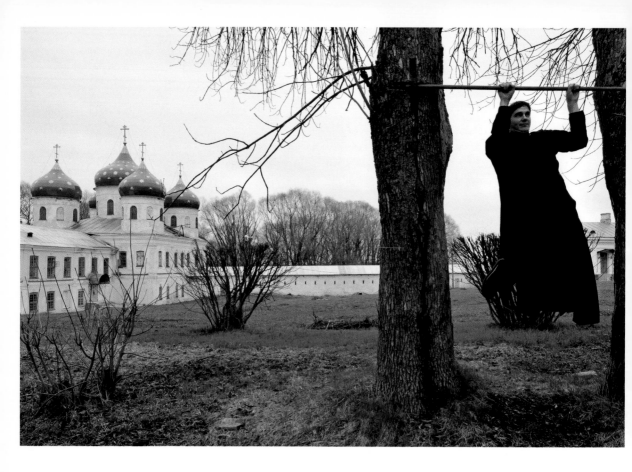

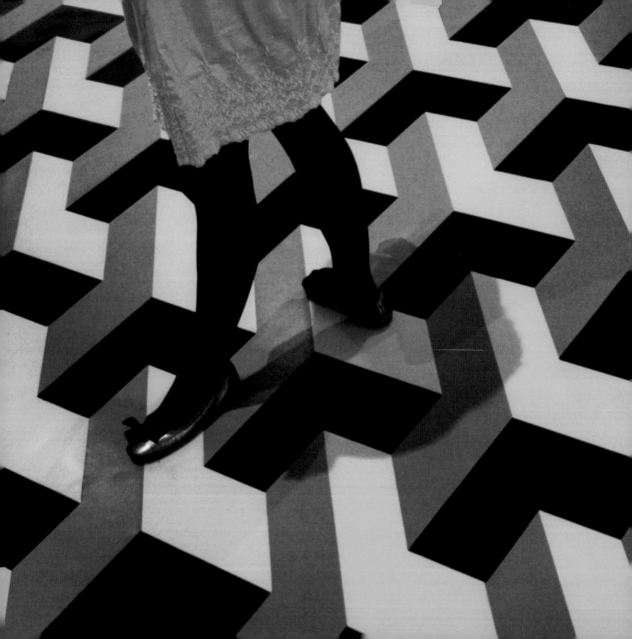

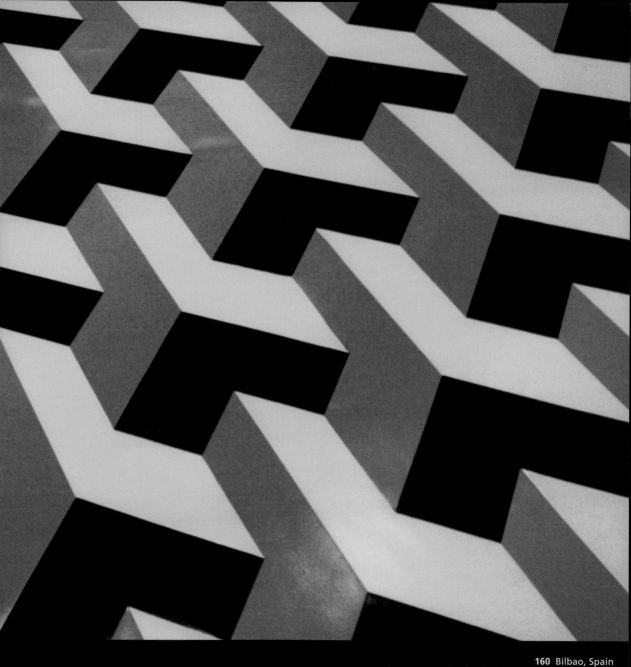

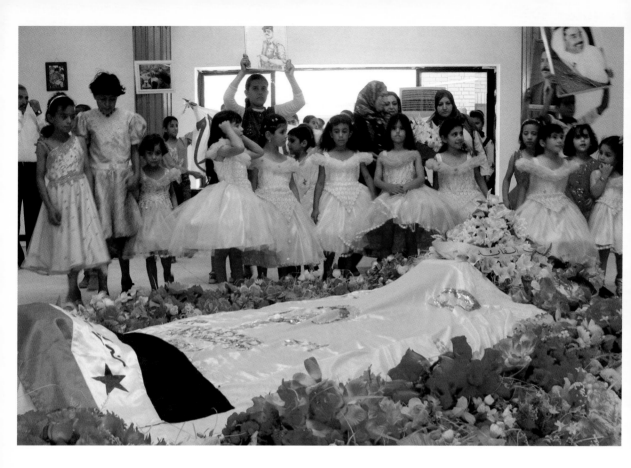

161 Tikrit, Iraq

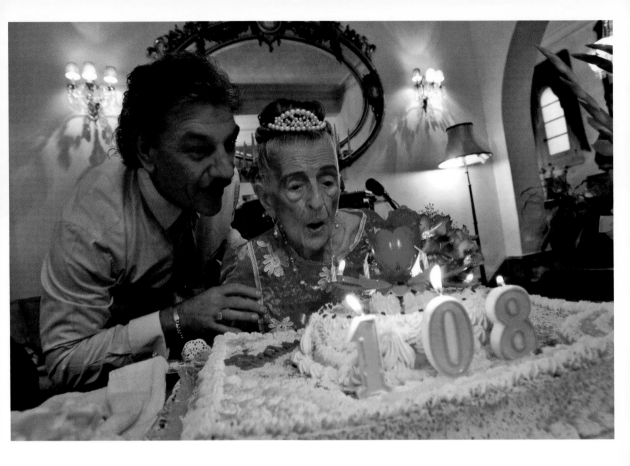

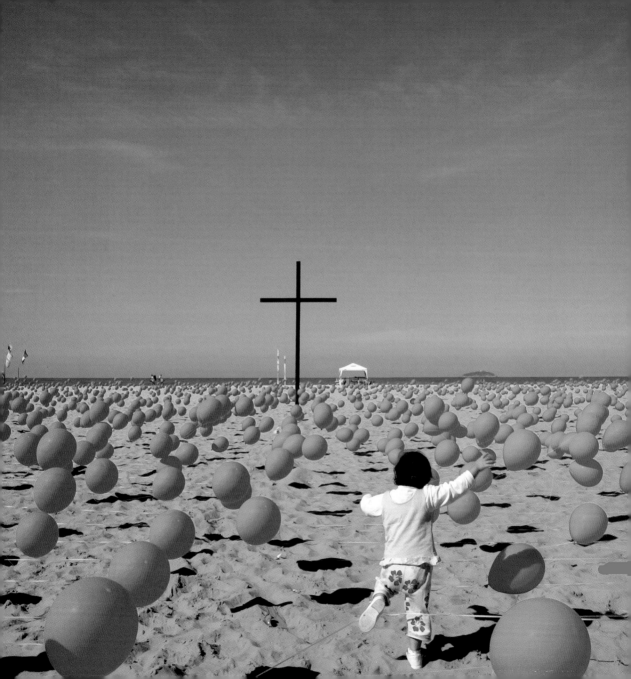

154 Performers from the U.S. dance company Shen Wei Dance Arts rehearse the ballet *Folding* in Budapest's Palace of Arts. 18 April 2008. Budapest, Hungary. Laszlo Balogh.

155 A model displays a creation during a fashion show in San Vittore prison in Milan. A group of fashion designers created the local cooperative 'Sartoria San Vittore' to help prisoners acquire job skills. Female inmates have learned tailoring from cooperative members and have made costumes for theatre and television. 14 May 2008. Milan, Italy. Stefano Rellandini.

156 A painting by Lucian Freud, entitled *Benefits Supervisor Sleeping*, is put on display at Christie's auction house in London. 11 April 2008. London, Britain. Alessia Pierdomenico.

157 A work by Belgian artist Guillaume Bijl, entitled *Het Nonneke Van Brugge*, is displayed at the opening of his retrospective exhibition at the S.M.A.K. modern art museum in Ghent. 4 April 2008. Ghent, Belgium. Yves Herman.

158 A monk exercises at St Yuri Monastery near Veliky Novgorod, 520 km (325 miles) northwest of Moscow. 16 April 2008. Veliky Novgorod, Russia. Mikhail Mordasov.

159 People walk past an artwork in a tunnel near Waterloo Station in London. The disused road tunnel was turned into a giant public exhibition space by secretive Bristol graffiti artist Banksy. It featured murals and other work by numerous leading graffiti artists. 23 June 2008. London, Britain. Finbarr O'Reilly.

160 A visitor walks across a floor pattern that forms part of the installation *The Wasteland* by Spanish artist Juan Muñoz (1953–2001), one of the exhibits in the show 'Juan Muñoz: A Retrospective' at the Guggenheim Museum in Bilbao. 26 May 2008. Bilbao, Spain. Vincent West.

161 Supporters and children celebrate ousted Iraqi leader Saddam Hussein's 71st birthday at his grave in the village of Awja near Tikrit, 175 km (110 miles) north of Baghdad. 28 April 2008. Tikrit, Iraq. Sabah al-Bazee.

162 Mary McCarthy celebrates her 108th birthday with her godson Elio Garcia at their home in Havana. The small fortune inherited by McCarthy when she was widowed in 1951 has been frozen in a Boston bank since 1959, when the United States placed Cuba under sanctions after Fidel Castro's revolution. 27 April 2008. Havana, Cuba. Claudia Daut.

163 A child plays near balloons on Copacabana beach. Peace activists released 4,000 red balloons to symbolize the number of predicted victims of violence in the city over the following six months. Rio is one of the most violent cities in the world, with heavily armed drug gangs controlling many of its slums and police responding with military-style invasions. 27 June 2008. Rio de Janeiro, Brazil. Sergio Moraes.

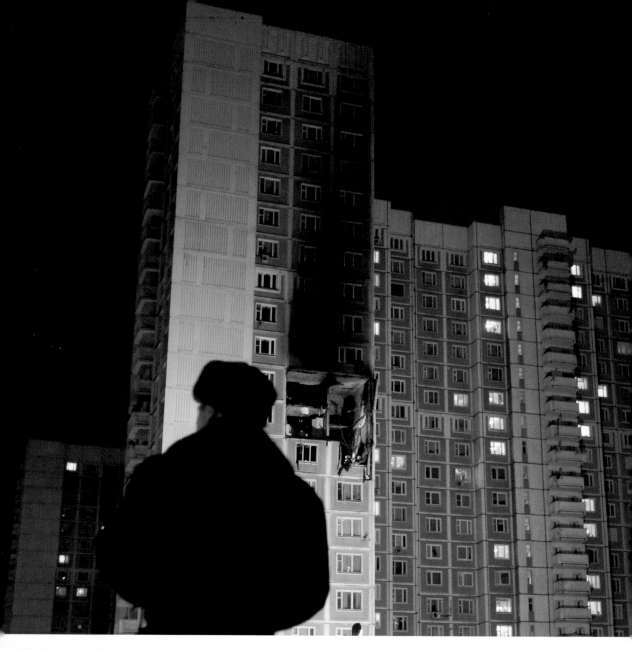

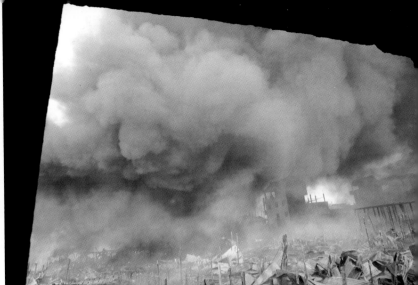

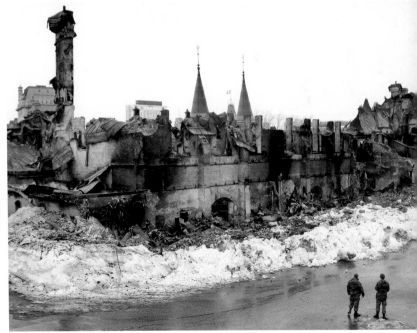

165 [TOP] Phnom Penh, Cambodia **166** [ABOVE] Quebec City, Canada

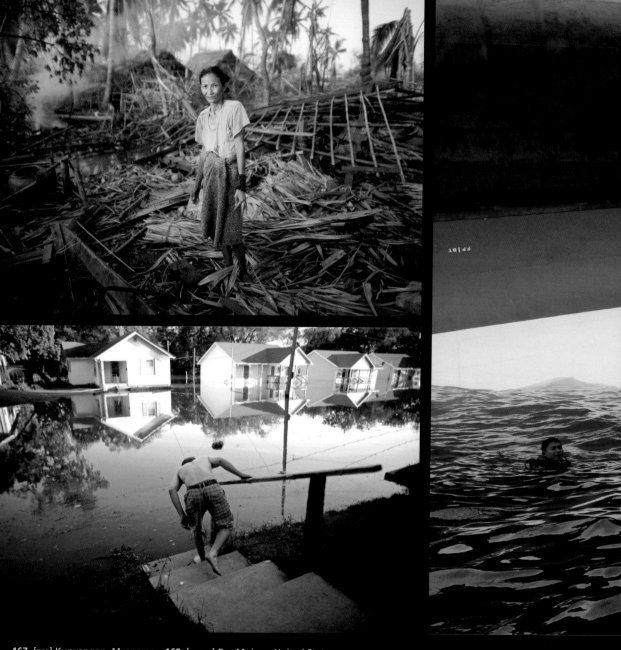

167 [TOP] Kunyangon, Myanmar **168** [ABOVE] Des Moines, United States

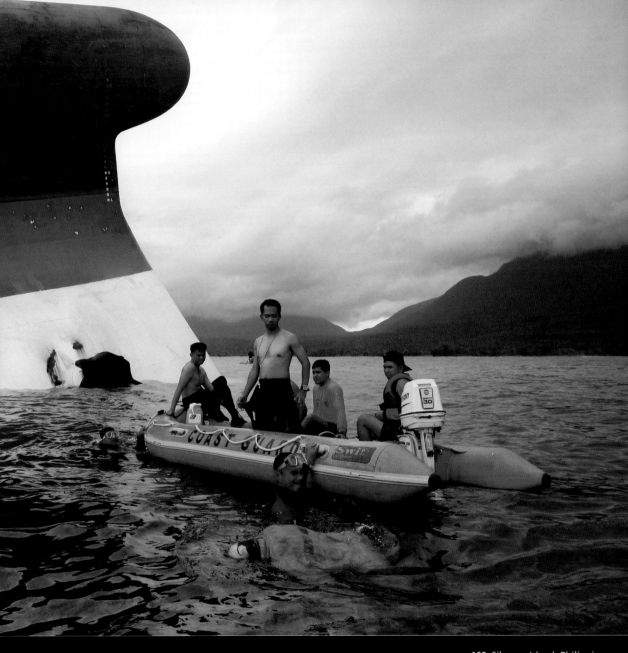

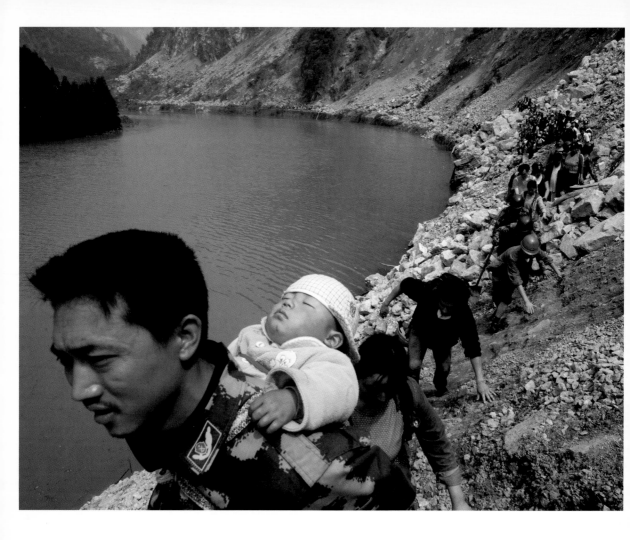

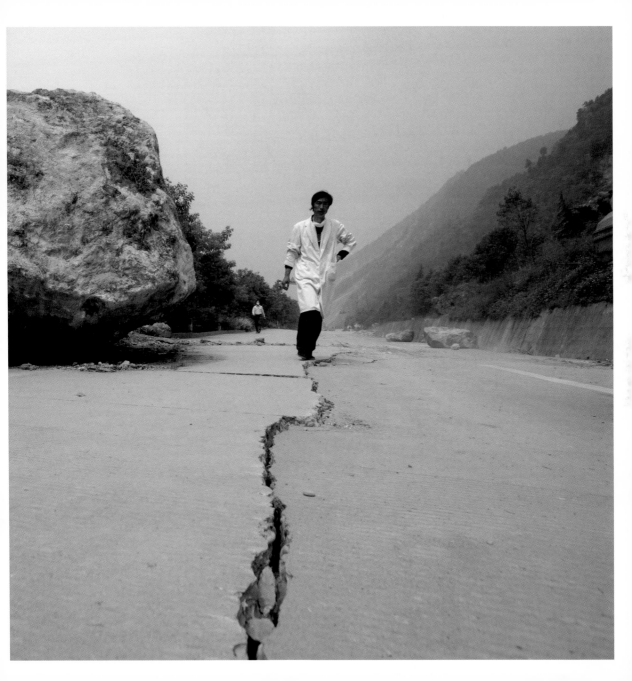

164 A police officer stands near a residential building in which a blast ripped apart the exterior walls of three apartments. At least three people were killed in the explosion which took place during maintenance work in one of the apartments, the RIA Novosti news agency reported. 4 April 2008. Moscow, Russia. Thomas Peter.

165 Smoke rises from burning houses in Phnom Penh. Several hundred people were affected by a huge blaze that hit the Rusey Koe district in the Cambodian capital, police said. 11 April 2008. Phnom Penh, Cambodia. Chor Sokunthea.

166 Soldiers pass the burned-out ruins of the historic Quebec City Armory, originally built in 1884. 5 April 2008. Quebec City, Canada. Mathieu Belanger.

167 A woman sifts through the debris of her destroyed home near Kunyangon, Myanmar. Cyclone Nargis ripped through Myanmar's Irrawaddy Delta and former capital, Yangon, on 2–3 May, smashing homes and flattening trees with 190 kph (120 mph) winds and a 3.5 metre (12 ft) sea surge. 9 May 2008. Kunyangon, Myanmar. Adam Dean.

168 Resident William Hood checks the water level in the Birdland neighbourhood of Des Moines, Iowa, after a levee holding back rising floodwaters broke and swamped Iowa's capital. The U.S. Midwest was hit in June by its worst flooding in 15 years. 14 June 2008. Des Moines, United States. Eric Thayer.

169 Coastguard divers retrieve a body from a capsized passenger ferry off Sibuyan Island, central Philippines. The ferry had more than 860 people on board when it flipped over in huge swells created by Typhoon Fengshen. Only 56 people survived. 24 June 2008. Sibuyan Island, Philippines. Romeo Ranoco.

170 An earthquake survivor carries his baby on his back as he and some 1,000 others make a 9-hour walk from the village of Qingping to Hanwang. Qingping, home to some 4,000 people, was left without water or electricity after an 8.0 magnitude earthquake struck Sichuan province on 12 May. 16 May 2008. Hanwang, China. Nir Elias.

171 A medical rescue worker walks past a fallen rock as he leaves the city of Beichuan, around 150 km (95 miles) north of Chengdu in Sichuan province. 16 May 2008. Beichuan, China. Bobby Yip.

172 A relative scans through a list of high school students in Beichuan who survived the earthquake in Sichuan province. 17 May 2008. Beichuan, China. Bobby Yip.

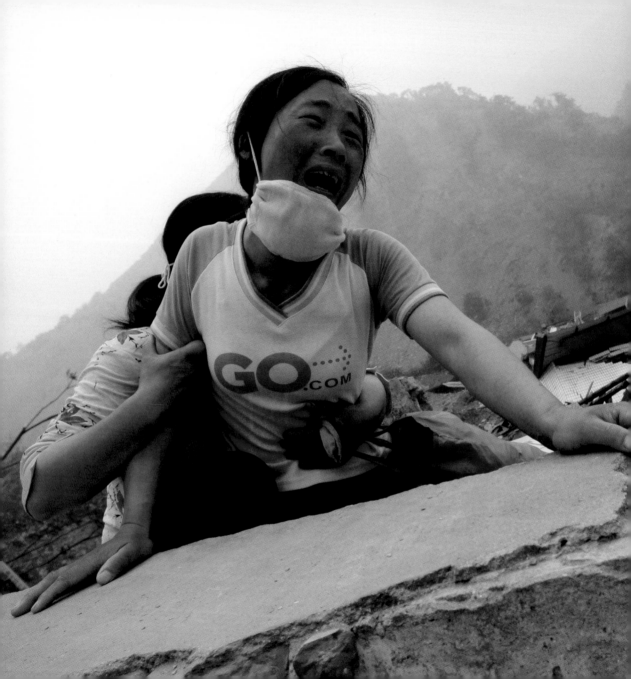

JASON LEE (Chinese name Li Jiangsong)
Photographer
Born: Sichuan, China, 1976
Based: Beijing, China
Nationality: Chinese

Heading home to disaster in Sichuan province

May 12, 2:28 p.m., almost all of my Reuters Beijing colleagues saw the office TV sets shaking. Those TV sets had often shown the news, but it was the first time they themselves had been the news. Within seconds, we realized it was an earthquake. An 8.0 magnitude earthquake had hit Sichuan province – my home. No more than 10 minutes later, I was driving to Beijing airport.

The next day I reached Hanwang town in Mianzhu, one of the first outsiders to arrive. Under gloomy skies and soft drizzle, it was like the end of the world. Terrified survivors pointed me in the direction of Hanwang Dongqi Middle School, saying it had been horribly damaged. It was unnaturally silent, the bodies of at least 20 students covered with plastic bags lying in a row on the ground. A mother gently removed the coverings trying to find her own child. The rain became heavier, the mourning louder. There was a choking smell of death.

On 15 May I set off for Beichuan. Here, amid a magnificent mountain landscape, was a valley of death. A landslide had almost buried the whole of the old district while the new part was just rubble, with fires flickering here and there. Once in a while there would be a shout of 'someone here!' as a survivor was located beneath the debris. At one collapsed kindergarten, I saw dozens of little faces almost untouched except for the dried blood rimming their eyes and mouths while the rest of their bodies were stuck beneath heavy rocks and concrete.

On 17 May, for the first time in my life, I felt the approach of death as I and more than 10,000 people ran for our lives. At around 2:55 p.m., a helicopter hovering overhead reported that a lake formed by landslides was about to burst its banks, and all rescue teams were ordered to retreat. All of a sudden everyone was running in complete terror – including me. After sprinting madly for 5 minutes, I realized what I was doing and turned back to record the scene with my cameras.

173 A woman cries as she fails to find her four-year-old daughter and husband in the ruins of a destroyed school in earthquake-hit Beichuan, Sichuan province. 17 May 2008.

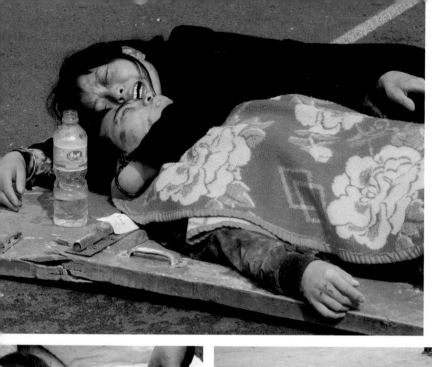
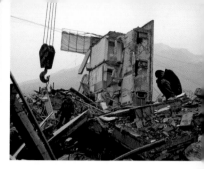
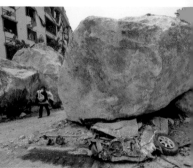

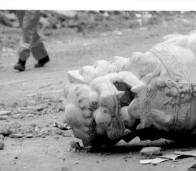
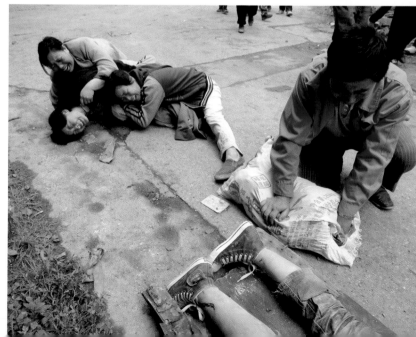

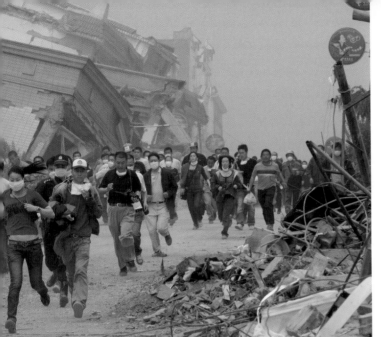

	175	
174		180
	176	
177		
	179	181
178		

174 A mother cries as she holds the body of her son in the playground of a school in Hanwang town, Mianzhu county. 14 May 2008. **175** A man cries next to a rescue worker on the roofs of destroyed houses in Hanwang town. 13 May 2008. **176** A survivor walks past a huge rock that crushed a car on a road near a mountain in the centre of earthquake-hit Beichuan county. 16 May 2008. **177** A rescue worker in Hanwang town cuts a lock of hair from the body of an elderly woman for identification purposes. 14 May 2008. **178** A rescue worker walks past a stone lion lying in a street in Beichuan. 17 May 2008. **179** Relatives cry next to the recovered body of a student in Hanwang town. 14 May 2008. **180** Residents and rescue workers flee amid fears a lake will burst its banks in Beichuan, near the earthquake's epicentre. 17 May 2008. **181** Parents holding portraits of their dead children attend a memorial service at the destroyed Fuxing primary school in Wufu town, Mianzhu county. 21 May 2008.

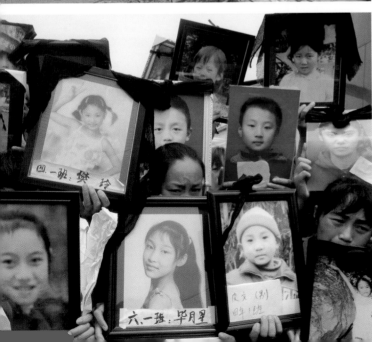

WITNESS

3

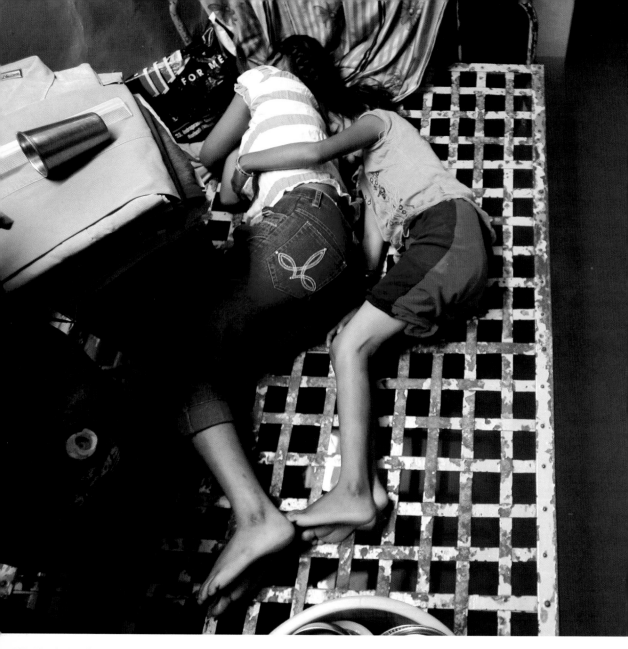

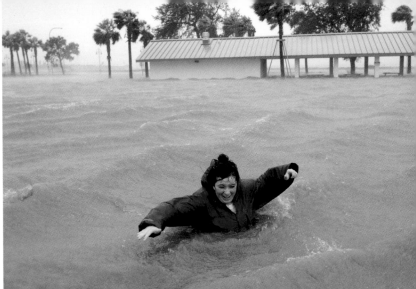

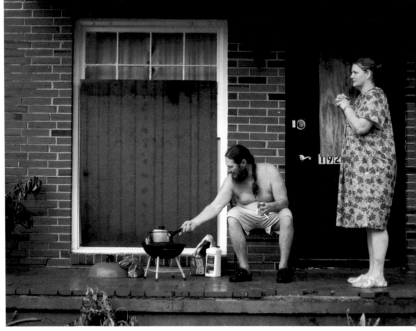

183 [TOP] New Orleans, United States **184** [ABOVE] Galveston, United States

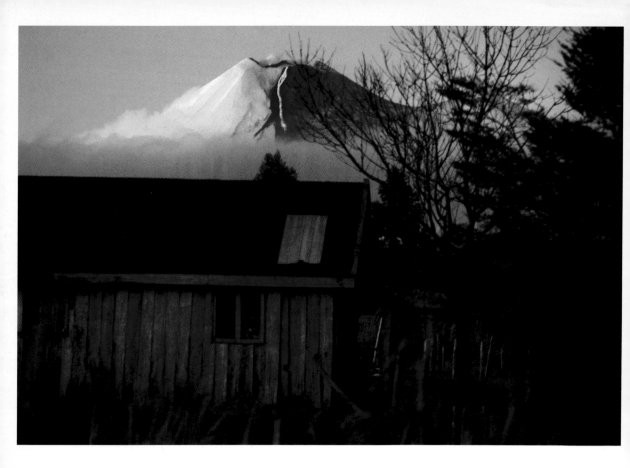

185 Cherquenco, Chile

186 [OPPOSITE] Woburn, United States

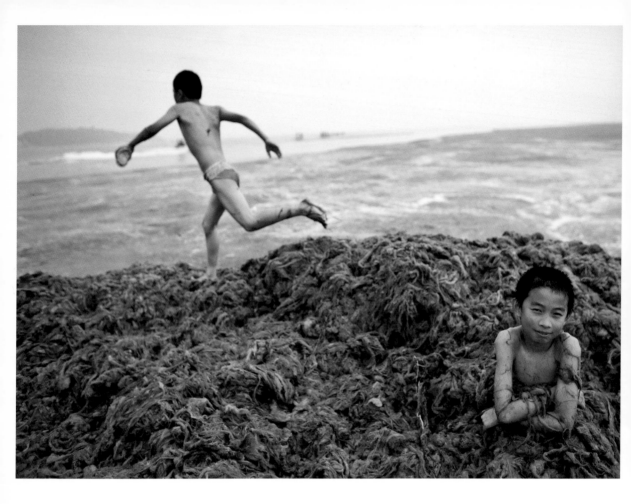

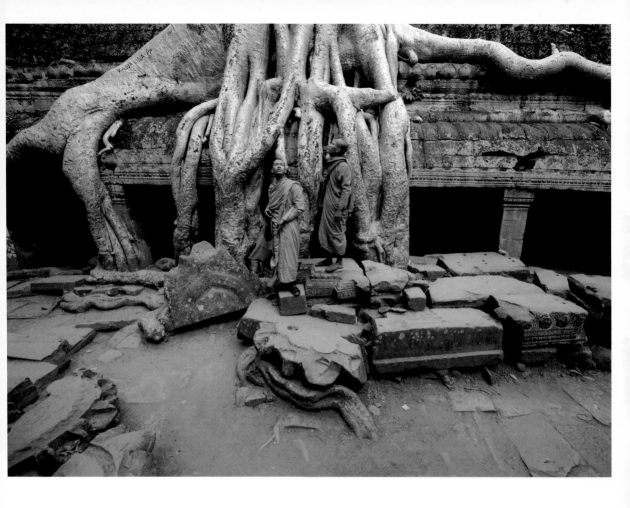

182 Children sleep inside their flooded house after a heavy monsoon downpour in Mumbai which flooded streets and disrupted transport, as city officials advised citizens to stay indoors. 1 July 2008. Mumbai, India. Punit Paranjpe.

183 Sarah Salley of New Orleans wades through floodwaters on the New Orleans lakefront after Hurricane Gustav came ashore as a Category 2 hurricane near Cocodrie, Louisiana. 1 September 2008. New Orleans, United States. Dave Martin.

184 Rick Schattel and his wife Jody cook outside their flooded house in Galveston, Texas. Hurricane Ike roared ashore on 13 September near Houston, the U.S. energy hub. The powerful storm displaced thousands of Texans, left millions without electricity, and devastated the historic resort town of Galveston. 14 September 2008. Galveston, United States. Carlos Barria.

185 The Llaima volcano spewing lava is seen on the horizon from the town of Cherquenco, Chile, 18 km (11 miles) away. Llaima is one of South America's most active volcanoes. 2 July 2008. Cherquenco, Chile. Ivan Alvarado.

186 A metal liner is fed down the chimney as a pellet stove is installed at a home in Woburn, Massachusetts. Record prices for home heating oil in 2008 boosted demand in the United States for wood stoves and other alternatives, forcing some traditional heating oil companies out of business. 10 July 2008. Woburn, United States. Brian Snyder.

187 Boys play on a pile of algae on a beach in Qingdao, Shandong province. A massive and unsightly bloom of more than 1 million tonnes of algae appeared in June off the rocky beaches of Qingdao, the city scheduled to host the sailing events in the Beijing 2008 Olympics. Thousands of troops and volunteers were mobilized for the clean-up. 6 July 2008. Qingdao, China. Nir Elias.

188 Buddhist monks stand beside massive tree roots growing over the Ta Prohm temple near Angkor Wat in Siem Reap, Cambodia. 25 July 2008. Siem Reap, Cambodia. Adrees Latif.

189 A visitor places her hands on a digital globe displaying real-time meteorological data from some 300 locations across the world. The globe was part of an exhibition staged in the media centre for the annual G8 summit being held in Rusutsu town, on Japan's northern island of Hokkaido. 6 July 2008. Rusutsu, Japan. Yuriko Nakao.

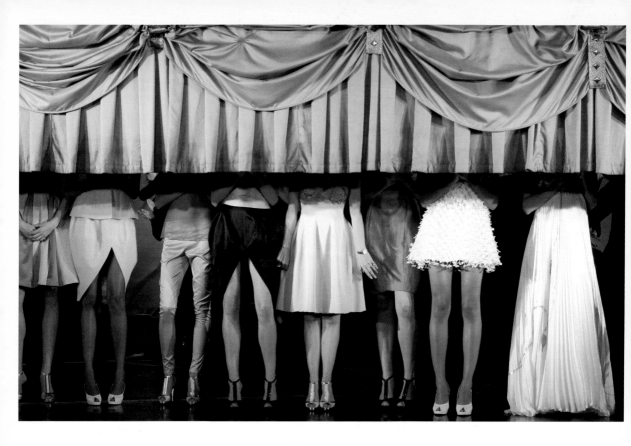

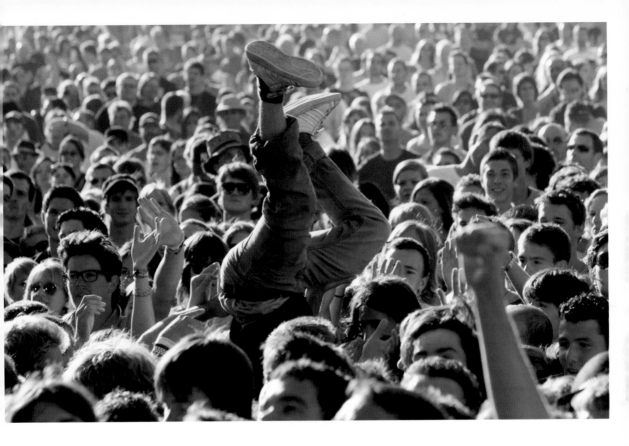

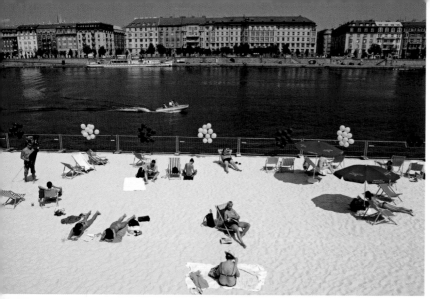

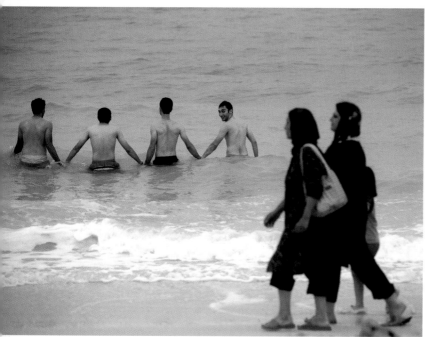

192 [TOP] Prague, Czech Republic **193** [ABOVE] Kish, Iran

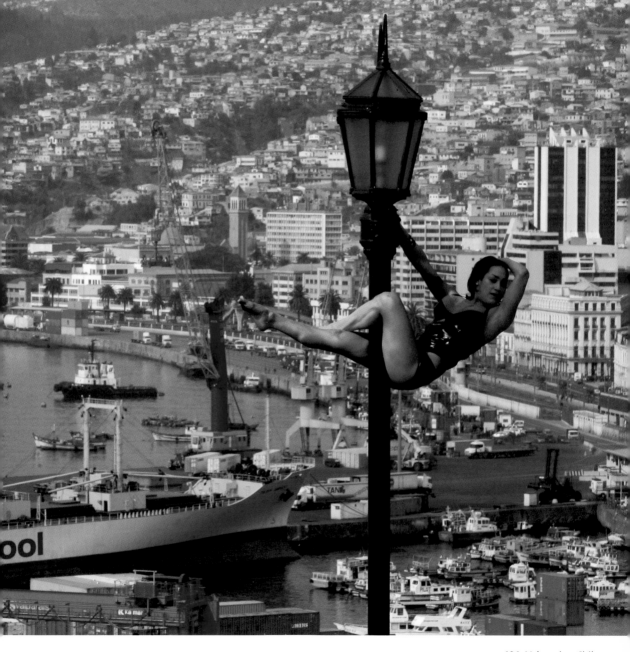

194 Valparaiso, Chile

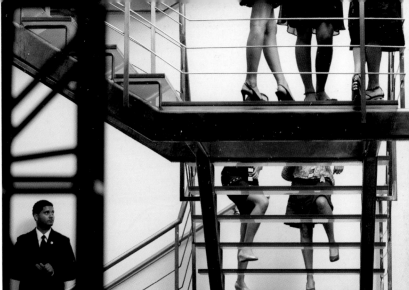

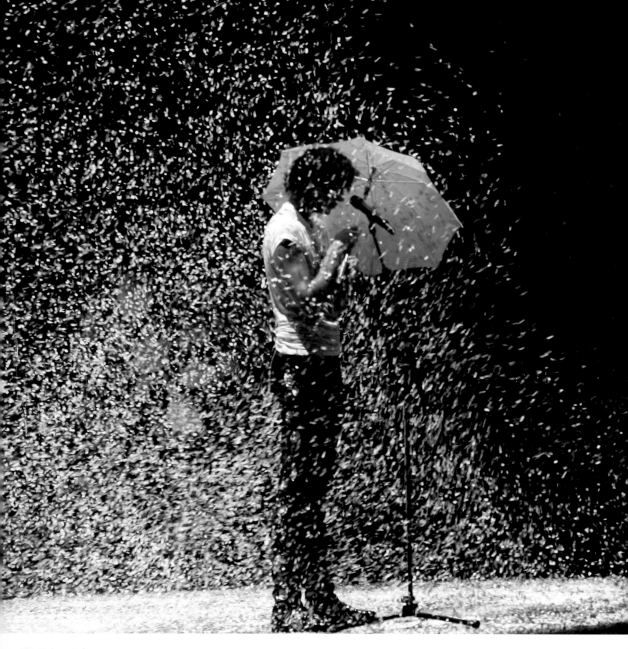

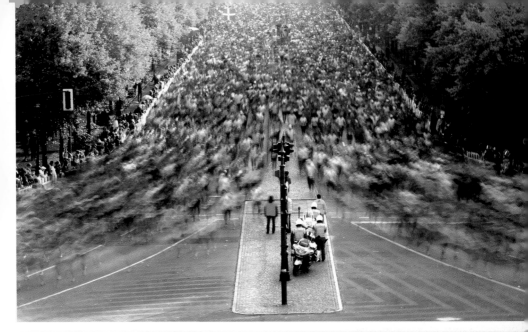

199 [TOP] Berlin, Germany **200** [ABOVE] New York, United States

190 191 192 193 194 195

196 197 198 199 200 201

Models line up at the end of Portuguese designer Fatima Lopes' Spring/Summer 2009 show in Paris. 27 September 2008. Paris, France. Benoit Tessier.

A festival-goer falls after being lifted by members of the crowd during the Paléo Music Festival in Nyon, Switzerland. 22 July 2008. Nyon, Switzerland. Denis Balibouse.

People sunbathe on an artificial city beach installed in central Prague, as temperatures rose to over 30 degrees Celsius (86 degrees Fahrenheit). 2 July 2008. Prague, Czech Republic. Petr Josek.

Two Iranian women walk along a beach on the island of Kish in the Persian Gulf as men swim. 4 August 2008. Kish, Iran. Morteza Nikoubazl.

Stripper Monserrat Morilles performs on a lamp post in the Chilean city of [Valparaiso. Morilles says her public ...]

195 Kristina Powis, a student, introduces herself on camera at the new Reality Television School in New York. The school caters to the growing number of people on both sides of the Atlantic seeking training to help them get on reality TV. 8 July 2008. New York, United States. Lucas Jackson.

196 A security guard watches women ascend a glass staircase at the Chelsea Art Museum prior to the Catherine Malandrino Spring 2009 show during New York Fashion Week. 8 September 2008. New York, United States. Lucas Jackson.

197 A flight attendant poses behind the bar in the business class section of Emirates' Airbus A380 after the jet touched down at John F. Kennedy International Airport in New York. Its arrival marked the first commercial landing of the giant, double-decker passenger plane on U.S. soil. 1 August 2008. New York, United States. Chip East.

198 Lebanon-born British singer Mika performs during a concert in downtown Beirut organized by the Beiteddine and Baalbeck International Festivals. 27 July 2008. Beirut, Lebanon. Issam Abdallah.

199 Runners pass the Brandenburg gate at the start of the 35th Berlin marathon. 28 September 2008. Berlin, Germany. Pawel Kopczynski.

200 A New York Yankees fan takes a picture before the start of the final regular season MLB American League baseball game at Yankee Stadium in New York. 21 September 2008. New York, United States. Gary Hershorn.

201 A man gestures after successfully purchasing tickets for the Olympic Games. Having waited in the summer heat for hours, in some cases days, tens of thousands of Chinese shouted pushed and shoved for their last chance at Olympic tickets after they [...]

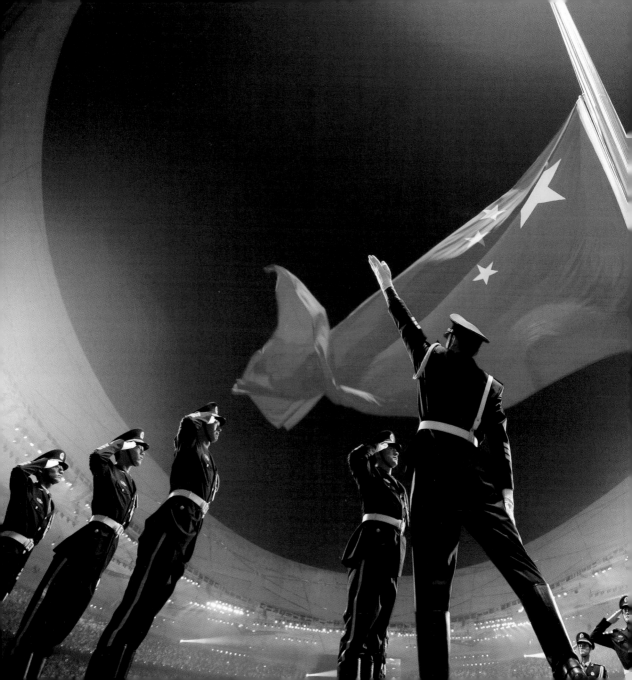

TOM SZLUKOVENYI
Global Editor, Pictures
Born: 1951, Budapest, Hungary
Based: London, Britain
Nationality: Hungarian

The long race to Beijing 2008

How do you organize a job with 50 photographers and 20 editors covering the equivalent of 38 world championships running practically simultaneously when you are committed to producing the best, world-beating coverage?

Welcome to the Summer Olympics, one of the toughest but most rewarding events for photographers and photo editors alike. Not only must we capture all the major moments of the Games, but we also aim to produce the great 'different' defining images. The groundwork starts four years ahead. Editors spend months and months going through every detail in advance, hugely experienced senior photographers add their expertise to the planning process, and the team of editors and photographers, a mixture of youth and experience, is pulled together. The Olympics is the ultimate team job.

The biggest stories of Beijing 2008 were of course Michael Phelps winning a record eight gold medals and Usain Bolt destroying sprint world records with unbelievable ease, but we also produced hundreds of outstanding images capturing all facets of this spectacular two-week event. A supremely talented group of photographers and editors was our main asset, but technology is also changing the way we work. Remote-editing software that allows editors to see images stream in live from the photographers' cameras combined with direct injection to clients meant that our pictures were delivered so fast as to be 'near live'. The men's 100 metre final started at 22:30 p.m. and the first image of Bolt celebrating his world record was with clients at 22:33:19 p.m. This was possible only through the great team work of 13 photographers, two primary editors and four processors working in the Olympic stadium.

With the photographers producing around 30,000 images a day, editors had to work like manic video gamers in order to get a daily selection of 1,200–1,400 images to our clients. Working 14–16 hours a day, we were soon living in a daze of exhaustion. But our reward was great – front pages around the world using our images to tell the story of the Games.

202 China's national flag is raised during the opening ceremony of the Beijing 2008 Olympic Games in the city's National Stadium, known as the Bird's Nest.
8 August 2008. Beijing, China. Jerry Lampen.

WITNESS

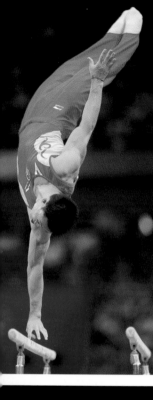
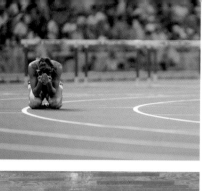
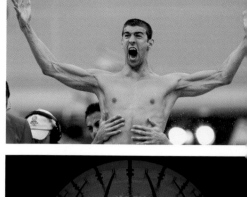

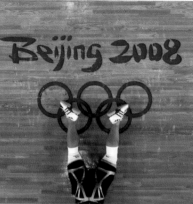
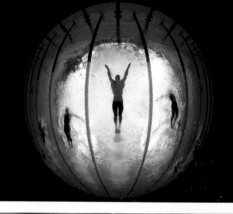
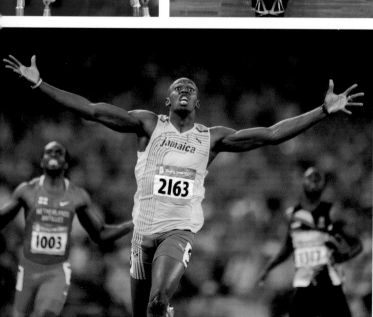

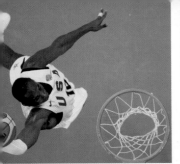

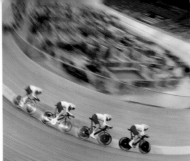

203	204	205	210	211
	206	207	212	
208		209	213	

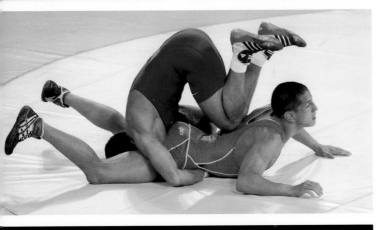

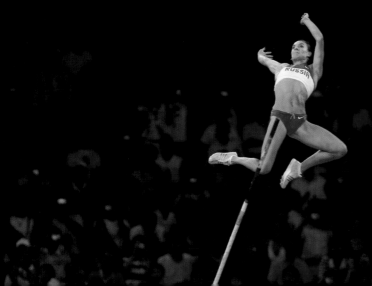

203 Yang Wei of China competes in the parallel bars of the men's team artistic gymnastics final. 12 August 2008. Mike Blake. **204** Lolo Jones of the U.S. reacts after coming seventh in the women's 100m hurdles final. 19 August 2008. Dylan Martinez. **205** Michael Phelps and Garrett Weber-Gale of the U.S. celebrate after winning the men's 4x100m freestyle relay swimming final. 11 August 2008. David Gray. **206** Lee Bae-young of South Korea falls as he fails to lift 186kg during the men's 69kg clean and jerk weightlifting competition. 12 August 2008. Yves Herman. **207** Michael Phelps (centre) swims the butterfly stroke in the men's 4x100m medley relay. 17 August 2008. Wolfgang Rattay. **208** Usain Bolt of Jamaica celebrates winning the men's 200m final with a new world record of 19.30 seconds. 20 August 2008. Dylan Martinez. **209** Bolt's shoe is seen untied after he won the men's 100m final in a world record time of 9.69 seconds. 16 August 2008. Gary Hershorn. **210** Kobe Bryant of the U.S. slam dunks against China during their Group B men's basketball game. 10 August 2008. Lucy Nicholson. **211** The British team pursuit quartet set a new world record as they qualify for the final of the track cycling event. 17 August 2008. Phil Noble. **212** Jake Deitchler of the U.S. (in red) fights Armen Vardanyan of Ukraine during the 66kg men's Greco-Roman wrestling competition. 13 August 2008. Dylan Martinez. **213** Yelena Isinbayeva of Russia competes in the women's pole vault final, where she broke her own world record with a vault of 5.05 metres. 18 August 2008. Mike Blake.

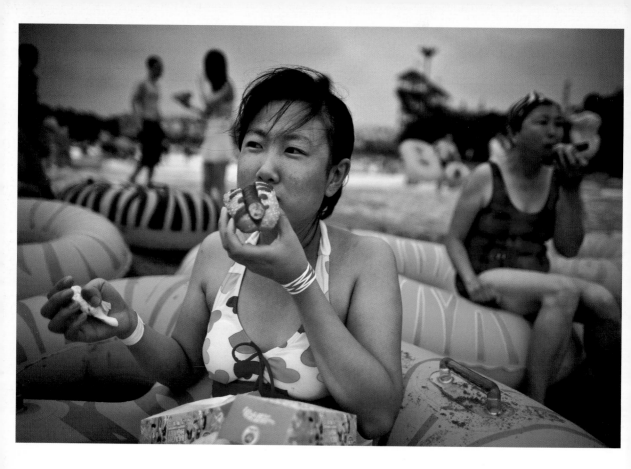

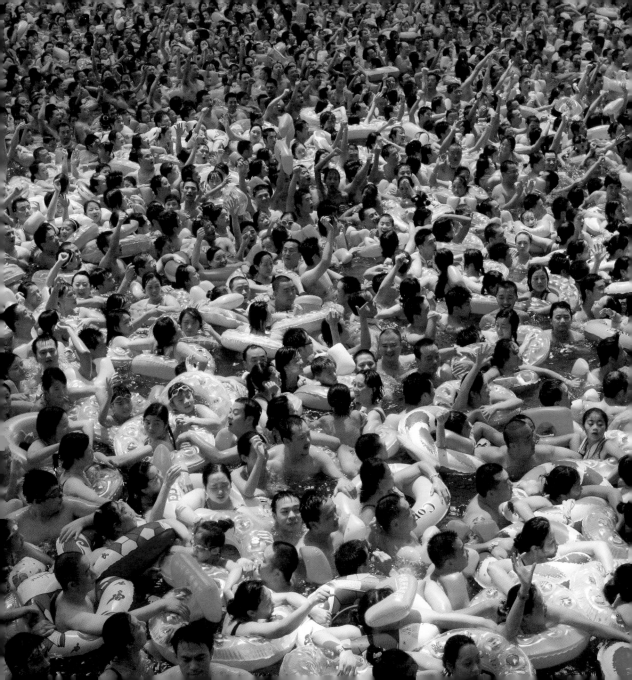

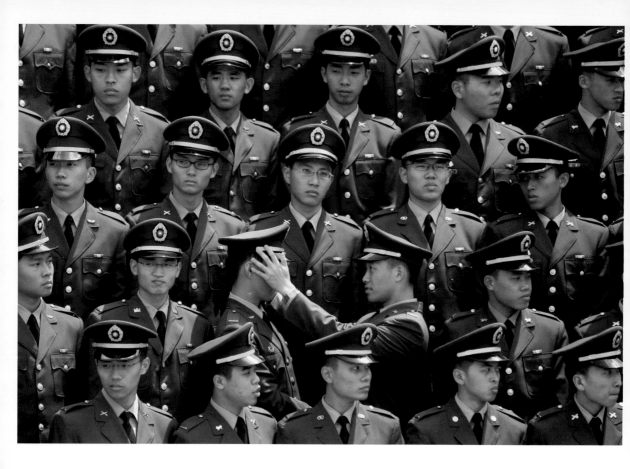

216 Kaohsiung, Taiwan

219 [TOP] **220** [ABOVE] Venice, Italy

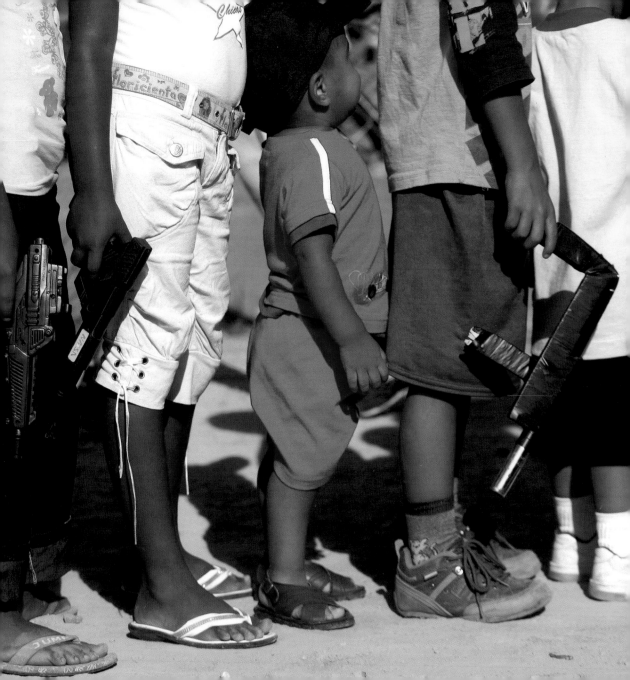

221 [OPPOSITE] Caracas, Venezuela

222 Montevideo, Uruguay

214 A woman eats a hotdog at Shanghai's Dino Beach, also known as the 'Fake Beach', one of the biggest water parks in Asia. 19 July 2008. Shanghai, China. Nir Elias.

215 Residents crowd a swimming pool in Suining, in China's Sichuan province, as the temperature reached 37 degrees Celsius (98.6 degrees Fahrenheit). 27 July 2008. Suining, China. Zhong Min.

216 A graduate of the Taiwanese Military Academy adjusts the hat of his colleague while preparing for a group photo. 2 July 2008. Kaohsiung, Taiwan. Pichi Chuang.

217 Motorcycle fuel tanks are exhibited on a wall during the grand opening of the Harley-Davidson Museum in Milwaukee. The museum showcases more than a century of the company's history. 12 July 2008. Milwaukee, United States. Finbarr O'Reilly.

218 A detail from a spectator's striped jacket is seen during the Henley Royal Regatta in Henley-on-Thames, west of London. 2 July 2008. Henley-on-Thames, Britain. Eddie Keogh.

219 British actress Tilda Swinton arrives at the Venice Film Festival. 28 August 2008. Venice, Italy. Max Rossi.

220 A gondolier cools off in 32 degree Celsius (90 degree Fahrenheit) heat by sitting in a garden chair in the Grand Canal in Venice. 5 August 2008. Venice, Italy. Manuel Silvestri.

221 Children queue in the Petare district of Caracas to exchange their toy guns for non-weapon toys as part of a government project to reduce violence in the area. 20 August 2008. Caracas, Venezuela. Susana Gonzalez.

222 First-grade students in Villa Garcia, a poor neighbourhood in the outskirts of Montevideo, use their XO laptop computers in the classroom. The Uruguay government is implementing a project to provide one free XO laptop to every public school student in the country. 22 August 2008. Montevideo, Uruguay. Andres Stapff.

223 Workers clean the sculpture *Balloon Dog* by U.S. artist Jeff Koons ahead of the opening of an exhibition of his work at the Palace of Versailles near Paris. 9 September 2008. Versailles, France. Benoit Tessier.

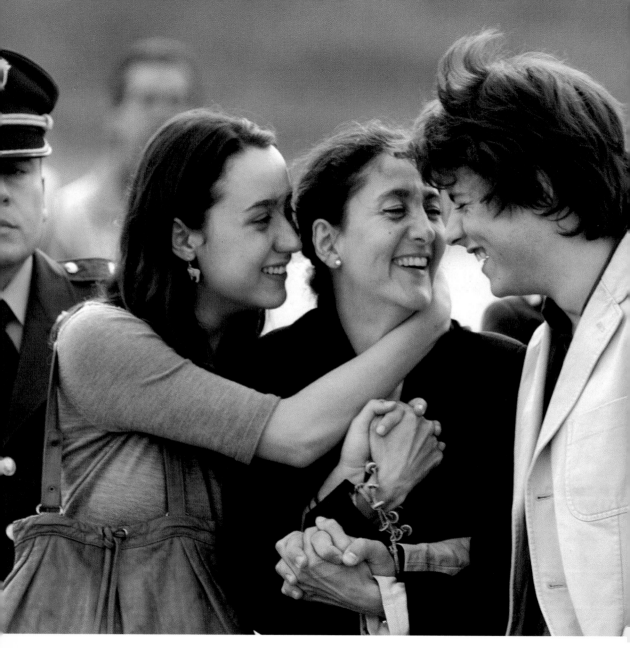

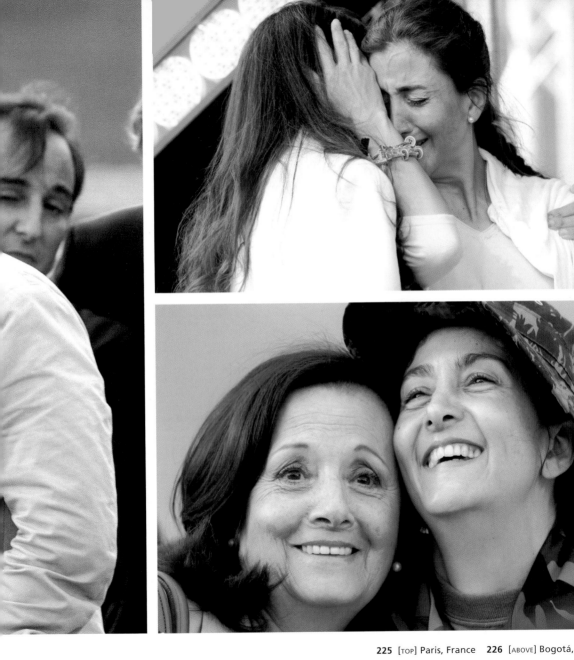

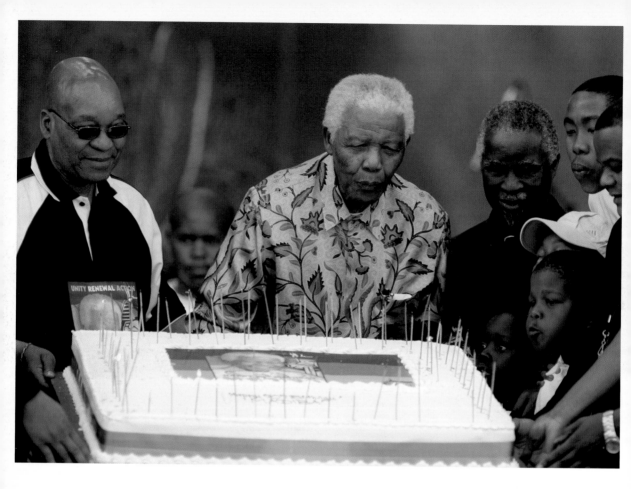

227 Pretoria, South Africa

228 [OPPOSITE] Havana, Cuba

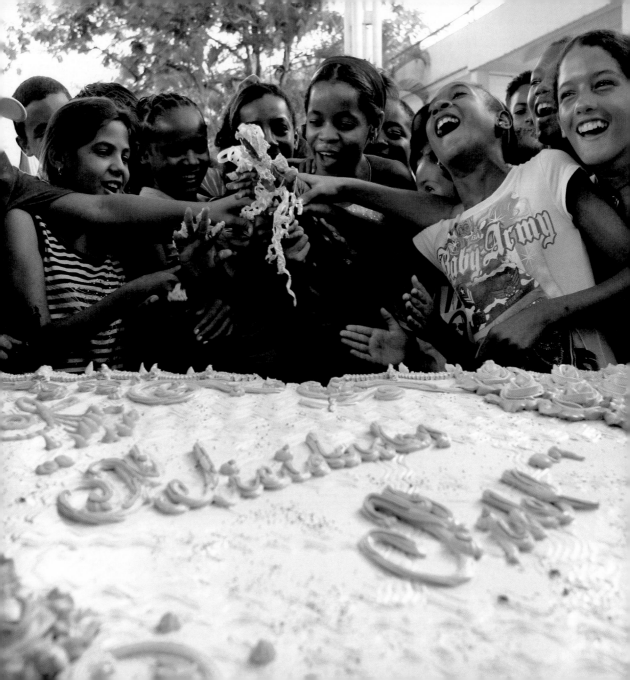

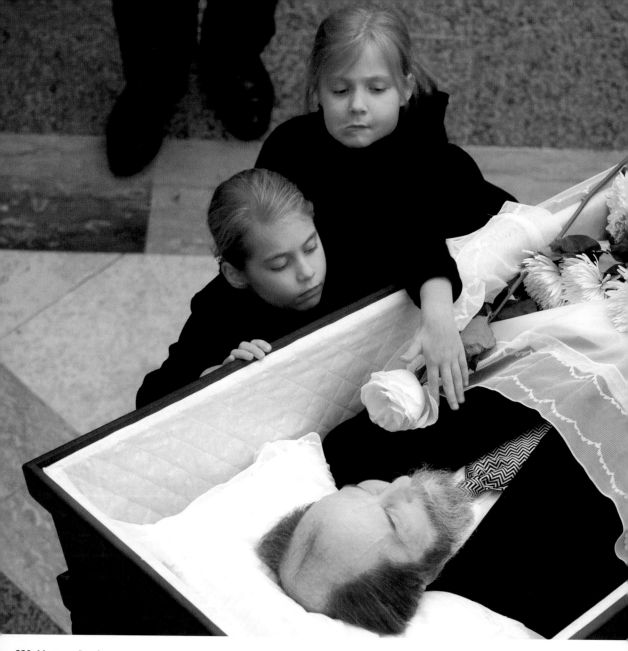

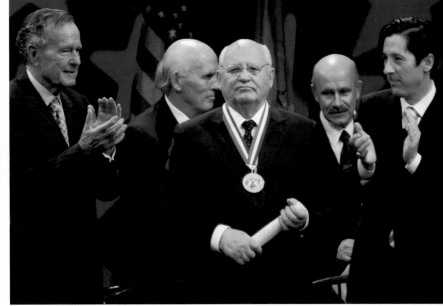

230 [TOP] Tbilisi, Georgia **231** [ABOVE] Philadelphia, United States

232 Belgrade, Serbia

233 [TOP] The Hague, Netherlands 234 [ABOVE] Tuzla, Bosnia

224 French–Colombian politician Ingrid Betancourt (centre) is pictured with her children Melanie and Lorenzo at Catam military airport in Bogotá. Betancourt was rescued with 14 other hostages on 2 July by Colombian troops posing as aid workers. She had been held for six years in jungle hide-outs by the Revolutionary Armed Forces of Colombia or FARC. 3 July 2008. Bogotá, Colombia. Jorge Silva.

225 Ingrid Betancourt (right) cries next to her sister Astrid during a concert in Paris to remember hostages still detained by guerrillas in Colombia and elsewhere. 20 July 2008. Paris, France. Vincent Kessler.

226 Ingrid Betancourt (right) hugs her mother Yolanda Pulecio after her arrival in Bogotá. 2 July 2008. Bogotá, Colombia. Carlos Duran.

227 African National Congress President Jacob Zuma (left) and then president of South Africa Thabo Mbeki (right) look on as former president Nelson Mandela blows out candles on a cake during a rally in Pretoria to celebrate Mandela's 90th birthday. 2 August 2008. Pretoria, South Africa. Siphiwe Sibeko.

228 Children prepare to cut a birthday cake for 82-year-old retired Cuban leader Fidel Castro at the Pioneer's Palace in Havana. Castro has not been seen in public since 2006. 13 August 2008. Havana, Cuba. Claudia Daut.

229 Grandchildren of Alexander Solzhenitsyn bid farewell at the coffin of the writer, Nobel Laureate and Soviet dissident, in the Academy of Science in Moscow. 5 August 2008. Moscow, Russia. Sergei Karpukhin.

230 French President Nicolas Sarkozy (left) talks to his Georgian counterpart Mikheil Saakashvili during a joint news conference in Tbilisi. 13 August 2008. Tbilisi, Georgia. David Mdzinarishvili.

231 Former Soviet leader Mikhail Gorbachev is presented with the 2008 Liberty Medal by former U.S. President George H.W. Bush (left) and Constitution Center CEO and President Joe Torsella (right) at the National Constitution Center in Philadelphia. The award recognizes leadership and vision in the pursuit of freedom from oppression, ignorance or deprivation. 18 September 2008. Philadelphia, United States. Tim Shaffer.

232 Supporters of Partizan Belgrade wave a flag bearing former Bosnian Serb leader Radovan Karadzic's picture during a friendly soccer match against Olympique Lyon in Belgrade. 23 July 2008. Belgrade, Serbia. Ivan Milutinovic.

233 Radovan Karadzic stands in the court room of the International Criminal Tribunal for the Former Yugoslavia in The Hague. Arrested on 21 July after 11 years on the run, Karadzic faced a U.N. war crimes judge for the first time to answer charges of genocide for his actions in the 1992–95 Bosnia war. 31 July 2008. The Hague, Netherlands. Jerry Lampen.

234 Sitting under pictures of victims of the genocide, Bosnian Muslim women from Srebrenica watch Karadzic's court appearance on television. 31 July 2008. Tuzla, Bosnia. Damir Sagolj.

235 Syrian President Bashar al-Assad (left) and his Iranian counterpart Mahmoud Ahmadinejad listen to the Syrian national anthem during a welcoming ceremony in Tehran. 2 August 2008. Tehran, Iran. Morteza Nikoubazl.

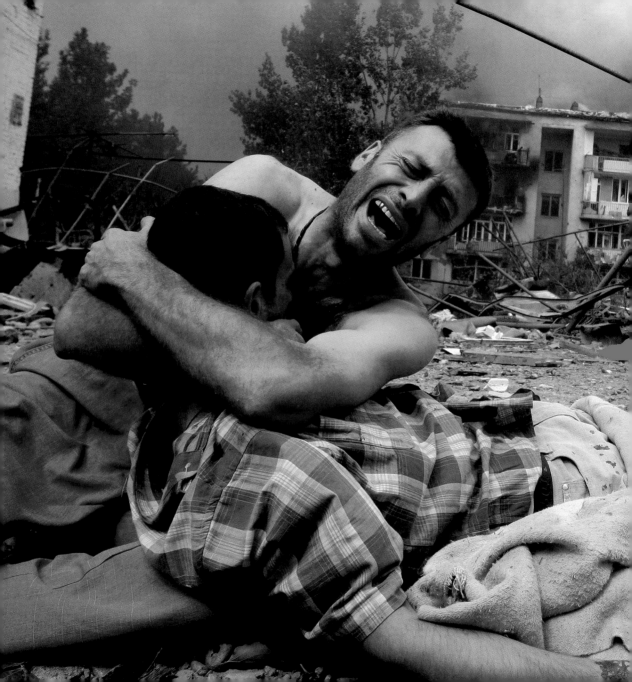

GLEB GARANICH
Photographer
Born: 1969, Sakhalin Island, Russia
Based: Kiev, Ukraine
Nationality: Ukrainian

Conflict in close-up

I landed in Tbilisi around midnight on 8 August, the day Russia sent in forces to repel a Georgian assault on the breakaway region of South Ossetia. Travelling to Gori early the next day along with a Reuters TV crew, we found the central square packed with thousands of reservists awaiting orders to head off to fight. Things were very tense. We took pictures of the crowd and decided to make our way towards Tskhinvali, capital of South Ossetia.

First off was Tbilisi photographer David Mdzinarishvili, equipped with a walkie-talkie I had brought to make up for poor telephone communications. Within 10 minutes, David was shouting down the line that a Russian bombardment was under way on the outskirts of Gori. Rushing to the site, we found many buildings on fire. Georgian soldiers were escorting the wounded out of apartment buildings and carrying away bodies covered in blankets. Entering a courtyard, I came upon a man weeping uncontrollably over a body. Georgian servicemen tried to help him and cover the corpse but in his grief he refused to allow anyone to approach, hurling his mobile phone at the soldiers. Eventually he was calmed down by neighbours and soldiers, and the body carried away.

We returned to the press centre in Gori and filed our pictures. Next morning they had been published on hundreds of front pages around the world. Only weeks later did I learn from an investigation by German journalists from *Bild am Sonntag* that the two men were brothers: Zaza Rasmadze (35), holding his brother Zviadi (33).

The next major task for our team was to depict the plight of thousands of refugees desperately trying to escape the bombardments and the Russian advance. I visited shelters in Tbilisi set up in buildings that once housed the Soviet military command in the Caucasus. Entire families were crammed into barren rooms with virtually no amenities, sleeping, preparing meals and trying to kill time while their children tried hard to amuse themselves by racing up and down darkened corridors.

I spent two and half weeks in Georgia. Russia moved its forces to within an hour of Tbilisi, but eventually agreed to pull out after a settlement brokered by France and the European Union – and I returned to Kiev.

236 Georgian Zaza Rasmadze holds the body of his brother Zviadi, killed in a Russian bombardment in Gori, 80 km (50 miles) from the Georgian capital Tbilisi. 9 August 2008.

WITNESS

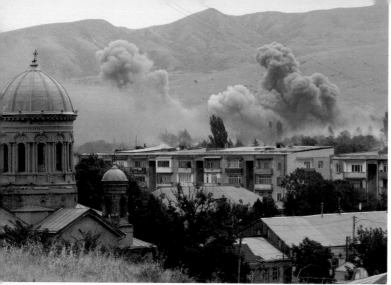

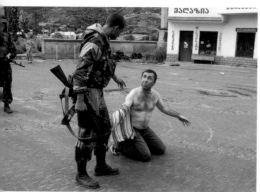
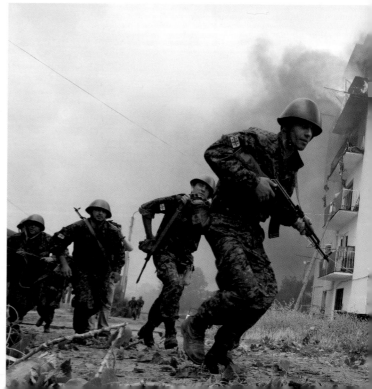

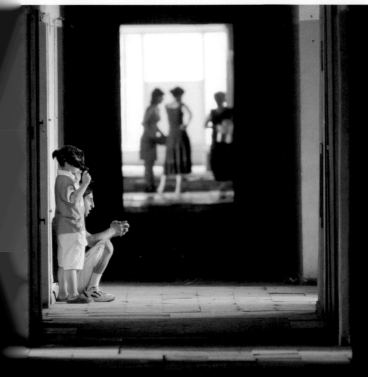

237	238
239	
241	242
240	

237 Smoke is seen over buildings after Russian aerial bombardment in Gori, Georgia, near the breakaway region of South Ossetia. 9 August 2008. **238** Major-General Vyacheslav Borisov, Russian commander in the Gori region, escorts Georgian refugees out of the conflict zone. 17 August 2008. **239** Russian soldiers detain a man who was found with a weapon in his car at a checkpoint in Gori. 14 August 2008. **240** People leave Gori. 13 August 2008. **241** Georgian soldiers run near a blazing apartment block in Gori. 9 August 2008. **242** Refugees from the conflict zone stand in a refugee shelter in Tbilisi. 23 August 2008.

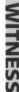

WITNESS

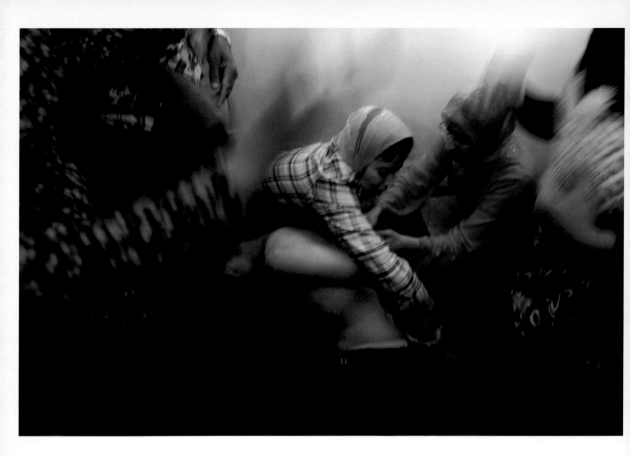

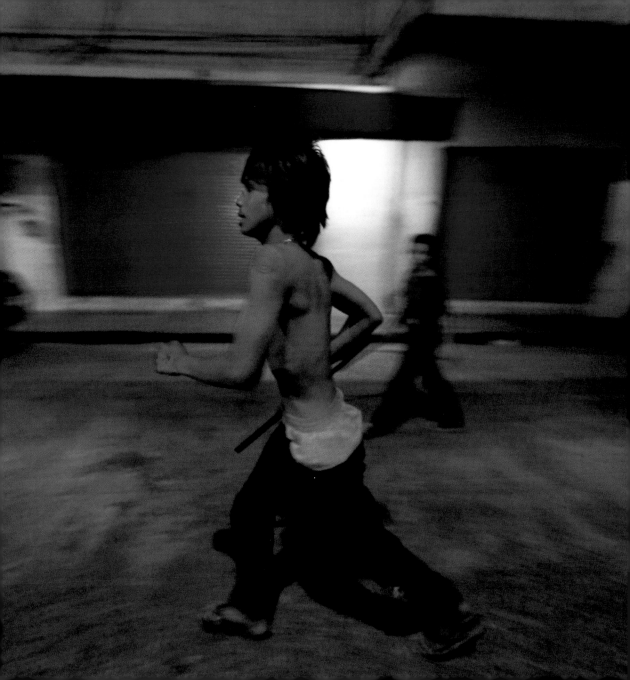

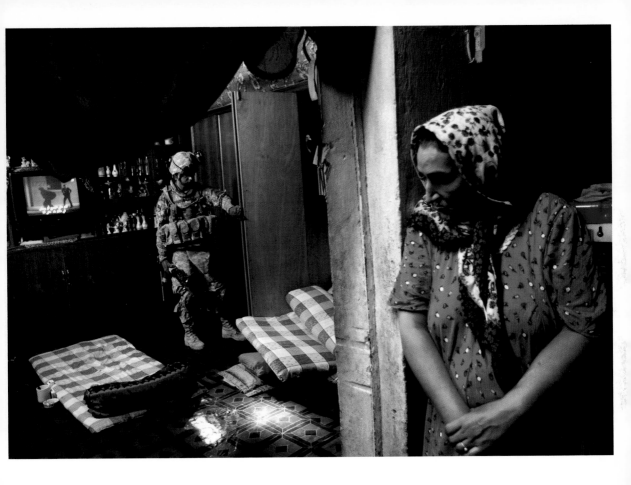

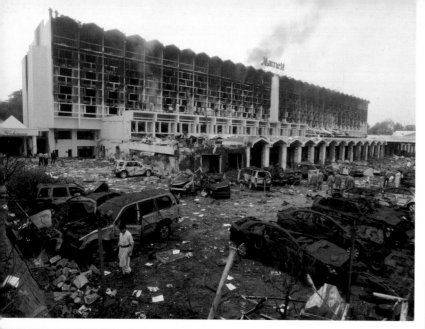

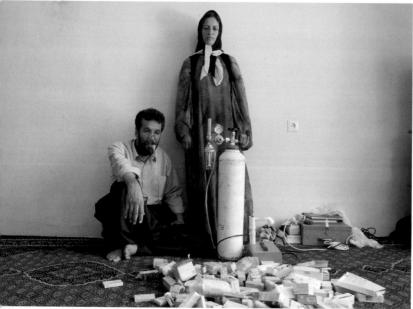

249 [TOP] Islamabad, Pakistan **250** [ABOVE] Nowdesheh, Iran

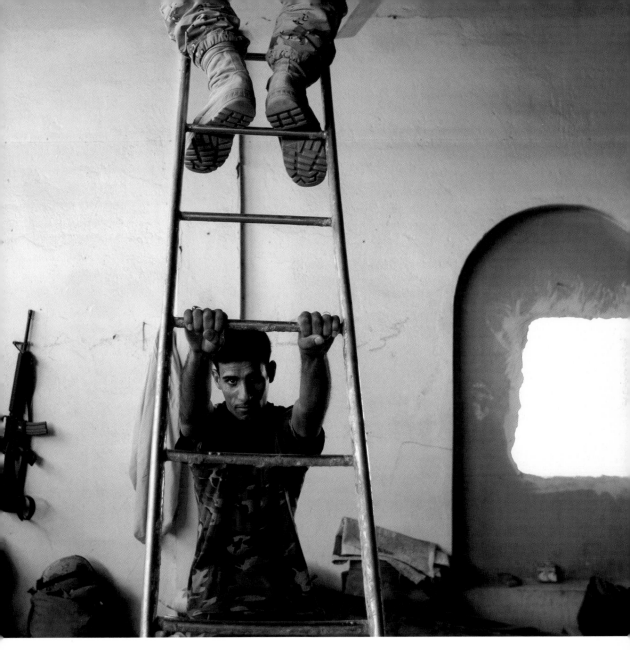

251 Baghdad, Iraq

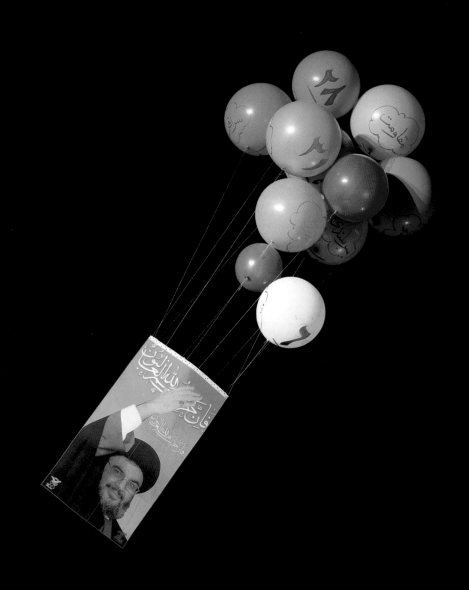

243 244 245 246 247 248

249 250 251 252

243 A man injured in a protest awaits an ambulance in Rabat. More than 1,000 people blocked an avenue as they demanded more public sector jobs. 2 July 2008. Rabat, Morocco. Rafael Marchante.

244 Government supporters chase anti-government demonstrators during clashes in Bangkok. 2 September 2008. Bangkok, Thailand. Adrees Latif.

245 Karnit Goldwasser (right) mourns during the funeral for her husband Ehud in the northern Israeli city of Nahariya. The bodies of Goldwasser and another slain soldier were returned to Israel in a prisoner swap with Hezbollah. The two were abducted by Hezbollah in a July 2006 border raid that triggered a 34-day war in Lebanon. 17 July 2008. Nahariya, Israel. Ronen Zvulun.

246 Freed prisoner Samir Qantar is held aloft during a welcome ceremony in his hometown of Abay, Mount Lebanon. Qantar was one of five Lebanese prisoners released by Israel in return for the bodies of two captured Israeli soldiers. 17 July 2008. Abay, Lebanon. Mohamed Azakir.

247 The top U.S. commander in Iraq, General David Petraeus, talks to Iraqi police and army commanders during a patrol with the Second Stryker Cavalry Regiment in Muqdadiyah, in Diyala province. Petraeus took command of U.S. forces in Iraq in February 2007, implementing a new strategy that brought in a 'surge' of some 30,000 extra troops. He is credited with turning Iraq back from the brink of all-out civil war. 26 July 2008. Muqdadiyah, Iraq. Damir Sagolj.

248 An Iraqi woman peers from behind a door at a U.S. soldier of the 2nd Brigade 1st Armored Division as he searches her home in Baghdad's Sadr City for weapons and explosives. 11 July 2008. Baghdad, Iraq. Damir Sagolj.

249 The Marriott hotel in Islamabad, after it was destroyed by a suicide truck bomb blast which started a fire that swept through the building. Fifty-five people were killed and more than 250 wounded. 21 September 2008. Islamabad, Pakistan. Faisal Mahmood.

250 Faik Fallahi, who was injured in an Iraqi chemical attack during the 1980–88 Iran–Iraq war, breathes with an oxygen tank as he and his wife pose next to his medicine in their home in Nowdesheh in Iran's Kermanshah province. High in remote Kurdish mountains, Iranian villagers still nurse ravaged eyes and lungs, 20 years after Iraqi poison gas attacks that went mostly ignored by world powers then mostly siding with Saddam Hussein against Iran. 5 July 2008. Nowdesheh, Iran. Morteza Nikoubazl.

251 A soldier of the Iraqi army elite mobile 3rd Brigade 1st Division holds a ladder for his comrade at an abandoned shopping mall serving as their base in Baghdad. 6 July 2008. Baghdad, Iraq. Damir Sagolj.

252 A picture of Hezbollah leader Sayyed Hassan Nasrallah hangs from balloons during a rally in Tehran to mark the second anniversary of the 34-day conflict between Lebanon's Hezbollah and Israel. 12 August 2008. Tehran, Iran. Morteza Nikoubazl.

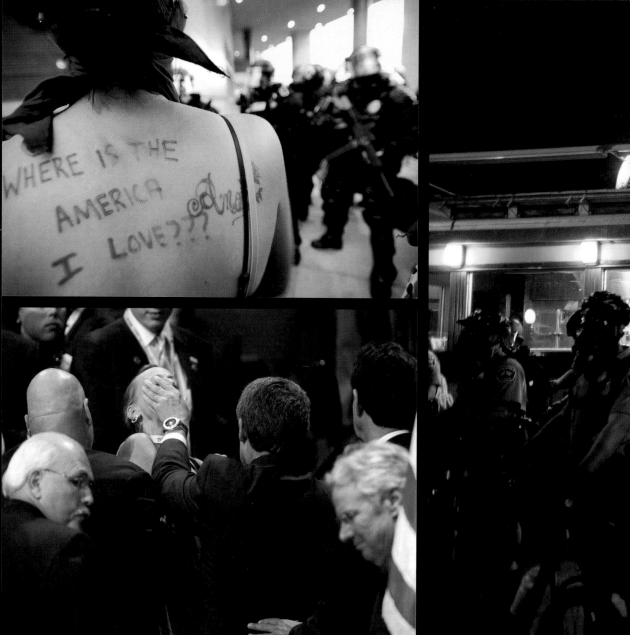

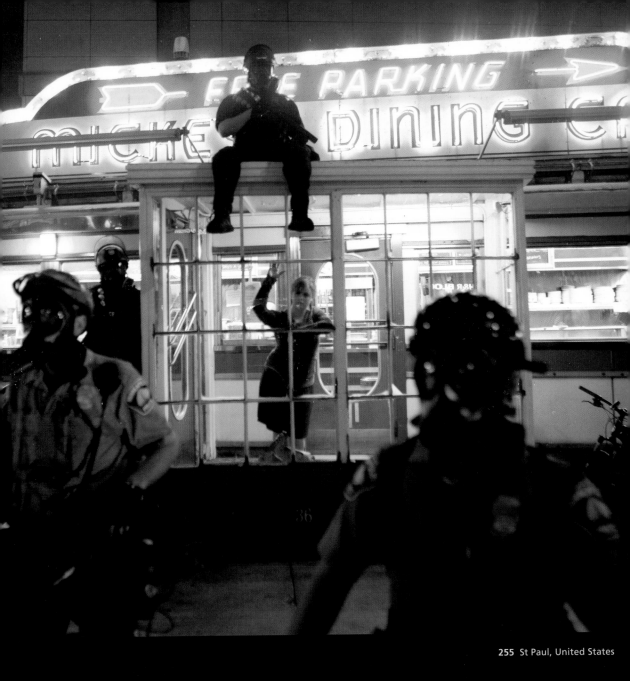

255 St Paul, United States

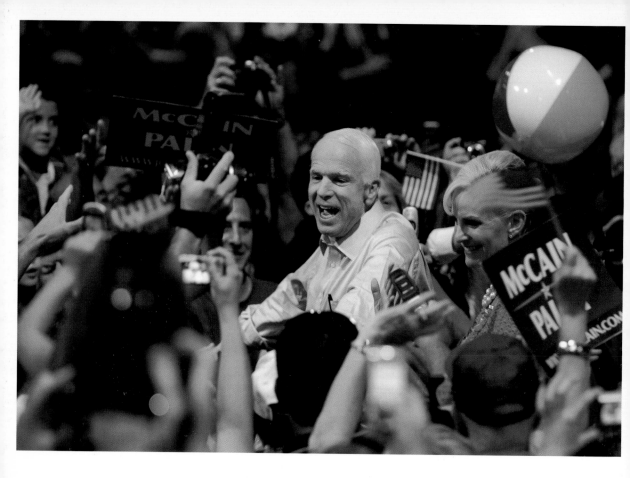

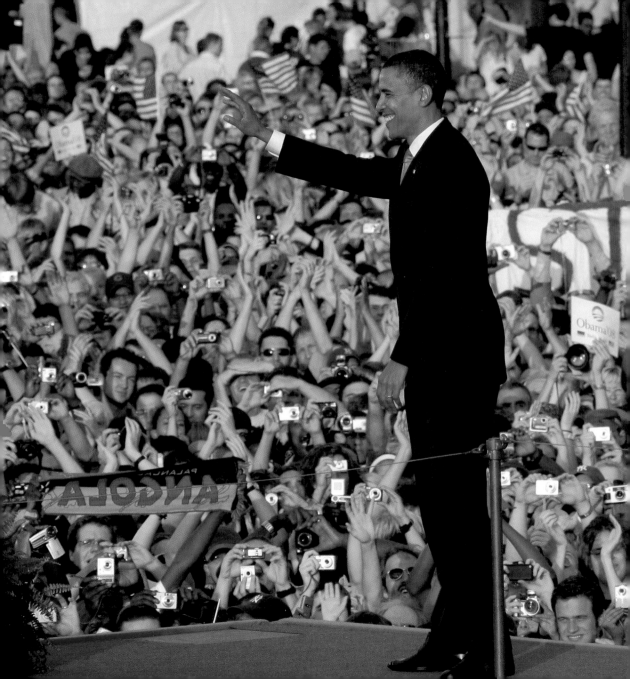

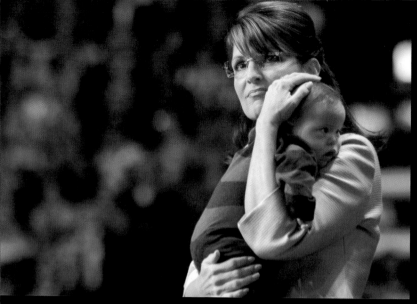

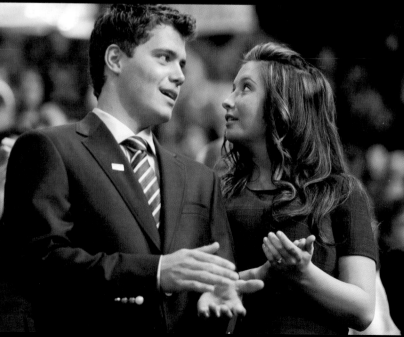

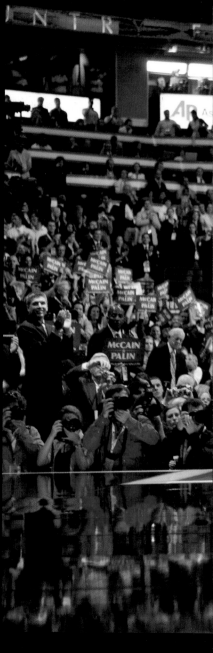

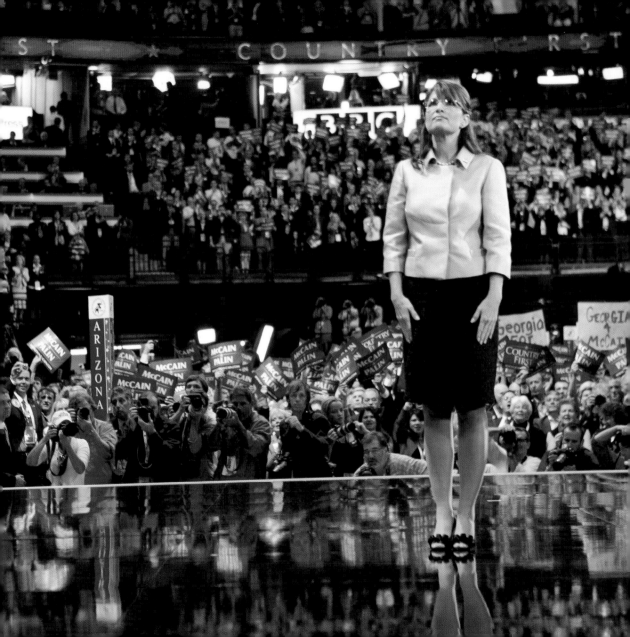

253 A protester wears a message written on her back in downtown Denver as the Democratic National Convention gets under way. 25 August 2008. Denver, United States. Mark Leffingwell.

254 A law enforcement official places his hand over the mouth of an anti-war protester from the 'Code Pink' group as she is escorted out of the hall during Republican vice presidential candidate Alaska Governor Sarah Palin's speech to the 2008 Republican National Convention in St Paul, Minnesota. 3 September 2008. St Paul, United States. Damir Sagolj.

255 Riot policemen take their position during clashes with protesters after demonstrations turned violent during the second session of the 2008 Republican National Convention. 2 September 2008. St Paul, United States. Damir Sagolj.

256 U.S. Republican presidential nominee Senator John McCain and his wife Cindy arrive for a campaign rally in Albuquerque, New Mexico. 6 September 2008. Albuquerque, United States. Brian Snyder.

257 U.S. Democratic presidential candidate Senator Barack Obama waves to the crowd after making a speech in front of the Victory Column in Berlin. 24 July 2008. Berlin, Germany. Tobias Schwarz.

258 Republican vice presidential candidate Sarah Palin hugs her son Trig onstage after her address to the 2008 Republican National Convention. 3 September 2008. St Paul, United States. Shannon Stapleton.

259 Levi Johnston talks with his girlfriend Bristol Palin in the VIP box on the floor of the 2008 Republican National Convention. On 1 September Sarah Palin announced that her daughter Bristol, 17, is five months pregnant and plans to marry Johnston. 3 September 2008. St Paul, United States. Damir Sagolj.

260 Sarah Palin listens to the applause after her address to the third session of the 2008 Republican National Convention. 3 September 2008. St Paul, United States. John Gress.

261 Supporters of Sarah Palin hold up lipsticks as she arrives to speak in Golden, Colorado. Palin described herself as a 'hockey mom' to the Republican nominating convention and joked that the only difference between a hockey mom and a pit bull was lipstick. 15 September 2008. Golden, United States. Rick Wilking.

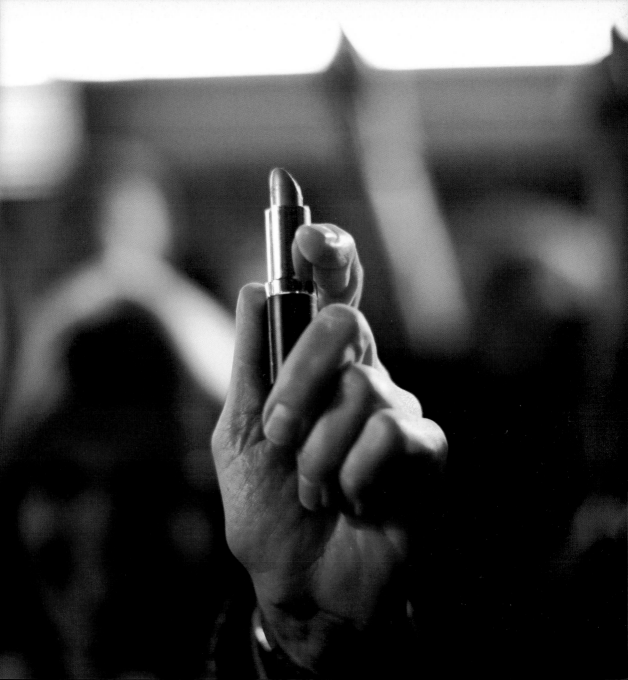

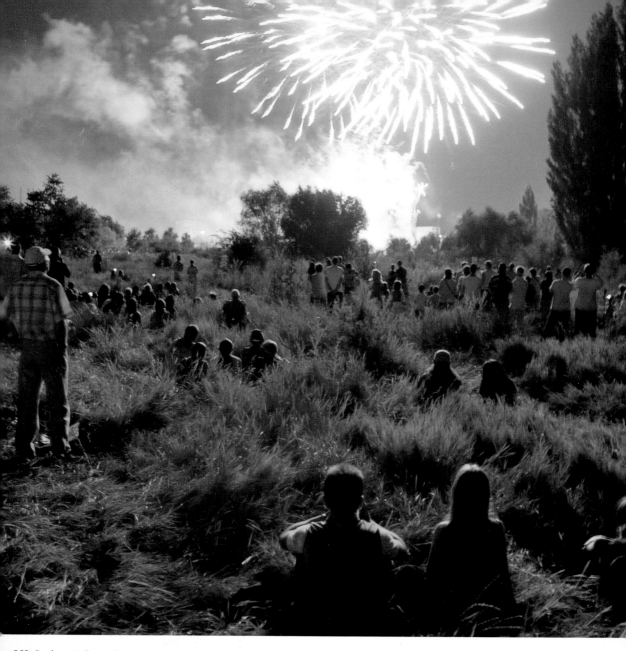

263 [TOP] Sofia, Bulgaria **264** [ABOVE] Mau Forest, Kenya

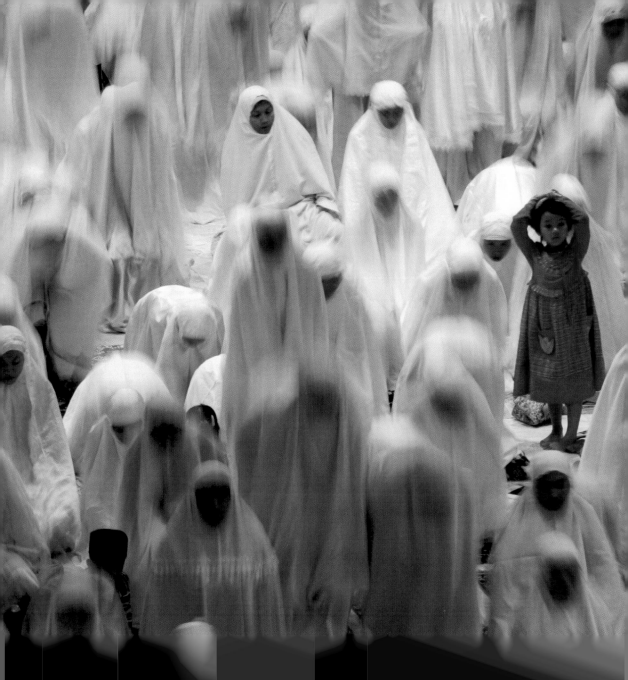

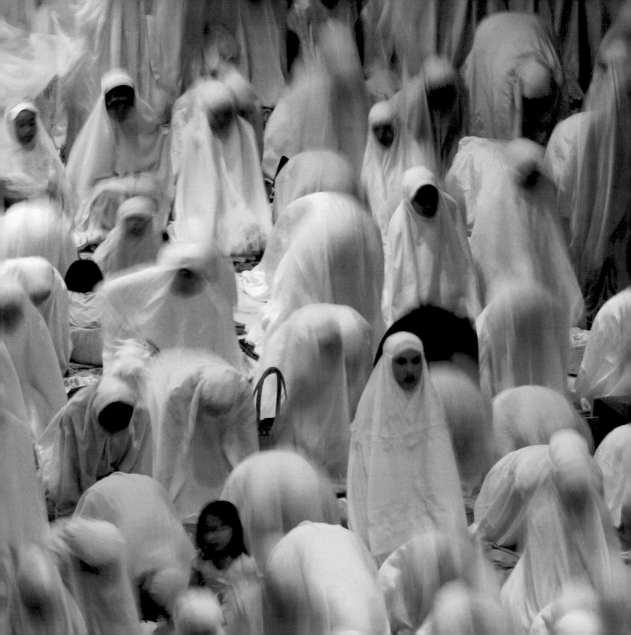

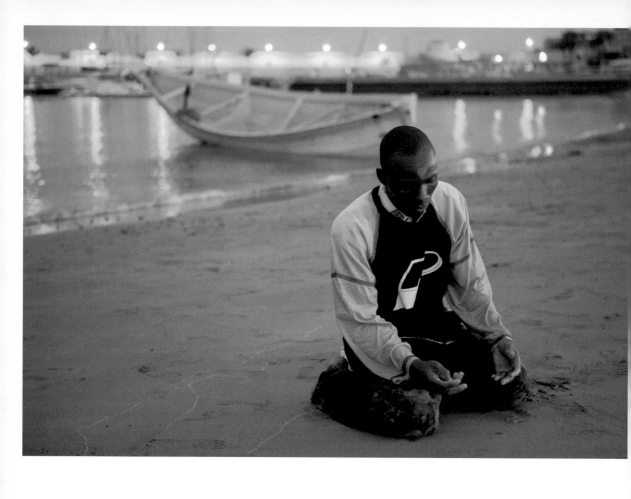

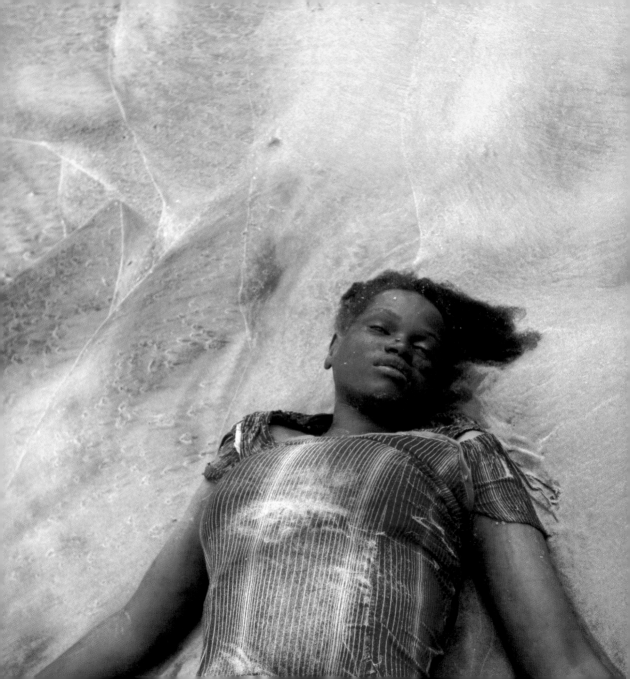

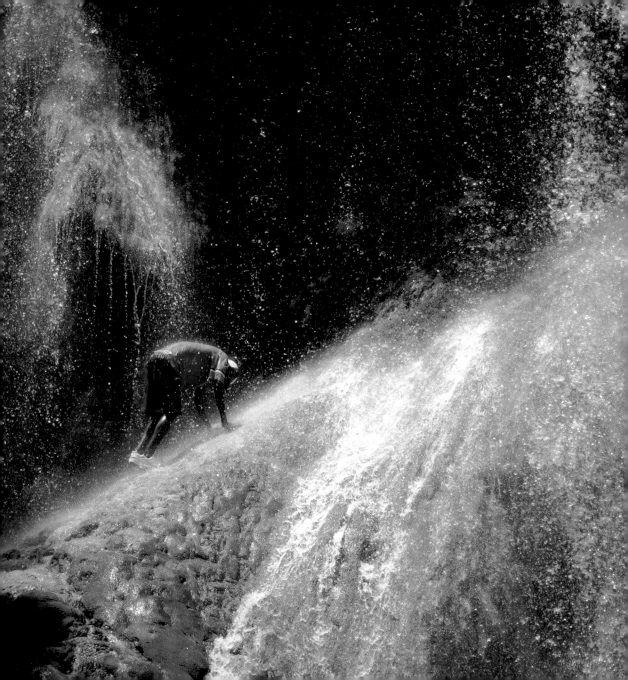

262 263 264 265 266 267

268

2 People watch fireworks during the first 'Golden Nights' International Pyrotechnic Festival in Bucharest. 5 July 2008. Bucharest, Romania. Mihai Barbu.

3 A journalist sits by the side of a blocked road outside the Bulgarian capital Sofia as a series of powerful explosions rocked a huge arms disposal depot on the outskirts of the city. The blasts lasted about eight hours, injuring three people, shaking apartment blocks and panicking thousands. 3 July 2008. Sofia, Bulgaria. Stoyan Nenov.

4 Leonard Chiruyat, a farmer living on disputed land in Kenya's Mau Forest, walks through an area cleared of trees. The 4,000 square kilometre (1,500 square mile) forest is a giant moisture reservoir and generator of rain. Destruction by rampant illegal settlement, logging and charcoal burning threatens severe damage to Kenya's water supplies and economy. In July Kenya's new coalition government set up a task force to try to halt the destruction. 26 August 2008. Mau Forest, Kenya. Finbarr O'Reilly.

265 Muslims attend prayers on the eve of the first day of the Islamic fasting month of Ramadan at a mosque in Surabaya, East Java. 31 August 2008. Surabaya, Indonesia. Sigit Pamungkas.

266 A would-be immigrant prays after arriving at the Puerto Rico beach on Spain's Canary Island of Gran Canaria. Tens of thousands of African migrants have made it to Spanish shores in recent years, prompting Spain's Socialist government to toughen its line on illegal immigration. Many thousands more are believed to have drowned or died of thirst or exposure in the attempt. 1 July 2008. Gran Canaria, Spain. Borja Suarez.

267 The body of an Ethiopian woman lies on Rada beach after she was washed up in the southern Yemeni province of Sabwa. At least four people drowned after smugglers forced around 110 passengers overboard as they approached the end of their trip from Somalia to Yemen across the Gulf of Aden, Yemeni coastguard officers said. 29 September 2008. Rada, Yemen. Khaled Abdullah.

268 A Haitian climbs up rocks leading to a waterfall as voodoo believers attend an annual festival in the town of Saut d'Eau. Hundreds of thousands gather every year to bathe in the waterfall, believing its waters to cleanse their souls. 16 July 2008. Saut d'Eau, Haiti. Eduardo Munoz.

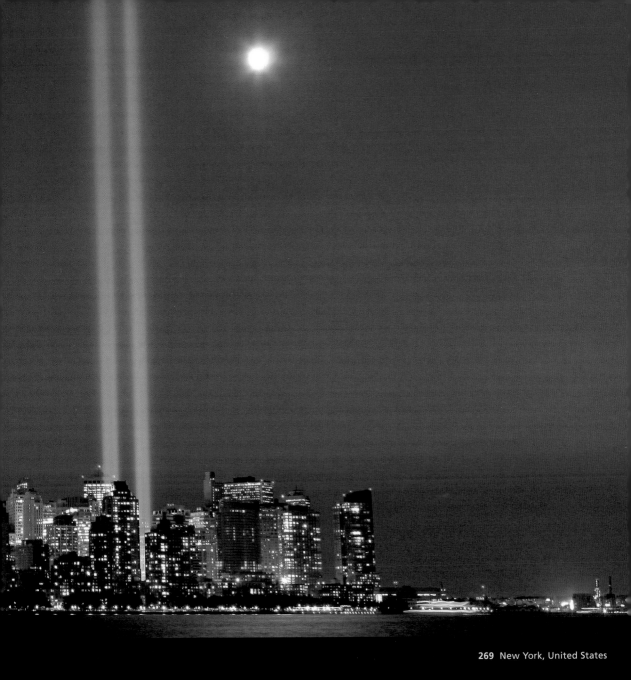

269 New York, United States

273 [TOP] New York, United States **274** [ABOVE] London, Britain

276 [TOP] Baghdad, Iraq **277** [ABOVE] Manila, Philippines

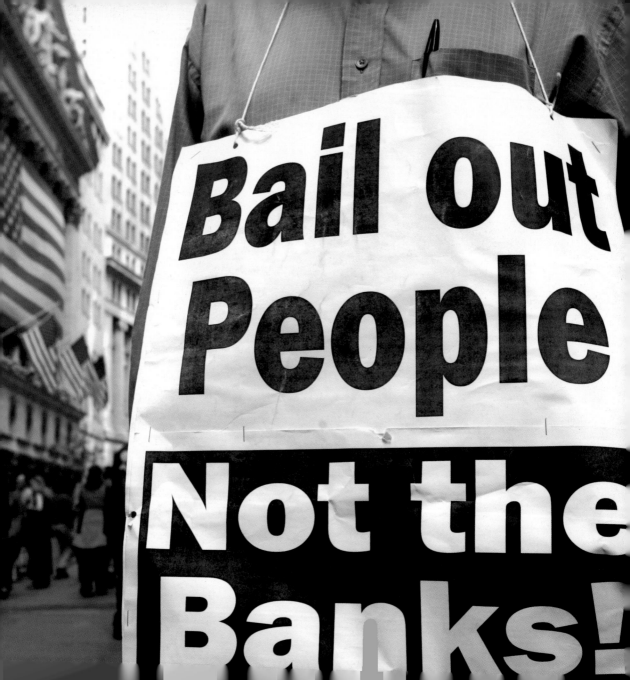

269 The moon rises over lower Manhattan as the 'Tribute in Lights' illuminates the sky on the seventh anniversary of the attacks on the World Trade Center. 11 September 2008. New York, United States. Gary Hershorn.

270 Ticker tape from the 1929 stock market crash is displayed at the Museum of American Finance in New York. 18 September 2008. New York, United States. Eric Thayer.

271 A styrofoam figure of a bull is pictured in front of the share price index DAX board at the Frankfurt stock exchange. 16 September 2008. Frankfurt, Germany. Alex Grimm.

272 A Rolls-Royce limousine is parked in Bahnhofstrasse, Zurich, as people look at a display showing the current stock prices outside the office of Swiss bank UBS. 30 September 2008. Zurich, Switzerland. Arnd Wiegmann.

273 A man walks through the revolving door of an American International Group (AIG) building in New York's financial district. On 16 September the U.S. Federal Reserve announced an $85 billion bailout loan to AIG to save the insurer from bankruptcy. 16 September 2008. New York, United States. Lucas Jackson.

274 A worker carries her belongings in a box as she leaves the office of the U.S. investment bank Lehman Brothers in London's Canary Wharf district. Global markets plummeted in the week that Lehman Brothers filed for bankruptcy protection, rival Merrill Lynch agreed to be taken over, and the U.S. Federal Reserve threw a lifeline to the battered financial industry. 15 September 2008. London, Britain. Andrew Winning.

275 Trader Gregg Russo works on the floor of the New York Stock Exchange. 25 September 2008. New York, United States. Brendan McDermid.

276 Traders update prices at the Iraq Stock Exchange in Baghdad. The Baghdad index climbed almost 40 percent in September as global stocks suffered. 18 September 2008. Baghdad, Iraq. Ceerwan Aziz.

277 A trader reacts on a floor of the Philippine Stock Exchange in Manila's Makati financial district. 19 September 2008. Manila, Philippines. John Javellana.

278 A demonstrator stands outside the New York Stock Exchange while U.S. lawmakers meet in Washington, DC, to vote on a $700 billion bailout of the financial industry. 29 September 2008. New York, United States. Shannon Stapleton.

October / November / December

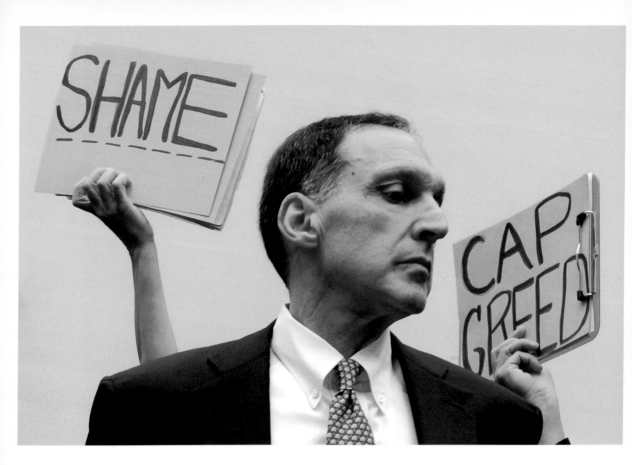

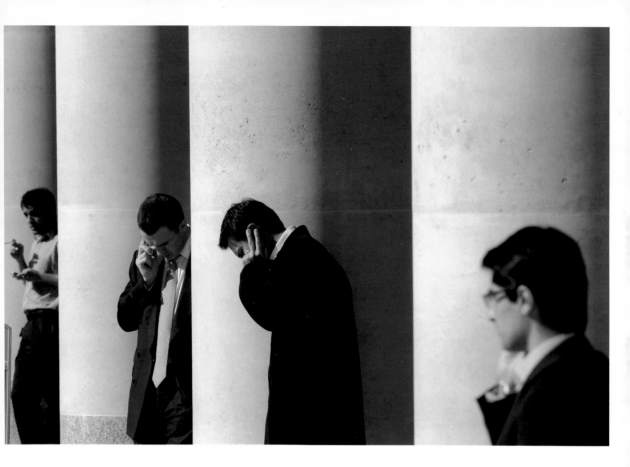

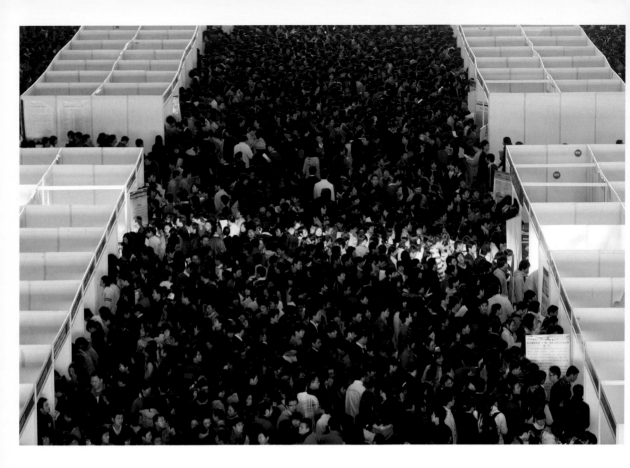

285　Berlin, Germany

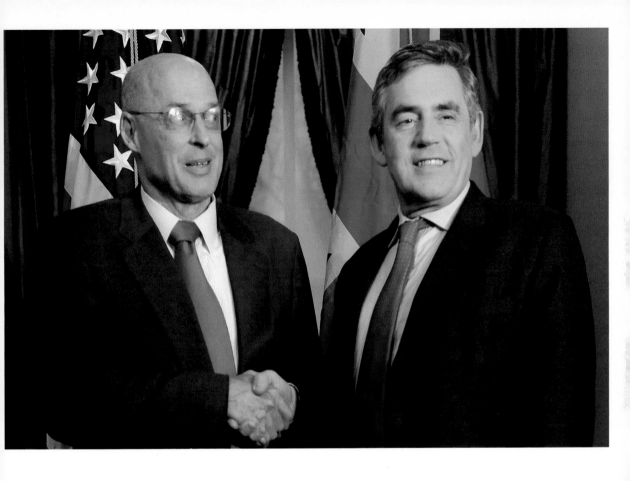

279 Protesters hold signs behind Richard Fuld, chairman and chief executive of Lehman Brothers Holdings, as he takes his seat to testify at a House Oversight and Government Reform Committee hearing on the causes and effects of the Lehman Brothers bankruptcy, on Capitol Hill in Washington. 6 October 2008. Washington, DC, United States. Jonathan Ernst.

280 City workers make lunchtime phone calls outside the London Stock Exchange in Paternoster Square. 1 October 2008. London, Britain. Toby Melville.

281 Chinese job-seekers visit company booths at a job fair for graduates in Nanjing, Jiangsu province. Faltering economic conditions have raised the spectre of growth falling below 8 percent, regarded by the government as an essential benchmark to create enough jobs to mop up excess labour and guarantee social stability. 20 November 2008. Nanjing, China. Sean Yong.

282 Members of the European Parliament attend a debate on the EU response to the world financial crisis and Washington's G20 Summit. 18 November 2008. Strasbourg, France. Vincent Kessler.

283 Peruvian President Alan García (centre, arm raised) talks to fellow leaders after a group photo at the Asia-Pacific Economic Cooperation summit in Lima. 23 November 2008. Lima, Peru. Mariana Bazo.

284 U.S. President George W. Bush remains in place as other world leaders gather for a second group photo at the G20 Summit on Financial Markets and the World Economy at the National Building Museum in Washington. 15 November 2008. Washington, DC, United States. Jason Reed.

285 German Chancellor Angela Merkel delivers a speech to the German lower house of parliament, the Bundestag, in Berlin. She insisted that Germany was well positioned to weather the global financial crisis while warning that 2009 would be a tough year. 26 November 2008. Berlin, Germany. Hannibal Hanschke.

286 U.S. Treasury Secretary Henry Paulson (left) shakes hands with British Prime Minister Gordon Brown at the Treasury Department in Washington. 14 November 2008. Washington, DC, United States. Jonathan Ernst.

287 Disgraced financier Bernard Madoff returns to his apartment in New York after being placed under house arrest and electronic monitoring by a U.S. federal judge. The one-time Wall Street powerbroker stood accused of orchestrating a $50 billion fraud touching investors and charities around the world. 17 December 2008. New York, United States. Shannon Stapleton.

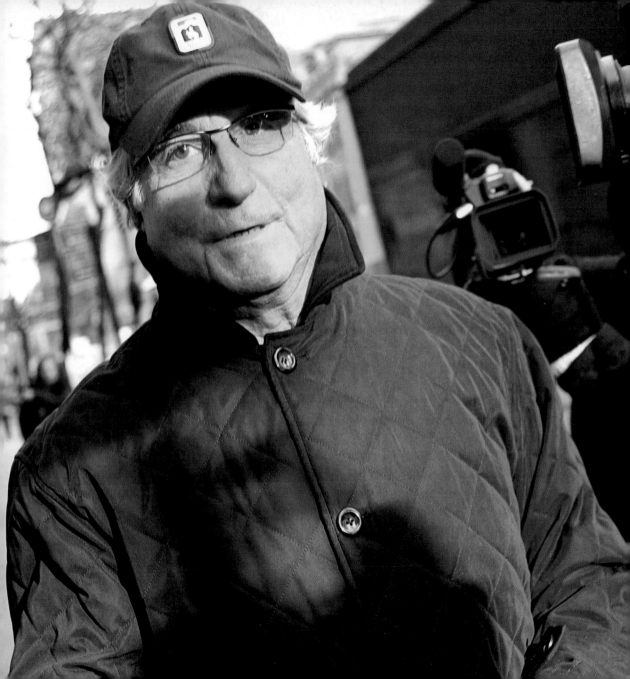

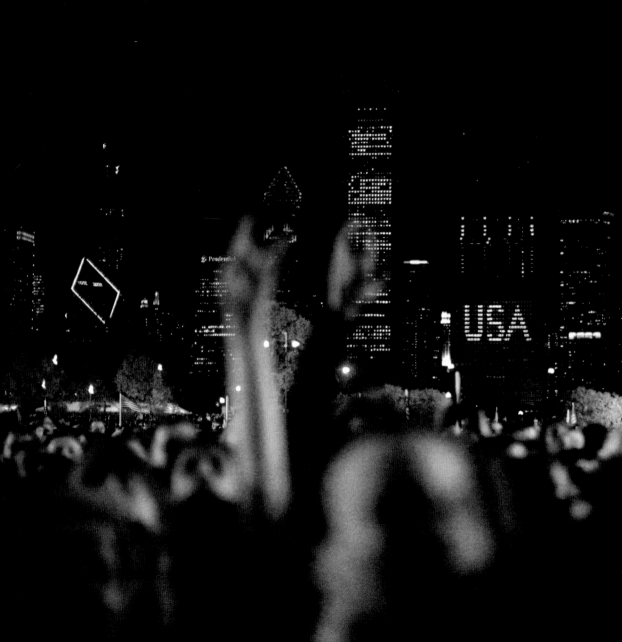

CARLOS BARRIA
Photographer
Born: Bariloche, Argentina, 1979
Based: Miami, United States
Nationality: Argentine

The long road to victory

I arrived in Chicago a few days before the U.S. election, prepared for a cold climate. But it was unexpectedly warm, making election night seem like a gentle finish to a very intense year of campaign coverage.

I began to cover the presidential elections during the run-up to the Iowa caucus in January 2008, just before Barack Obama's win in that state launched him as a serious contender against the leading Democratic Party candidate, Hillary Clinton.

I watched the candidates sit in high school classrooms, or attend town hall meetings, speaking to gatherings of as few as 20 people. They discussed everyday concerns, and listened to complaints, ideas and problems. It was an extraordinary opportunity to see up close how the U.S. political system works and how personal the democratic process can be.

Early in the year, I spent a few weeks travelling with Obama's campaign. That meant flying in the same plane as the candidate and sleeping in the same hotels. We darted back and forth across the United States, hitting four to six cities a day. It could be disorientating – at times I wasn't quite convinced I knew where I was, and I had to be extra careful to get my captions right.

The hope some people invested in Obama was at times overwhelming. At one rally, in New Orleans, I turned around to see a middle-aged black woman with tears running down her cheeks. That was the first time I ever saw anyone cry at a political event.

On election day, I woke at 5 a.m. to cover Obama casting his ballot. Then at 5 p.m. we were allowed to enter Grant Park and take our positions. Photographers were not permitted a head start over ordinary supporters, so we had to race them, with all our gear, to reach the staging area.

Six hours later, when a victorious Obama finally took the stage, I photographed him waving to the crowd, and then I took a second to look around me. There were tears everywhere. I was deeply moved, and also a little envious. Could this, I wondered, ever happen in my home country of Argentina?

288 Supporters cheer while awaiting the arrival of U.S. Democratic presidential candidate Senator Barack Obama at his election night rally in Grant Park, Chicago. 4 November 2008.

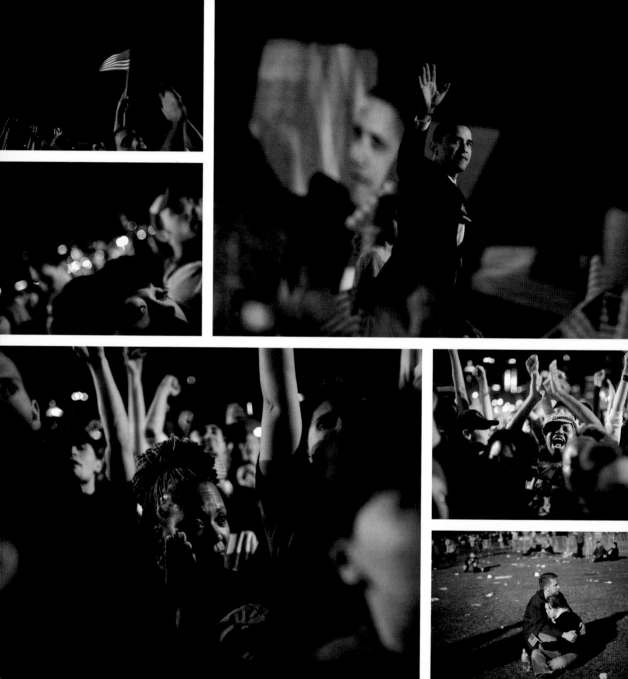

289	291	295
290		
292	293	296
	294	

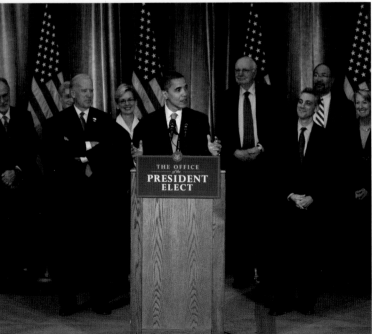

289 Supporters react to the news of Barack Obama's victory in the 2008 U.S. presidential campaign during his election night rally in Grant Park, Chicago. 4 November 2008. **290** Supporters wait for Obama to arrive after his victory is declared. 4 November 2008. **291** Obama takes the stage after his victory is declared. 4 November 2008. **292** Supporters react to the news of Obama's victory. 4 November 2008. **293** The crowd reacts to Obama's victory. 4 November 2008. **294** Supporters sit in Grant Park after Obama's victory address to his election night rally. 4 November 2008. **295** Obama hugs his wife Michelle after his victory is declared. 4 November 2008. **296** Obama answers a journalist's question during his first news conference following his election victory. 7 November 2008.

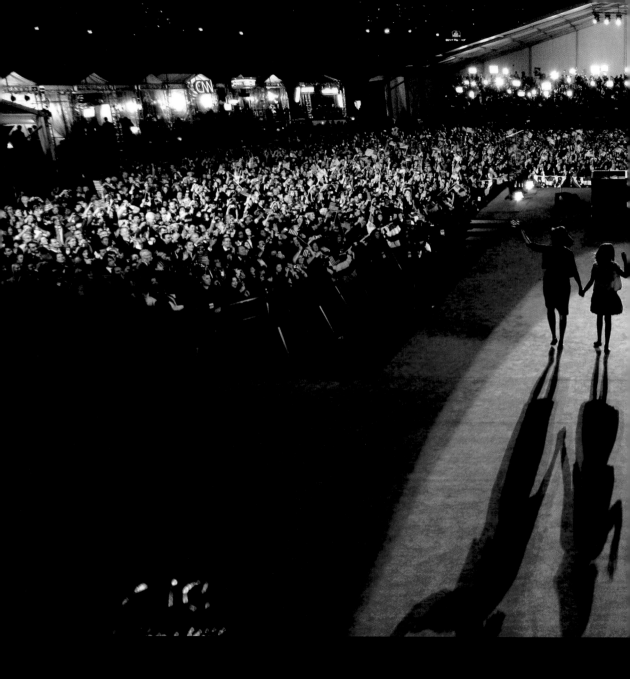

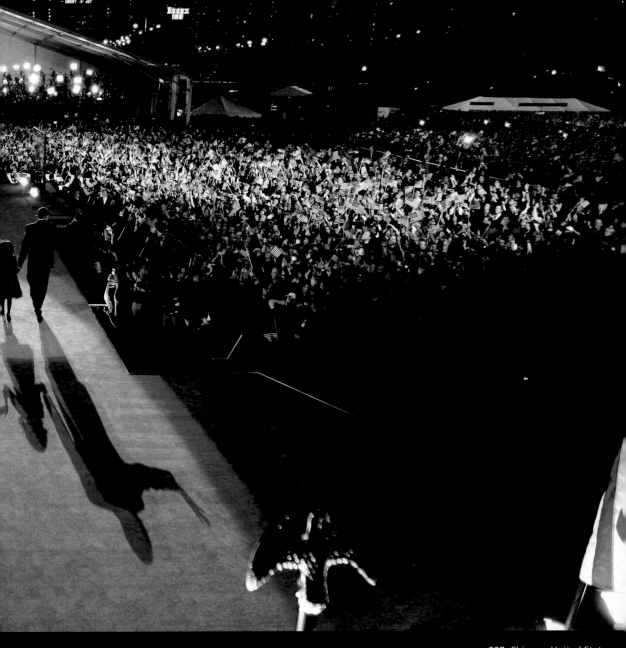

299 [TOP] Washington, DC, United States **300** [ABOVE] Ivry-sur-Seine, France

303 [TOP] Paris, France **304** [ABOVE] Reims, France

CHAIRMAN

297 U.S. President-elect Senator Barack Obama arrives to speak to supporters with his wife Michelle and their children Malia (left) and Sasha (right) during his election night rally in Chicago after he was declared the winner of the 2008 U.S. presidential election. 4 November 2008. Chicago, United States. Gary Hershorn.

298 The day after Obama's victory, a Palestinian man in the West Bank city of Ramallah reads a newspaper depicting the president-elect and his wife. The headline in Arabic reads 'Obama the first black president on the doorstep of the White House.' 5 November 2008. Ramallah, West Bank. Fadi Arouri.

299 A woman views the front pages of newspapers from around the world displayed outside the 'Newseum' in Washington. 5 November 2008. Washington, DC, United States. Molly Riley.

300 An employee checks the latest edition of French daily evening newspaper Le Monde at a printing press in Ivry-sur-Seine near Paris. 5 November 2008. Ivry-sur-Seine, France. Benoit Tessier.

301 Venezuelan President Hugo Chavez (top left) joins candidates of his United Socialist Party of Venezuela in the neighbourhood of Petare in Caracas to campaign ahead of elections for state governors and city mayors. 11 November 2008. Caracas, Venezuela. Jorge Silva.

302 Bolivian President Evo Morales greets supporters upon his arrival in Caracollo town. Thousands gathered in Caracollo to start a march toward La Paz, some 190 km (120 miles) away, to pressure congressmen to pass a law enabling a referendum to approve a new constitution. 13 October 2008. Caracollo, Bolivia. David Mercado.

303 Ségolène Royal, former presidential candidate (right), accompanies Martine Aubry, the new leader of the French Socialist party, at the party headquarters in Paris. 26 November 2008. Paris, France. Charles Platiau.

304 François Hollande, French Socialist Party first secretary, attends the final day of the French Socialist Party National Congress in Reims. 16 November 2008. Reims, France. Benoit Tessier.

305 International Monetary Fund Managing Director Dominique Strauss-Kahn poses for a group photo with members of the joint secretariat of the annual International Monetary Fund–World Bank meeting in Washington. Amidst the global financial crisis, Strauss-Kahn apologized for 'an error of judgment' over an affair with a subordinate, but was cleared of abuse of his position. 13 October 2008. Washington, DC, United States. Yuri Gripas.

306 Ilham Aliyev is sworn in as Azerbaijan's president during his inauguration ceremony in Baku. 24 October 2008. Baku, Azerbaijan. Irakly Gedenidze.

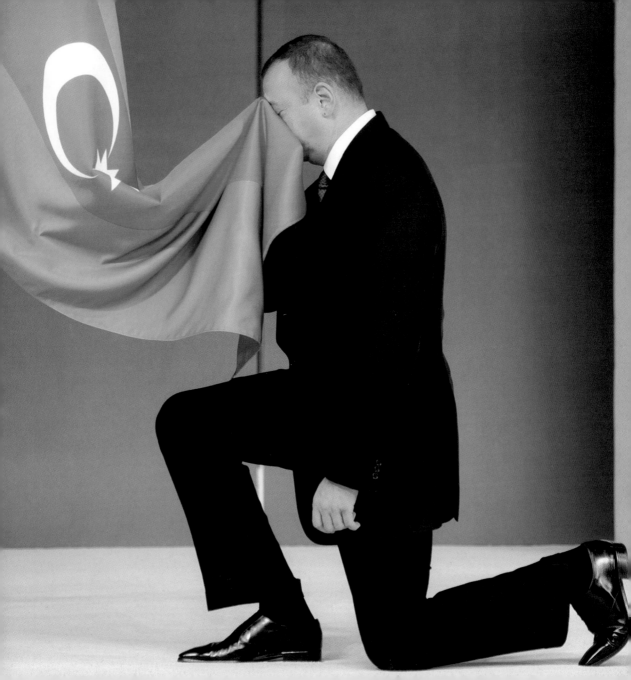

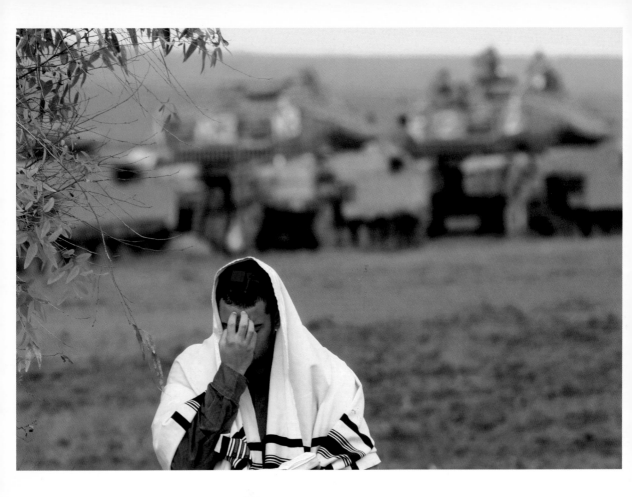

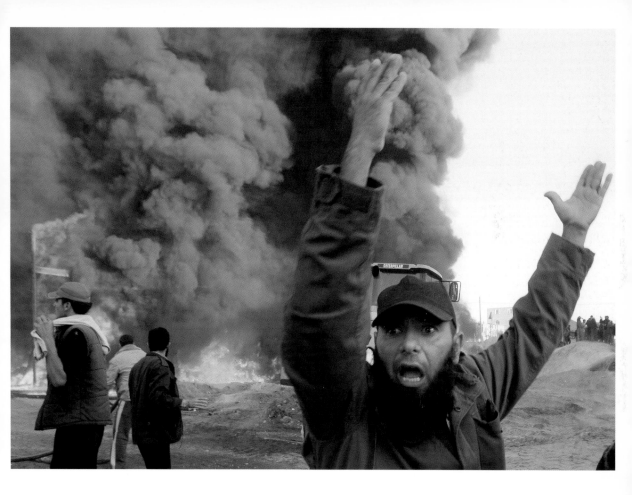

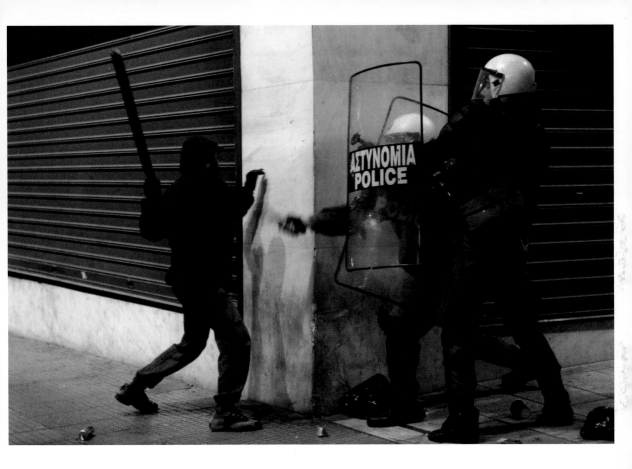

311 [TOP] Manila, Philippines **312** [ABOVE] Calais, France

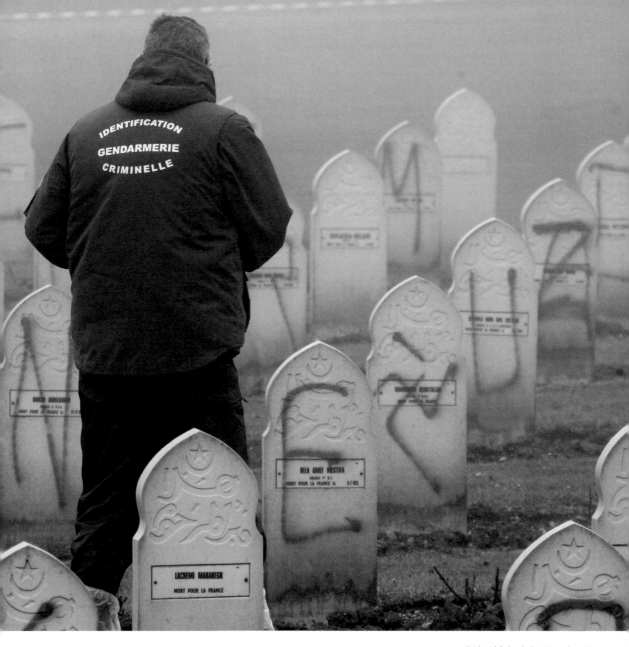

313 Ablain-Saint-Nazaire, France

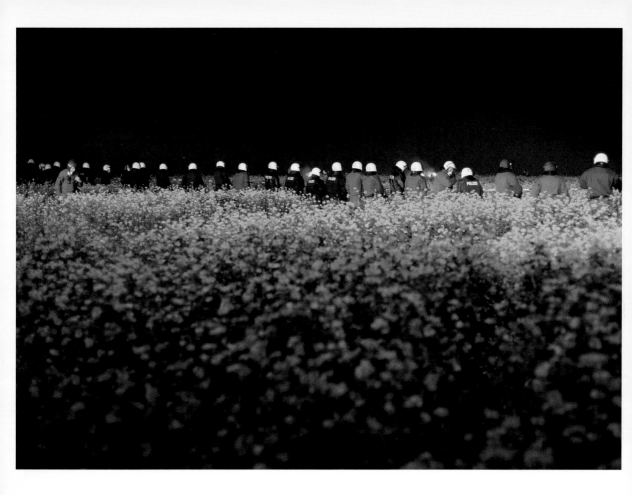

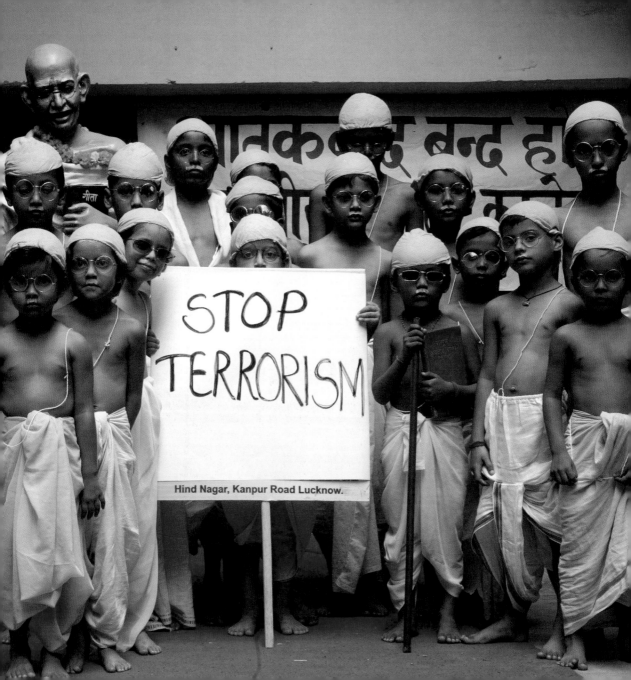

307
308
309
310
311
312
313
314
315
316

307 An Israeli soldier prays in front of tanks just outside the central Gaza Strip. Israel launched massive air strikes on Gaza on 27 December in response to intensified rocket and mortar fire into Israel by Palestinian militants. Hamas declared the end of a six-month Egyptian-brokered ceasefire on 18 December. 30 December 2008. Israel–Gaza border. Yannis Behrakis.

308 A Hamas policeman shouts in front of a burning building following an Israeli air strike in Gaza. 28 December 2008. Gaza. Ibraheem Abu Mustafa.

309 A man's hand drips blood as he stands in front of riot police during a demonstration outside the Greek parliament in Athens. Greece's worst protests in decades, sparked by the fatal shooting of a teenager by police, were fuelled by simmering anger at youth unemployment and the world economic crisis. 9 December 2008. Athens, Greece. John Kolesidis.

310 A protester clashes with police during riots in central Athens. 11 December 2008. Athens, Greece. Yiorgos Karahalis.

311 A boy climbs onto gravestones in a cemetery in Manila. Many poor urban dwellers in the Philippines make their homes in public cemeteries, converting abandoned tombs and mausoleums into houses. 21 October 2008. Manila, Philippines. Cheryl Ravelo.

312 An asylum seeker from Afghanistan waits for his meal during a daily midday food distribution service near Calais in northern France. 1 December 2008. Calais, France. Pascal Rossignol.

313 A policeman searches among Muslim graves defaced with Nazi inscriptions and swastikas in Notre Dame de Lorette cemetery in Ablain-Saint-Nazaire, northern France. Some 500 graves were desecrated in the Muslim section of the World War One military cemetery. 8 December 2008. Ablain-Saint-Nazaire, France. Pascal Rossignol.

314 German riot police guard a convoy carrying nuclear waste to an interim nuclear waste storage facility in the northern German village of Gorleben. The shipment was delayed by multiple anti-nuclear demonstrations, blockades and sit-ins along its route from the French reprocessing plant of La Hague. 11 November 2008. Laase, Germany. Christian Charisius.

315 A Thai Muslim woman is seen praying through frosted glass in the departures hall of Bangkok's Suvarnabhumi airport. Hundreds of Thai Muslims on a once-in-a-lifetime pilgrimage to Mecca were among an estimated 250,000 people stranded by an eight-day blockade of Thailand's main airport by anti-government protesters. 28 November 2008. Bangkok, Thailand. Adrees Latif.

316 Children dressed as Mahatma Gandhi pose on the eve of the 139th anniversary of his birth in the northern Indian city of Lucknow. 1 October 2008. Lucknow, India. Pawan Kumar.

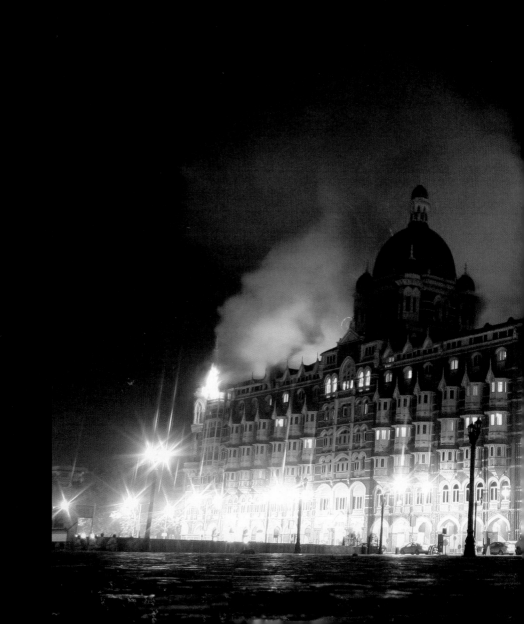

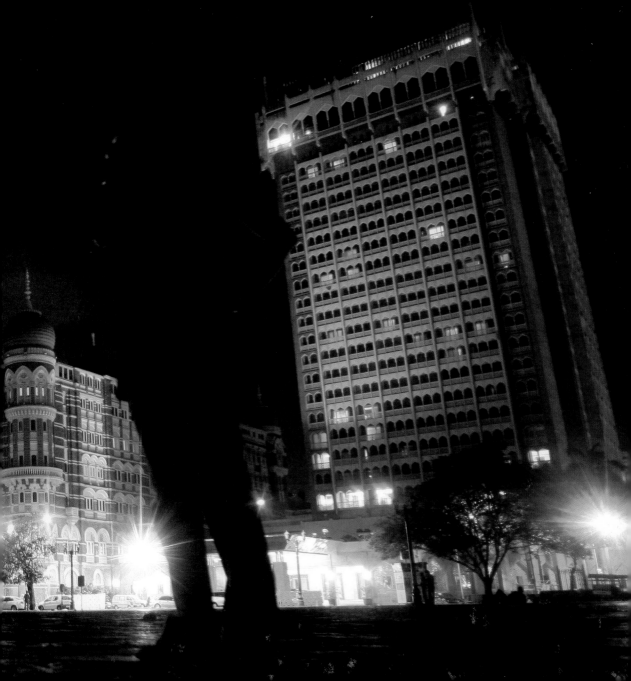

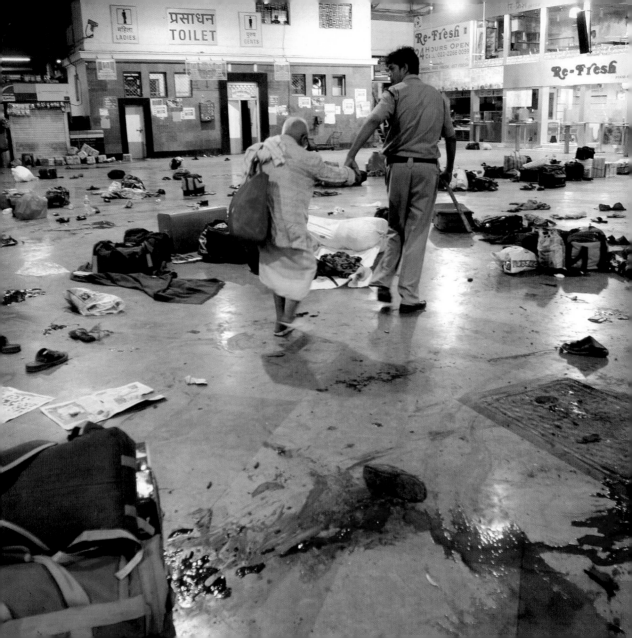

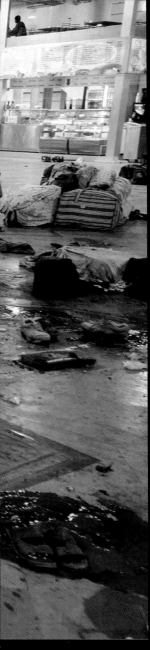

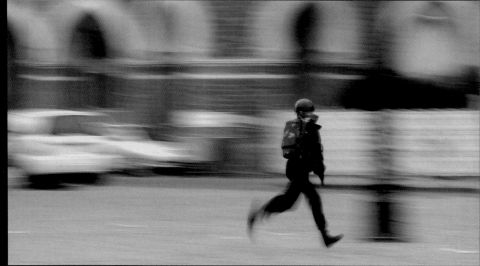

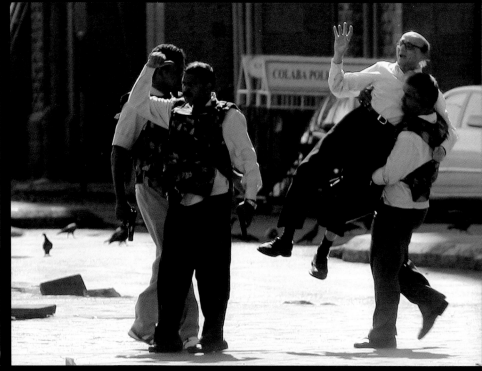

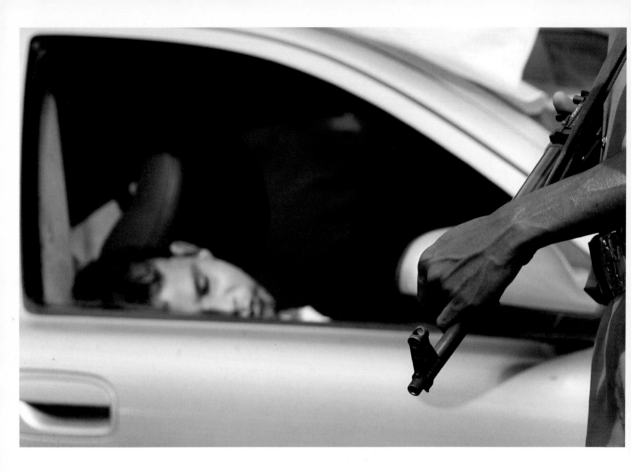

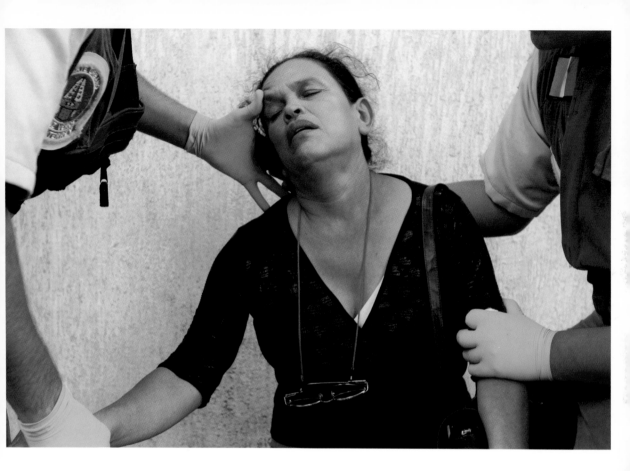

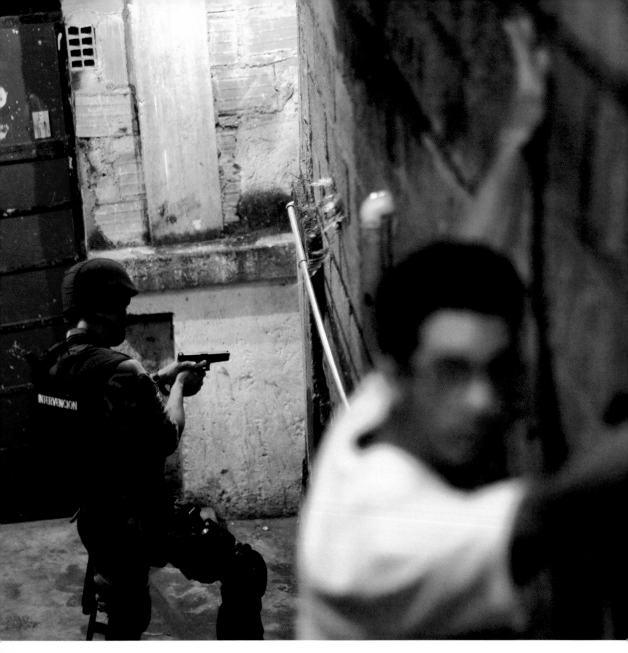

323 Caracas, Venezuela

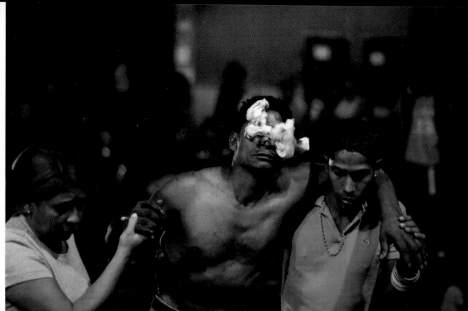

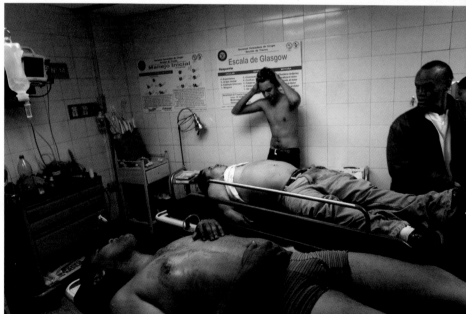

324 [TOP] **325** [ABOVE] Caracas, Venezuela

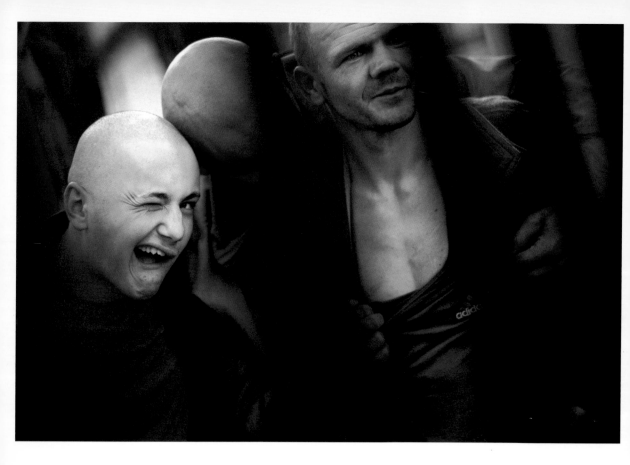

Zenica, Bosnia

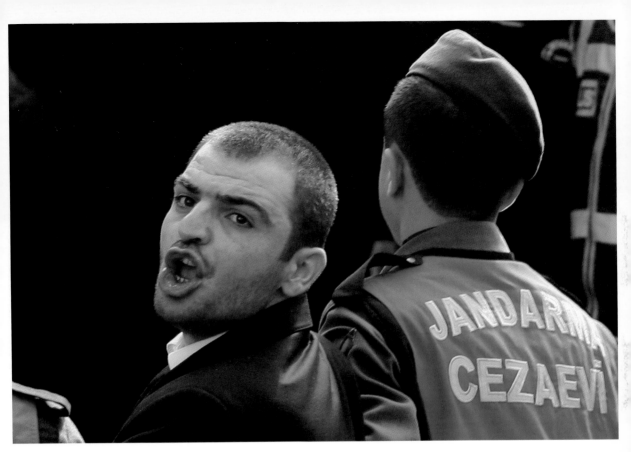

317 318 319 320 321 322 323 324 325 326 327 328

317 A reporter talks on her phone as smoke pours from the Taj Mahal hotel in Mumbai. Islamist gunmen attacked targets including luxury hotels, hospitals, a railway station and a Jewish centre in a three-day rampage that killed 179 people. 27 November 2008. Mumbai, India.

318 A policeman escorts an elderly man away from the scene of shootings at the Chhatrapati Shivaji Terminus railway station. 26 November 2008. Mumbai, India.

319 An Indian commando runs into the Taj hotel prior to a gun battle. 28 November 2008. Mumbai, India. Arko Datta

320 Police escort a guest from the Taj hotel. 27 November 2007. Mumbai, India. Arko Datta.

321 A policeman guards the scene of a shooting in Athurugiriya, a suburb of Colombo. Kumaraswami Nandagoban (alias Ragu), personal secretary of Eastern Province chief minister and former Tamil rebel Pillayan, was shot dead along with another person, police said. 14 November 2008. Colombo, Sri Lanka. Anuruddha Lokuhapuarachchi.

322 Paramedics aid a relative of an inmate after she fainted outside Topo Chico prison in Monterrey, northern Mexico. Mexico saw a surge in deadly prison riots in 2008 as a drug war between rival gangs spilled over into prisons packed with traffickers. 8 October 2008. Monterrey, Mexico. Tomas Bravo.

323 Police patrol and search a suspect in the Caracas shanty town of Petare. Venezuela has one of the world's highest murder rates. Heavily armed police scour Petare every night but they are gravely understaffed and many corners of the neighbourhood, where gang members are equipped with flak jackets and grenades, are considered no-go areas. 14 November 2008. Caracas, Venezuela. Jorge Silva.

324 A man arrives at hospital after being stabbed in a fight near Petare. 15 November 2008. Caracas, Venezuela. Jorge Silva.

325 A young man reacts to the sight of his injured relatives in a hospital near Petare. The man in the centre died as the other was stabilized; both had suffered gunshot wounds. 15 November 2008. Caracas, Venezuela. Jorge Silva.

326 Bosnian prisoners joke behind the bars of the country's biggest prison in the central town of Zenica. The 122-year-old complex is the sole high-security facility in the Muslim-Croat federation, one of two autonomous regions of post-war Bosnia. Inmates include war criminals, minors and mentally ill convicts. 29 October 2008. Zenica, Bosnia. Damir Sagolj.

327 Yasin Hayal, accused of involvement in the killing of Turkish-Armenian editor Hrant Dink in January 2007, is taken to a Turkish court shortly before his hearing. 13 October 2008. Istanbul, Turkey. Osman Orsal.

328 A poster of U.S. President George W. Bush is seen under a pair of shoes during a protest at a university in Beirut in solidarity with Iraqi TV reporter Muntazer al-Zaidi, who threw his shoes at Bush during a news conference in Baghdad, a gesture that is a deep insult in the Arab world. 17 December 2008. Beirut, Lebanon. Mohamed Azakir.

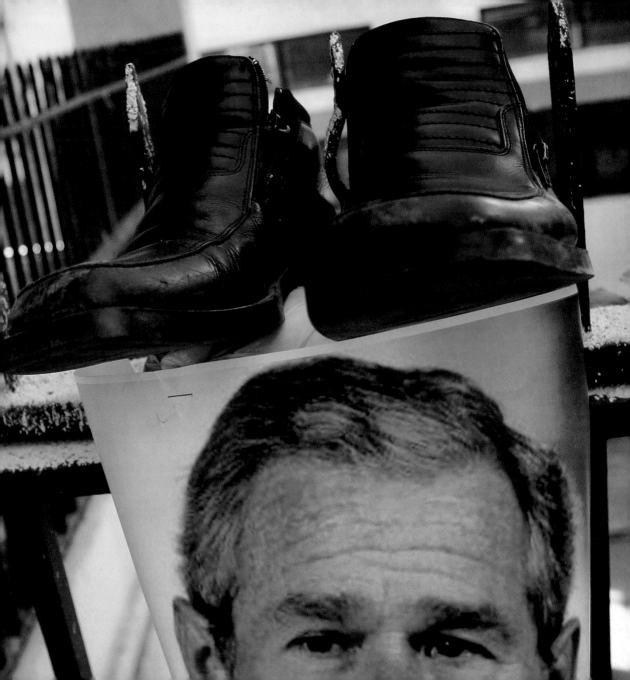

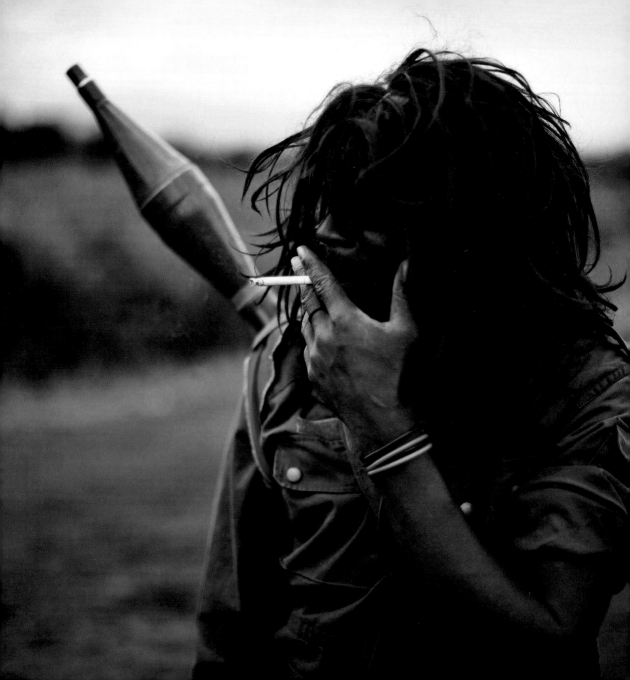

FINBARR O'REILLY
Photographer
Born: Swansea, Britain, 1971
Based: Dakar, Senegal
Nationality: Canadian/British

Life and death in Congo

A refugee in a tattered baseball cap begged me for a cigarette at Kibati, a camp in North Kivu province that is home to 65,000 people displaced by fighting in eastern Congo. I scolded him, saying smoking was bad for his health – as if anything could be worse for your health than living in this conflict-racked corner of the Democratic Republic of Congo. Machine gun fire soon erupted and people dived for cover, ducking into rows of flimsy tents made from sheets of white plastic stretched over sticks.

'Mister, mister, come lie down in here,' a voice called from one tent, as bullets hummed nearby like an electric current. I crawled through the curtain door to find a man and two children huddled on the ground. I kneeled above them and took a few more photographs.

'When you hear gunshots, if you lie flat, you can be OK, but if you stay up like that, paff!' said the man.

My protector was Boniface Buhoro, a tailor who had fled weeks of combat in an area since taken by anti-government Tutsi rebels. For 45 minutes, I lay with my legs intertwined with Buhoro's, his three-year-old son Sadiki wedged between us. Army boots crunched past over black lava rock as soldiers fired their weapons at full stride. At first we assumed rebels were attacking, but it turned out that drunken government soldiers were fighting each other, shooting randomly. In the panic, soldiers went from tent to tent robbing refugees who had already lost almost everything.

'Every day, something like this happens. They rob and steal and kill us or rape the girls. We don't even have anything to eat, but they take what they want,' said Buhoro.

I crawled outside as things calmed down. The man who'd asked me for a cigarette lay face down.

'He's dead already – stress,' said someone in the small crowd around the body. He had apparently suffered a heart seizure.

This is how many Congolese die: if not by the gun, then from conflict-induced illnesses, preventable diseases or hunger in a resource-rich but shattered nation lacking infrastructure. More than 5 million have perished during a decade of fighting and upheaval, according to aid agencies. This makes Congo's continuing conflict the deadliest since World War Two.

329 A Congolese government soldier wearing a wig smokes by the roadside in eastern Congo.
11 November 2008.

WITNESS

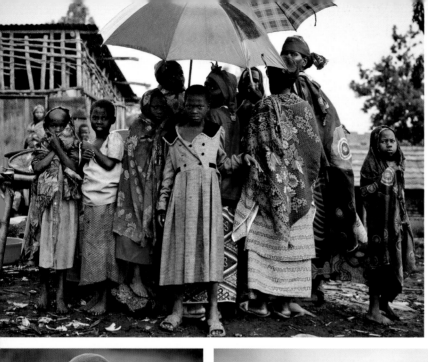
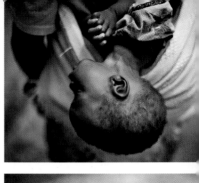
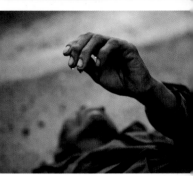
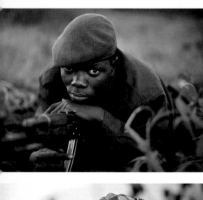

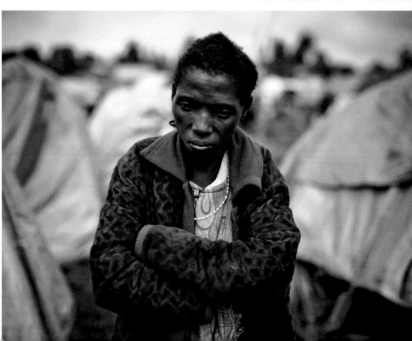

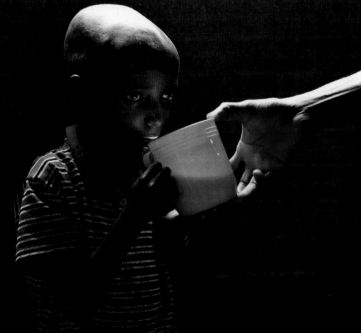

	331	
330		336
	332	
333		
	335	337
334		

330 Congolese displaced by fighting stand by a roadside north of Goma in eastern Congo. Weeks of violence forced more than 250,000 people from homes or ramshackle camps, bringing the number of internal refugees from years of fighting in North Kivu province to more than 1 million. 11 November 2008. **331** A severely malnourished infant hangs limp from her mother's back at a Catholic mission feeding centre in rebel-held Rutshuru. 13 November 2008. **332** Raindrops cling to the fingertips of a dead Congolese government soldier lying on the road near Kibati, where Tutsi rebels and government troops face each other from positions just 200 metres (650 feet) apart in the verdant bush and fields. 12 November 2008. **333** A Congolese government soldier rests on his weapon at the frontline near Kibati. 12 November 2008. **334** A woman displaced by war prays during a Sunday service in an outdoor church in Goma. 23 November 2008. **335** Domitra Mbonigaba N'Bahunde, 53, who fears her sons are dead, stands in a refugee camp in Kiwanja. 11 November 2008. **336** Severely malnourished Sadiki Basilaki, nine, receives a mug of milk at a Catholic mission feeding centre in Rutshuru. 13 November 2008. **337** The coffin of eight-month-old Alexandrine Kabitsebangumi, who died from cholera, is lowered into a grave in a banana grove at Kibati. 12 November 2008.

WITNESS

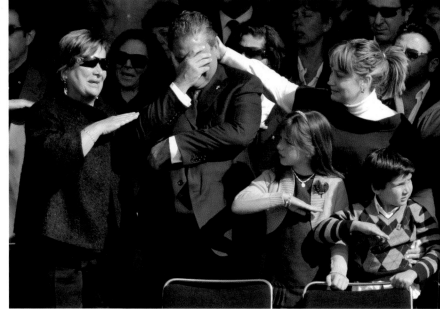

339 [TOP] Klagenfurt, Austria **340** [ABOVE] Mexico City, Mexico

341 London, Britain

קניון ירושלים
Jerusalem Mall
كنيون اورشليم
הכניסות הבאות

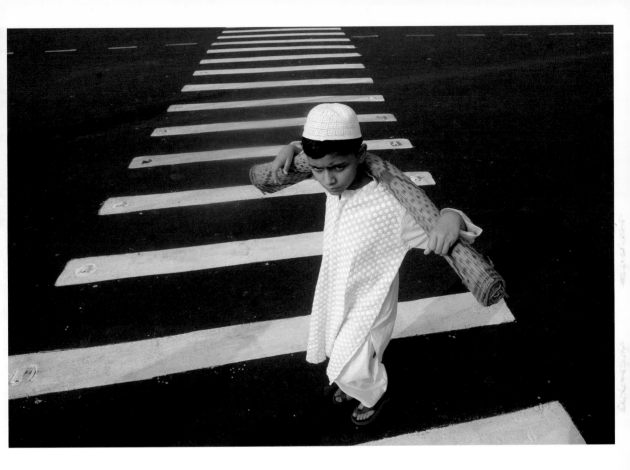

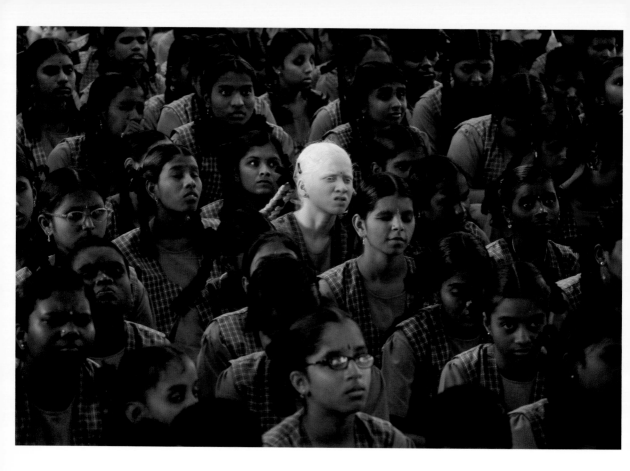

345 Chennai, India

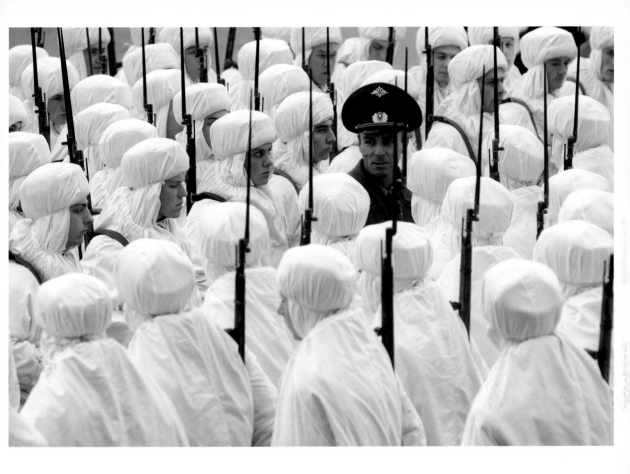

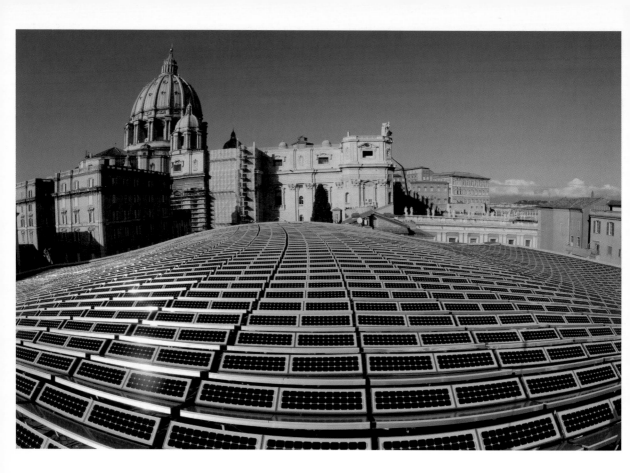

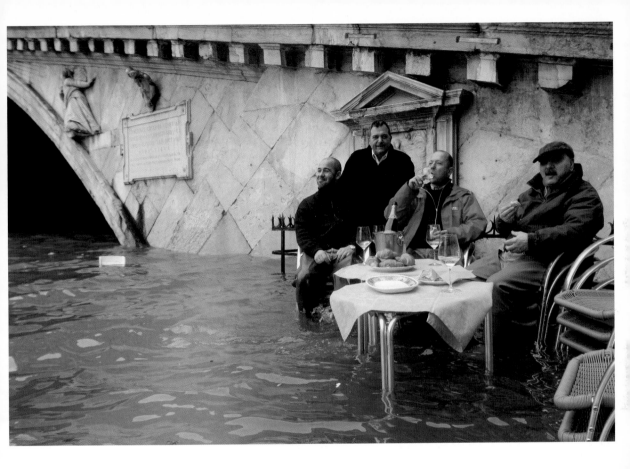

338 A girl watches a funeral rehearsal for Thai Princess Galyani Vadhana, the late sister of King Bhumibol Adulyadej. Tens of thousands of Thais gathered in old Bangkok on 15 November for the princess's cremation, part of 6-day, $9 million funerary rites. 2 November 2008. Bangkok, Thailand. Chaiwat Subprasom.

339 Pallbearers in traditional clothes carry the coffin of Jörg Haider into the cathedral of Klagenfurt. Around 25,000 mourners attended a memorial service for Haider, who died in a high-speed car crash on 11 October. Haider was a right-wing populist politician who helped thrust anti-immigrant politics into the European mainstream. 18 October 2008. Klagenfurt, Austria. Leonhard Foeger.

340 The family of Mexico's Interior Minister Juan Camilo Mouriño cry during a ceremony in Mexico City to honour him and eight others who were killed in an aircraft crash, which also killed five people on the ground in the midst of evening rush hour traffic in Mexico City. 6 November 2008. Mexico City, Mexico. Daniel Aguilar.

341 A poppy floats in a fountain in Trafalgar Square following ceremonies to mark the 90th anniversary of Armistice Day in central London. 11 November 2008. London, Britain. Alessia Pierdomenico.

342 A child runs with a kite bearing a red ribbon during a World AIDS Day event in Beijing. There are about 700,000 cases of HIV/AIDS in China, according to official statistics. 30 November 2008. Beijing, China. Jason Lee.

343 Children play in an empty street during the Jewish holiday of Yom Kippur in Jerusalem's Malcha neighbourhood. Yom Kippur, or the Day of Atonement, is the holiest of Jewish holidays, when observant Jews atone for the sins of the past year and traffic largely comes to a halt. 9 October 2008. Jerusalem. Yannis Behrakis.

344 A Muslim boy walks to attend prayers for the festival of Eid al-Adha in the eastern Indian city of Kolkata. 9 December 2008. Kolkata, India. Parth Sanyal.

345 Children watch a welcome ceremony in honour of Belgium's Queen Paola at a school for disabled children in Chennai. 10 November 2008. Chennai, India. Francois Lenoir.

346 Soldiers in historical uniforms take part in a military parade in Red Square in Moscow. 7 November 2008. Moscow, Russia. Denis Sinyakov.

347 Solar panels cover the roof of the Paul VI hall near Saint Peter's Basilica in the Vatican. The Vatican has made a commitment to use renewable energy for 20 percent of its needs by 2020. 26 November 2008. Vatican. Tony Gentile.

348 Gondoliers eat breakfast while sitting in flood waters in Venice. Sea levels reached their highest level in 22 years on 1 December, flooding large parts of the lagoon city. Ferry and water taxi services were suspended and officials urged people to stay indoors. 1 December 2008. Venice, Italy. Manuel Silvestri.

349 A woman shelters under an umbrella beside the beach in Nice, southern France. 29 October 2008. Nice, France. Eric Gaillard.

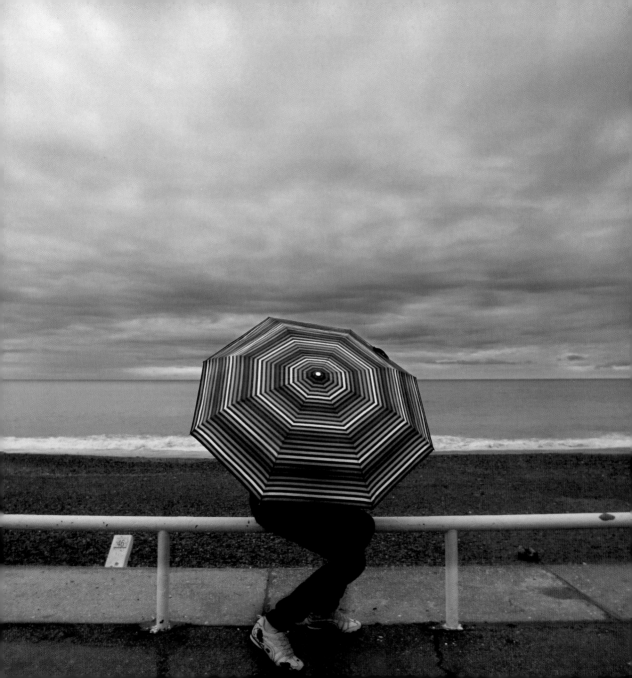

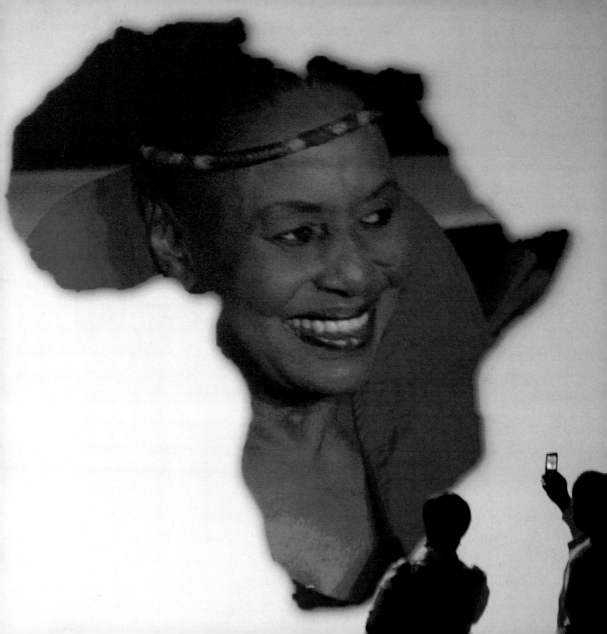

354 Los Angeles, United States

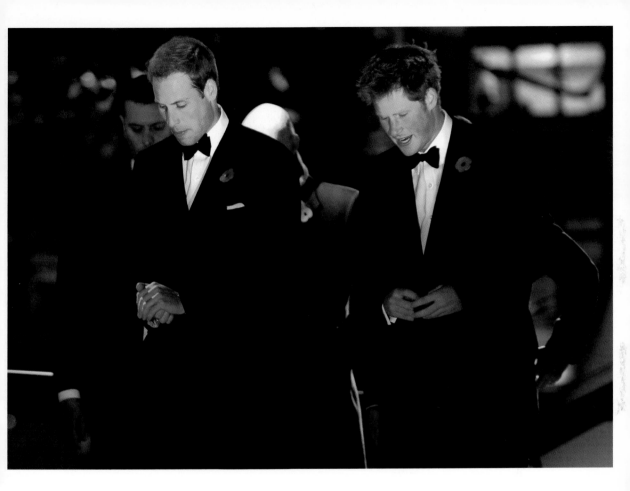

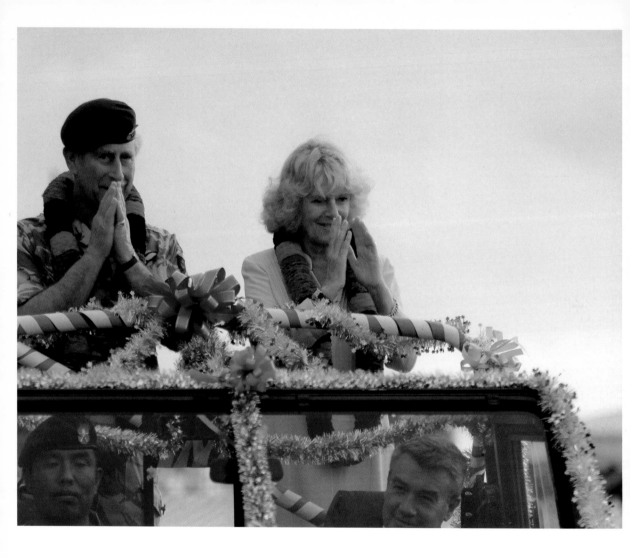

356 Seria, Brunei

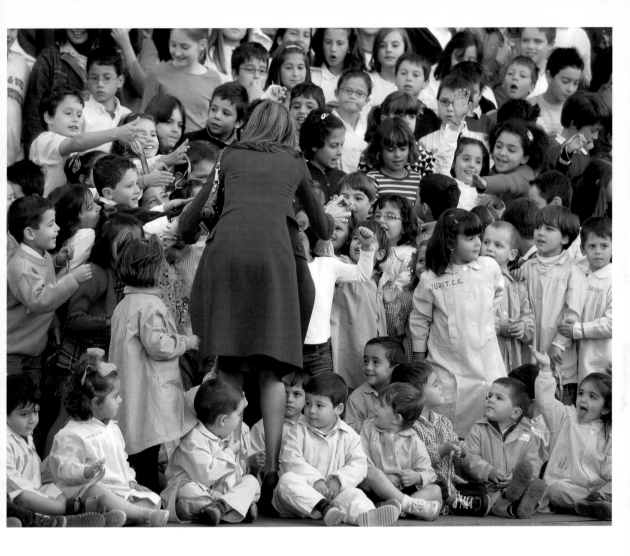

357 Oviedo, Spain

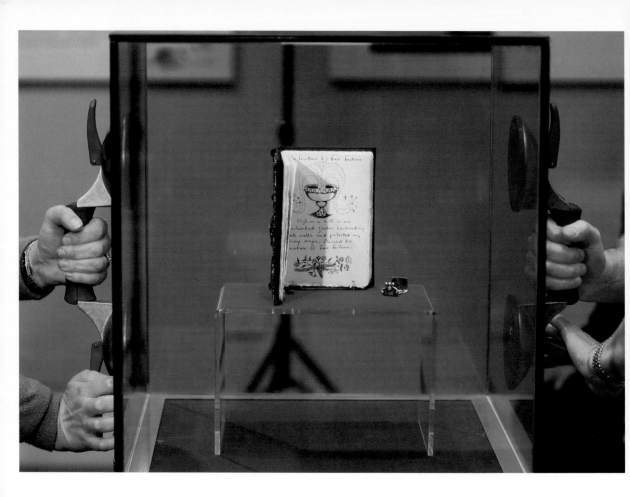

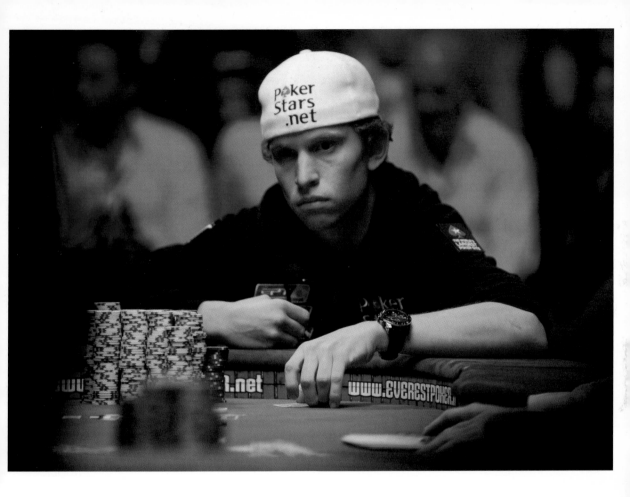

350 351 352 353 354 355

356 357 358 359 360

50 Actor Benicio Del Toro poses next to a statue of Argentine-born revolutionary hero Ernesto 'Che' Guevara before a news conference in Buenos Aires to promote the film *Che*, a four-hour epic directed by Steven Soderbergh. 28 October 2008. Buenos Aires, Argentina. Marcos Brindicci.

51 Mourners take pictures at the end of a memorial service in Johannesburg for South African singer Miriam Makeba. Makeba, known as 'Mama Africa', was one of Africa's best known voices and a champion of the fight against apartheid during three decades in exile. She died aged 76 after performing at a concert in Italy on 9 November. 15 November 2008. Johannesburg, South Africa. Siphiwe Sibeko.

52 Goodwill ambassador and actress Nicole Kidman listens to a presentation about violence against women during a news conference at the United Nations Headquarters in New York. 25 November 2008. New York, United States. Lucas Jackson.

353 French actor Guillaume Depardieu is seen shooting a film scene in Bucharest. Depardieu, son of French actor Gérard Depardieu, died of pneumonia on 13 October 2008, aged 37. He had rebelled against his famous father and led a tumultuous, angst-ridden life. 1 October 2008. Bucharest, Romania.

354 Britney Spears performs with Madonna during the Los Angeles date of Madonna's 'Sticky and Sweet' tour. 6 November 2008. Los Angeles, United States. Mario Anzuoni.

355 Britain's Prince William (left) and Prince Harry arrive for the world premiere of the latest James Bond movie *Quantum of Solace* at Leicester Square in London. 29 October 2008. London, Britain. Dylan Martinez.

356 Britain's Prince Charles and Duchess of Cornwall greet the crowd after visiting the British Forces Brunei in Seria. 31 October 2008. Seria, Brunei. Ahim Rani.

357 Spain's Princess Letizia talks with children during a visit to a college in Oviedo in northern Spain. 23 October 2008. Oviedo, Spain. Felix Ordonez.

358 Staff at the National Library of Scotland lift a glass case containing one of seven copies of JK Rowling's book *The Tales of Beedle the Bard* hand-written and illustrated by Rowling herself. The author gave six away as gifts and auctioned the seventh for charity, raising $4 million. It was bought by online retailer Amazon. 3 December 2008. Edinburgh, Britain. David Moir.

359 Peter Eastgate of Denmark plays poker against Ivan Demidov of Russia during the World Series of Poker at the Rio Hotel and Casino in Las Vegas, Nevada. Eastgate, 22, defeated Demidov to win $9.15 million and become the youngest champion of the World Series of Poker main event. 11 November 2008. Las Vegas, United States. Steve Marcus.

360 Actress Meryl Streep books a trade during the 16th annual global charity day of ICAP, the world's largest interdealer broker, in Jersey City, New Jersey. ICAP said the day's trading had raised around $16 million to be donated to over 100 charities worldwide. 10 December 2008. Jersey City, United States. Jacob Silberberg.

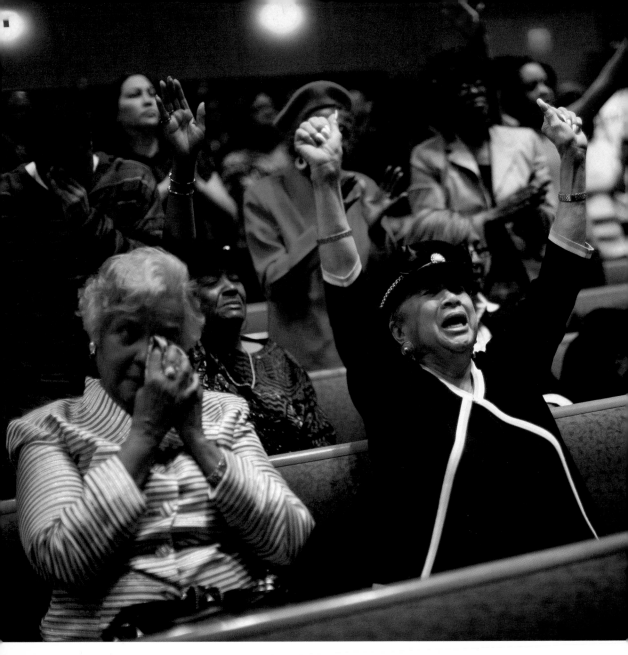

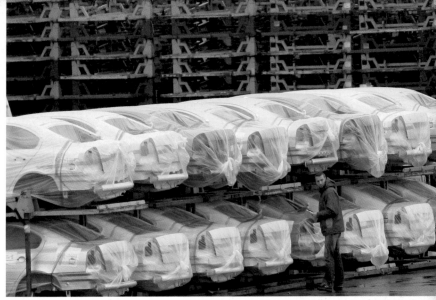

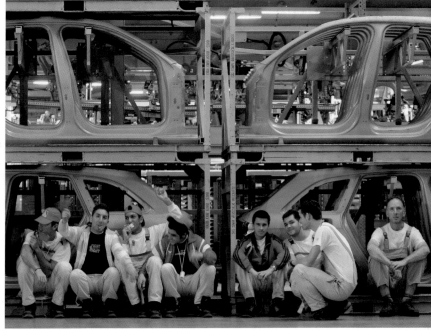

362 [TOP] Mladá Boleslav, Czech Republic　**363**　[ABOVE] Ingolstadt, Germany

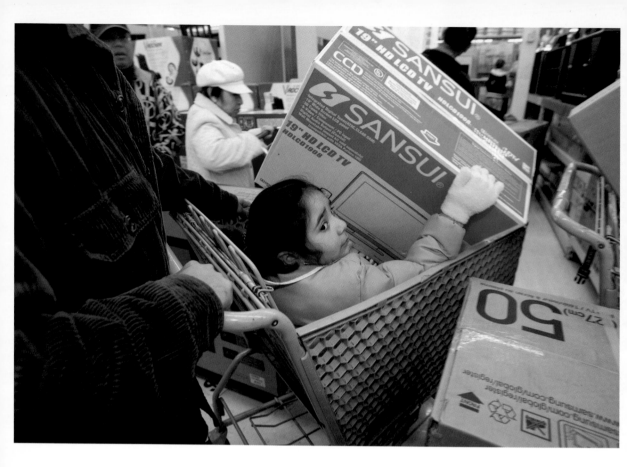

364 Oakland, United States

361 People pray for the future of the American auto industry during a special service at the Greater Grace Temple in Detroit, Michigan. With sport utility vehicles at the altar and auto workers in the pews, the congregation offered up prayers for Congress to bail out the struggling industry. 7 December 2008. Detroit, United States. Carlos Barria.

362 An employee examines cars at the Skoda Auto factory in Mladá Boleslav. The factory halted production for one week in October in reaction to falling sales in Europe because of the financial crisis. 30 October 2008. Mladá Boleslav, Czech Republic. David W. Cerny.

363 German workers take part in a strike at the Audi luxury car factory in Ingolstadt. German industrial trade union IG Metall was demanding a pay rise of 8 percent, its biggest in 16 years, for the 3.6 million workers in the German engineering and metalworking industries. 6 November 2008. Ingolstadt, Germany. Michaela Rehle.

364 A girl sits in a shopping cart holding a television in a Wal-Mart store in Oakland, California. Although shoppers across the United States flocked to stores before dawn to make the most of post-Thanksgiving holiday sales, many vowed to keep spending down in the face of a shrinking economy. 28 November 2008. Oakland, United States. Kimberly White.

365 A worker stuffs newly made toys in a factory in the suburbs of Shanghai. The number of Chinese firms exporting toys overseas halved in the first seven months of 2008 compared to the year before, according to China's General Administration of Customs. 31 October 2008. Shanghai, China. Nir Elias.

366 A model presents a dress from Podium Concept during the opening night of the fourth annual Millionaire Fair in Moscow. Russia's economic boom of the past eight years has created dozens of billionaires and unleashed a wave of extravagant consumption, making Russia the world's fourth-biggest luxury goods market. 27 November 2008. Moscow, Russia. Thomas Peter.

367 A woman looks on as the Cunard cruise liner Queen Elizabeth 2 arrives in Port Rashid in Dubai. The famous liner is to be moored permanently alongside Dubai's Palm Jumeirah, where she will become a first-class hotel and entertainment centre. 26 November 2008. Dubai, United Arab Emirates. Jumana El Heloueh.

368 A 'going out of business' sign is displayed at a branch of Mervyns department store in West Covina, California. 29 November 2008. West Covina, United States. Lucas Jackson.

369 Letters addressed to Jesus of Nazareth and God lie in a sorting room of a post office in Jerusalem. Hundreds of letters addressed to God arrive in Israel each year, most around Jewish holidays, to be placed between the stones of the Western Wall. 9 December 2008. Jerusalem. Baz Ratner.

Acknowledgments

Executive Picture Editor Ayperi Karabuda Ecer is Vice-President of Pictures, heading an international team dedicated to enhancing news photography through content initiatives, business development and creative projects including award-winning multimedia essay Bearing Witness. She was Editor-in-Chief of Magnum Photos Paris for 12 years and Bureau Chief for Sipa Press in New York. She participates in juries and teaching to share her experience of the editorial photographic world.

Project Director Jassim Ahmad joined Reuters in 2000 and works in the Media division as Head of Visual Projects, with responsibility for advancing Reuters content identity through books, multimedia and other visual communications. Recent projects include *Reuters – The State of the World*, published in 10 languages and exhibited in 30 international cities; bestseller *Reuters – Sport in the 21st Century*; and acclaimed multimedia story *Bearing Witness*.

With thanks to Paul Barker, Valerie Bezzina, Lynne Bundy, Jane Chiapoco, Hamish Crooks, Shannon Ghannam, Emma Goh, Jeremy Lee, Ginny Liggitt, Simon Newman, Dennis Owen, Alexia Singh, Kate Slotover, Akio Suga, Thomas Szlukovenyi, Amanda Vinnicombe, Thomas White, Alison Williams.

Contributing Photographers

The country that follows each name represents the photographer's nationality.

Adam Dean, Britain
Adrees Latif, United States
Ahim Rani, Brunei
Ahmad Masood, Afghanistan
Ahmed Jadallah, Palestinian Territories
Alessia Pierdomenico, Italy
Alex Grimm, Germany
Ali Hashisho, Lebanon
Alireza Sotakbar, Iran
Amir Cohen, Israel
Ammar Awad, Israel
Andrei Kasprishin, Russia
Andres Stapff, Uruguay
Andrew Winning, Britain
Anuruddha Lokukapuarachchi, Sri Lanka
Arko Datta, India
Arnd Weigmann, Germany
Bai Gang, China
Baz Ratner, Germany
Benoit Tessier, France
Bob Strong, United States
Bobby Yip, Japan
Borja Suarez, Spain
Brendan McDermid, United States
Brian Snyder, United States
Carlos Barria, Argentina
Carlos Duran, Colombia
Ceerwan Aziz, Iraq
Chaiwat Subprasom, Thailand
Charles Platiau, France
Cheryl Ravelo, Philippines
Chip East, United States
Chor Sokunthea, Cambodia
Christian Charisius, Germany
Christinne Muschi, Canada
Claudia Daut, Germany
Cynthia Karam, Lebanon
Damir Sagolj, Bosnia
Daniel Aguilar, Mexico
Darren Staples, Britain
Darren Whiteside, Canada
Dave Martin, United States
David Gray, Australia

David Mdzinarishvili, Georgia
David Mercado, Bolivia
David Moir, Britain
David W Cerny, Czech Republic
Denis Balibouse, Switzerland
Denis Sinyakov, Russia
Dylan Martinez, Britain
Eddie Keogh, Britain
Eduardo Munoz, Colombia
Edwin Montilva, Venezuela
Eliseo Fernandez, Chile
Enrique Castro-Mendivil, Peru
Enrique Marcarian, Argentina
Eric Gaillard, France
Eric Miller, United States
Eric Thayer, United States
Erin Siegal, United States
Fadi Arouri, Palestinian Territories
Faisal Mahmood, Pakistan
Fatih Saribas, Turkey
Fayaz Kabli, India
Felix Ordonez, Spain
Fernando Soutello, Brazil
Finbarr O'Reilly, Canada
Francois Lenoir, Belgium
Frank Polich, United States
Gary Hershorn, United States
Gleb Garanich, Ukraine
Gonzalo Fuentes, Mexico
Goran Tomasevic, Serbia
Grigory Dukor, Russia
Hannibal Hanschke, Germany
Helmiy al-Azawi, Iraq
Howard Burditt, Zimbabwe
Ibraheem Abu Mustafa, Palestinian Territories
Irakly Gedenidze, Georgia
Ismail Zaydah, Palestinian Territories
Issam Abdallah, Lebanon
Ivan Alvarado, Colombia
Ivan Milutinovic, Serbia
Jacob Silberberg, United States
Jason Lee, China
Jason Reed, Australia
Jayanta Shaw, India
Jeff Topping, United States
Jerry Lampen, Netherlands
Jessica Rinaldi, United States
Jim Young, Canada

Jo Yong-Hak, South Korea
John Gress, United States
John Javellana, Philippines
John Kolesidis, Greece
John Sommers II, United States
Jonathan Ernst, United States
Jorge Silva, Mexico
Juan Carlos Ulate, Costa Rica
Jumanah El Heloueh, Lebanon
Kai Pfaffenbach, Germany
Kevin Coombs, Britain
Kevin Lamarque, United States
Khaled Abdullah, Yemen
Kimberly White, United States
Laszlo Balogh, Hungary
Leonhard Foeger, Austria
Lucas Jackson, United States
Lucy Nicholson, Britain
Luiz Vasconcelos, Brazil
Luke MacGregor, Britain
Mahmoud Raouf Mahmoud, Iraq
Mal Langsdon, Britain
Manuel Silvestri, Italy
Marcelo Del Pozo, Spain
Marcos Brindicci, Argentina
Mariana Bazo, Peru
Mario Anzuoni, Italy
Mark Leffingwell, United States
Mark Wessels, South Africa
Mathieu Belanger, Canada
Max Rossi, Italy
Michaela Rehle, Germany
Mick Tsikas, Australia
Mihai Barbu, Romania
Mike Blake, Canada
Mike Segar, United States
Mikhail Mordasov, Russia
Mohamed Azakir, Lebanon
Mohammed Salem, Palestinian Territories
Molly Riley, United States
Morteza Nikoubazl, Iran
Nacho Doce, Spain
Nasser Nuri, Egypt
Nayef Hashlamoun, Palestinian Territories
Nicholas Roberts, United States
Nir Elias, Israel
Noor Khamis, Kenya
Osman Orsal, Turkey

Parth Sanyal, India
Pascal Rossignol, France
Pawan Kumar, India
Pawel Kopczynski, Poland
Peter Andrews, Poland
Petr Josek, Czech Republic
Phil Noble, Britain
Pichi Chuang, Taiwan
Punit Paranjpe, India
Rafael Marchante, Spain
Rick Wilking, United States
Robert Sorbo, United States
Rogan Ward, South Africa
Romeo Ranoco, Philippines
Ronen Zvulun, Israel
Sabah Al-Bazee, Iraq
Sean Yong, China
Sergei Karpukhin, Russia
Sergio Moraes, Brazil
Shannon Stapleton, United States
Sigit Pamungkas, Indonesia
Siphiwe Sibeko, South Africa
Stefan Wermuth, Switzerland
Stefano Rellandini, Italy
Stephen Hird, Britain
Steve Marcus, United States
Stoyan Nenov, Bulgaria
Suhaib Salem, Palestinian Territories
Susana Gonzalez, Mexico
Susana Vera, Spain
Thomas Peter, Germany
Tim Shaffer, United States
Tim Wimborne, Australia
Tobias Schwarz, Germany
Toby Melville, Britain
Tomas Bravo, Mexico
Tony Gentile, Italy
Toru Hanai, Japan
Umit Bektas, Turkey
Vincent Kessler, France
Vincent West, Britain
Wolfgang Rattay, Germany
Yannis Behrakis, Greece
Yiorgos Karahalis, Greece
Yuri Gripas, Russia
Yuriko Nakao, Japan
Yves Herman, Belgium
Zhong Min, China
Zohra Bensemra, Algeria